USING YOUR CAMERA

A BASIC GUIDE TO 35MM PHOTOGRAPHY

USING YOUR CAMERA

A BASIC GUIDE TO 35MM PHOTOGRAPHY ■ REVISED AND ENLARGED EDITION

GEORGE SCHAUB

AMPHOTO BOOKS
*An imprint of Watson-Guptill
Publications/ New York*

George Schaub is a writer/photographer whose work has appeared in many newspapers and magazines. He served as Executive Editor for *Popular Photography* magazine and as editorial director of a group of photo/imaging magazines at Cygnus Publishing, including *Studio Photography & Design* magazine. He is the author of twelve books on photography and digital imaging, and has been a frequent contributor to the *New York Times* Arts and Leisure section on photography. Schaub lives with his wife, Grace, in Cocoa Beach, Florida.

Senior Editor: Victoria Craven
Associate Editor: Elizabeth Wright
Designer: Jay Anning
Text set in 11 pt Electra LH

First edition published in 1990 in New York by AMPHOTO BOOKS.
Revised edition published in 2001 in New York by AMPHOTO BOOKS,
an imprint of Watson-Guptill Publications,
a division of BPI Communications, Inc.
770 Broadway, New York, NY 10003

Library of Congress Cataloging-in-Publication data is available.

ISBN 0-8174-6354-2

Printed in Malaysia

First Printing, 2001

1 2 3 4 5 6 7 8 9 / 08 07 06 05 04 03 02 01

To my father, who lent me his craft,

and

To Grace, always

ACKNOWLEDGMENTS

The photographs in this book were taken exclusively by my wife, Grace, and myself. Without Grace's keen eye and sense of color and light, this project would have been overwhelming, and I thank her for her time, energy, understanding, and patience.

I would also like to thank Canon, Eastman Kodak, Minolta, Nikon, Olympus, and other manufacturers for their kind permission to use some of the technical art and diagrams appearing in this book.

Contents

Introduction 8

The Camera Components 16

The Lens 38

Film: Photography's Recording Material 64

Buying Accessories 86

Focusing 102

Understanding Exposure 114

Creative Possibilities 135

Glossary 154

Index 160

INTRODUCTION

Photography literally means "drawing with light." Just as a painter works with brushes and paint and a sculptor with chisel and stone, a photographer works with tools that aid in the process of creation. The tools we are going to discuss in this book are the 35mm **single-lens-reflex (SLR) camera,** a variety of lenses, various accessories such as tripods and flashes, and the medium upon which the drawing is made—film.

There are many approaches to learning about photography. Some involve delving deeply into theories, the principles of physics, and the interaction of light and matter. In my view, however, no theory ever took a great picture. That's why in my 15 years of teaching photography at the New School in New York City and in my workshops and lectures, I have emphasized the practice of photography as a craft. As interesting as those theories are, their complexity needn't get in the way of taking a good picture.

Nevertheless, an appreciation of how light and film interact and the effects of various camera controls can lead to taking better pictures. This book's goal is to provide the knowledge essential for taking full advantage of that marvelous photographic instrument called a 35mm single-lens-reflex camera. I hope to do so in a way that doesn't burden you with an armload of theories and charts.

Photography is a unique blend of art and science—an exciting balance of left brain/right brain activity. The scientific side deals with optics, physics, and electrochemical reactions. Modern SLR cameras mirror our technological age and incorporate microprocessors and miniaturized motors and circuitry. Today, these

Photography allows us to capture fleeting moments of delicacy and grace. This balloon floated for a second or two above the fingertips of a child on Lantau Island near Hong Kong.
Photo: Grace Schaub

You can make photographs that express the beauty and moods of your surroundings, that show a unique personal point of view, or that comment on the social scene.

elements are found in even the most basic SLR. The artistic side comes from the person using the camera and the unique way that person sees the world and interprets it through the viewfinder. The combination of science and art is both challenging and appealing. It encourages individual expression in a sometimes conformist world and allows you to explore aspects of yourself, others, and the environment around you.

Photography has many uses. It can be an autobiographical tool or a medium of social commentary. It freezes moments in time and memorializes them. It captures a fleeting glance or the impression of something more enduring and deeply contemplated. The images you create can be an excellent way to understand yourself and your world. They are also an artistic expression of the beauty you see around you and a manifestation of your personal vision.

The challenge of learning photography is to understand enough of the science to be able to apply it to your art. By "art," I don't necessarily mean the work that is hung on the walls of a museum. Art, for me, is a "re-creation," a way to pursue personal and spiritual discovery. Photography, in particular, is an art form that involves both photographer and viewer in a process that can help change perceptions about people and the world.

Photography is perhaps the most accessible of all the visual arts. With the simple pressure of your finger on the shutter-release button, you can create lasting images of fleeting moments in time and life. Photography is a vehicle for recording your instinctive reactions to the ongoing rush of energy, motion, and light surrounding you. Those captured moments can be examined later, at leisure, and grouped with other moments to form a visual diary of your life and time. Such a record is also a legacy of memories for you and your family, one that is of the moment and historical at the same time. The split-second nature of photography differentiates it from the other visual arts. Its amazing ability to record fleeting moments has changed the way we see the world, and may even have changed our history. Photography is a form of magic unique to our times.

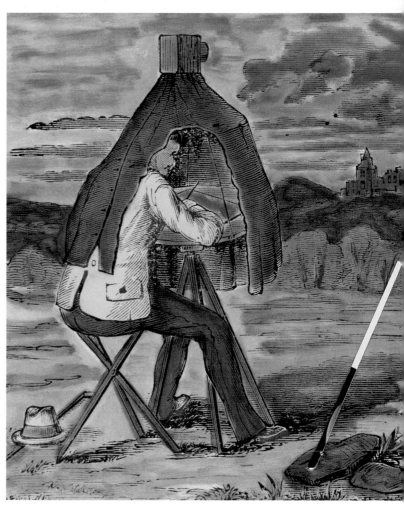

The photographic camera evolved from sketching aids that artists used to make images from nature. Light once used for tracing became the means of creating images mechanically

Using your camera means making it an expressive tool for sharing your views of the world.

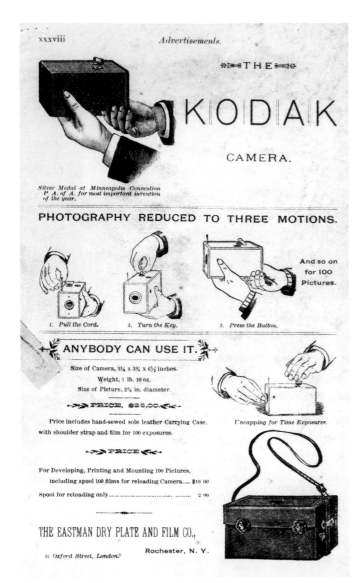

One of the first mass produced cameras was this Kodak, introduced around 1890. Even then manufacturers were touting the ease of their instruments.
Courtesy: Eastman Kodak Company

THE CAMERA

From the outside a camera is nothing more than a light-tight box with various metal, plastic, and glass appendages. Inside, it contains a complex mass of gears, motors, electrical circuits, microchips, and light-sensitive cells. The purpose of all the engineering is to capture light on the recording medium—film.

The ease of modern technology—autofocus, auto-exposure and automatic flash—has arguably lessened the importance of learning about how photography works. This is certainly true for those who use photography for the occasional snapshot at a party or wedding, and there are numerous point-and-shoot camera models that serve such purposes admirably.

Once you begin to see photography as a medium for personal expression, however, you'll want to learn more about its basic concepts. As you develop your "eye," and when, occasionally, you encounter the frustration that follows a failed effort to capture an important moment, you may find that you want to bring into play some concrete understanding of what makes a picture work.

Investment in an SLR camera often signals a desire to learn more about the craft of photography. Rather than allow an automated SLR to make all your decisions for you, you may want to learn how to fine-tune the controls that can make an image a personal expression. It's true that automatic features for exposure and focusing have made it easier to take good pictures and have made cameras more responsive than ever before. The proper use of these features, however, does require some fundamental knowledge. The intricacies of electronics are not as important as the effect they have when you use them. The photographic process involves cause and effect; gaining an understanding of that process turns the camera and its functions into the servants of your eye rather than its master.

Getting started with an SLR might seem intimidating. There are exposure modes and programs to master, and a host of dials and pushbuttons to operate. Although the jargon and hardware may seem overwhelming, what you're dealing with are some very basic photographic principles dressed in high-tech clothing. These principles have remained essentially the same for the last 150 years. The major change among them is that we now have films that can be used in very low levels of light and sophisticated technology to perform tasks once done by hand and eye.

A BRIEF HISTORY

Today's cameras evolved from a device known as a camera obscura. This artist's tool had many variations and designs. It allowed the artist to make a sketch from nature using a light-tight box and an optical glass. In the mid-1700s, a handy little camera obscura was devised that could be used indoors as a tabletop sketching aid or could be brought outdoors if used under a dark cloth. It had a reflex or mirror-reflecting viewing system. When light traveled through the lens, it was reflected by the mirror up to a translucent sheet of glass set into the top of the box. This groundglass was where the artist put the tracing or sketching paper. With some variation, this is the same viewing arrangement used in today's 35mm SLRs.

Photography itself was invented in the early nineteenth century, although all its components were already part of scientific knowledge before its public unveiling in 1839. Its discovery was achieved through the convergence of many principles of science with one principal goal: to capture and hold an image from nature by mechanical means.

Before photography burst onto the world stage, people knew that certain silver-salt compounds would change when struck by light. Researchers had made camera images before the 1830s, but they had no way of making the images stable. When they were brought into strong light, the images would disappear and some of the silver salts would turn black. The turning point in the invention of photography was the discovery and later application of a chemical that would "fix," or make stable, the change that light caused in the silver-salt compounds. After the "latent," or exposed, image was developed or visually amplified by certain chemicals, this new fixing stage of the process removed any metallic salts not struck by or exposed to light, while leaving the exposed, image-forming salts untouched. This changed the course of the world. Finally, a more or less permanent image could be created by machine.

Once the process of capturing images of nature with a camera became publicly known, photography—and a new breed of artists, avid hobbyists, and professionals known as photographers—were born.

A very popular form of photography in the mid to late 19th century was the ferrotype, or tintype, often produced at resorts or fairs in portable studios. The tintype image actually sits in a metal base. Flea markets and antique stores are great sources of these amazing images.
Collection: Grace Schaub

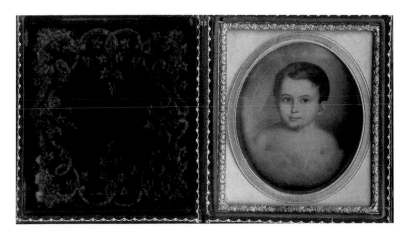

Although we have come to accept one form of photography, there have, in fact, been many different experiments and image-forming techniques throughout the history of the craft. This daguerreotype, which was sold in a velvet and gold leaf case, was for a time a rival to the negative/positive process we use today.
Collection: Grace Schaub

MAKING AN IMAGE

The modern method for making photographic prints is similar to the one used throughout the nineteenth century. An image is created when a sensitized material is placed inside a camera and exposed to light. This image is called a **negative** because the tones, or light values of the original scene, are reversed. The bright part of a scene affects a greater amount of silver. The dark portion of the original scene creates less change in the silver salts and appears as gray or near-white in the negative.

Paper was the first material to be coated with the silver-salts. Glass plate was used later, and now flexible film is the universal choice. The image created by the silver-salts is at first invisible to the naked eye; the image must be developed in chemicals to make it visible. Once the negative is developed, light is projected through it onto another sensitized sheet. The tones on the negative are reversed in this process, which creates a **positive** print resembling the actual light values in nature.

Early experimenters in photography explored hundreds of different chemicals and sensitizing combinations. The origin of photography is filled with stories of people who dedicated their lives to the technical progress of the craft. For many years photographers had to sensitize their own recording material and literally carry their laboratories on their backs into the field. Today we can go into a store and pick and choose from dozens of different types of films and get our negatives enlarged in a matter of minutes.

Modern films still use silver compounds, called **silver halides**, as the light-sensitive material. When exposed to light, the microscopic grains of silver form a latent image. When the film is developed, these grains are amplified to form a visible, negative image, which is then projected onto light-sensitive paper to make prints. In color film, these grains are disbursed throughout color-recording layers that yield life-like color images when combined.

The size of a film's **grain** determines how light-sensitive the film is. The larger the grains, the "faster," or more light-sensitive, the film. Early photographic recording materials were very slow compared to those available now, and recording an image required a long exposure time. In the earliest days, it took minutes to get an image. By comparison, even today's slow films can record a scene in as little as 1/250 of a second.

The image is formed by a mass of silver grains, known as silver halides, that change when struck by light. The image is made visible by developing the film in a series of chemical baths. Grain resides in all photographic images, and you can see it if you enlarge the image enough. Making a high-contrast rendition of the scene has enhanced this grain.

A PERSONAL APPROACH

All the parts that work together to create a picture—lens, camera and film—make an important contribution to the technical and creative aspects of photography. Each part adds another variable that affects how your pictures come out. Although one part may play a dominant role in a particular picture, all are designed to work together.

Learning about photography means learning the fundamentals of each of these elements. Yet once you understand the basics, the most important element is the way you see and think about pictures. So, as you read through this book, apply the discussions to your camera and your need for practical advice.

Before we get started I'd like to tell you about my relationship to the photographic craft. After thirty years of steady work and study in this field it still remains a magical and fascinating part of my life. I continue to learn about the tools and techniques of the craft and about myself. Photography has given me an appreciation of light, form, and motion, gifts that stay with me even when I don't have a camera in my hand.

Taking pictures is an all-involving process that continually calls for my interaction with the world. It has taken me places I would have never seen otherwise and introduced me to people I might not have met. I have come to know it as a vehicle for self-expression as well as a means of creating a visual diary of my life that keeps the memory of people, places, and moments alive. Photography is a wonderful vehicle for studying the world, and is also a lot of fun. It offers infinite possibility for experimentation, study, and deep enjoyment.

My goal is to help you break through any barriers preventing you from experiencing these joys and to introduce you to the pleasures and wonders of the craft. I hope to clear away some of the jargon and give you the working knowledge to make great pictures with any SLR. It is great when light, film and lens create a strong picture by accident. But it is even better when you know what you will get when you snap the shutter.

Making effective pictures requires experience, "seeing," and a sense of what you're trying to express. Making great pictures means all that plus a vivid application of technique. In order to help you acquire that technique, I will explain the anatomy of an SLR and explore its many parts, discussing how the principles of focus and exposure are applied in today's cameras. I hope to show you how to put this knowledge to use and how your personal decisions can have a major impact on what comes out on film.

Photography is a technological marvel. Its power to capture moments of time on film also gives it a touch of the miraculous. Throughout your study and growing understanding of photography, don't lose touch with your sense of the wonder of it all.

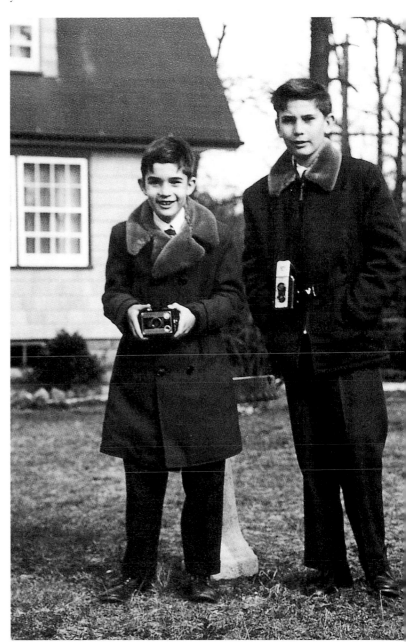

A relationship with photography can begin very early and stay with you throughout your life. It serves as a visual diary of the people, places, and events that shape your life and the lives of those around you. It is both a legacy and of the moment. This photograph of my brother and me was taken in the 1950s. The author is the boy holding his camera sideways.

THE CAMERA COMPONENTS

In this section we are going to take a camera tour. You may have a different camera, one that lacks some of the elements described here and identifies other elements differently. You may be working with an older model that lacks some of the automation, or you may have the latest full-featured single-lens-reflex camera (SLR). What I'll describe here are elements that are common to almost every SLR in use today. Throughout this book I'll cover techniques that just about everyone can use.

The modern 35mm SLR is a highly sophisticated instrument. It contains circuitry, gears, and motors that perform complex tasks in fractions of a second. The latest models have microprocessors that perform amazing exposure and focusing calculations.

At its most basic, an SLR performs the function of providing a light-tight chamber for film, a mechanism for film advance and rewinding, a shutter that opens and closes to allow light to expose the film, and a mount for a lens. Think of your camera as the control center from which you can exercise any number of options to influence the way a picture is made.

If your camera offers a high degree of automation, you can program it to perform in any way you like. You can use it as a fully automatic system that still can be modified to give your pictures a personal touch. You can also work with manual cameras, or use autofocus and autoexposure cameras in a way that allows you to make every exposure decision based on the information the

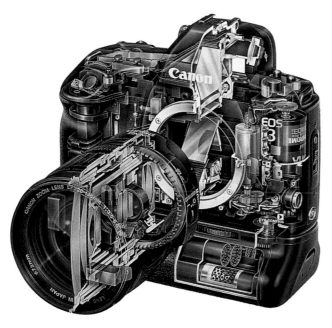

The interior of a modern SLR is a complex arrangement of gears, microprocessors, miniature motors, and circuits. Today's cameras are technological marvels that respond to light and motion in ways that allow for spontaneous picture-making.
Courtesy: Canon USA

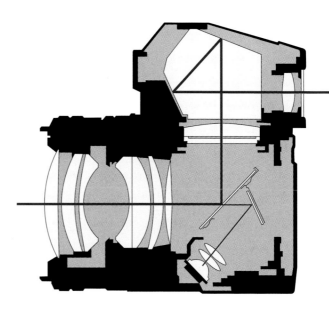

The light path in a SLR camera allows you to see exactly what will be recorded on film. When you're viewing the scene, the light comes through the lens and bounces off a mirror up and into the pentaprism, or viewing box, of the camera. The exit path is the eyepiece. The light may also be directed toward metering cells and autofocusing detector arrays. When you press the shutter release to make a picture, the reflecting mirror moves out of the way and the light travels through the opened shutter to strike the film at the back of the camera. In many cameras the exposure is read again as it reflects off the film itself. After the exposure is made, the mirror returns to its original position.

camera and your honed photographic instincts provide.

Single lens reflex means that one viewing lens is used for focusing and capturing light. In contrast, point-and-shoot 35mm cameras have a separate **viewfinder** that approximates the view the lens provides. With the SLR, there is much more control over the way light is seen and recorded. The SLR can also take interchangeable lenses, a feature that gives it a distinct advantage over point-and-shoot cameras.

The term **reflex** refers to the way light travels from the scene into the viewfinder. In SLRs, light comes in through the lens and reflects up by mirror to a viewfinder screen. What you see in the viewfinder is a view of the scene corrected by a double set of mirrors in the viewfinder housing, or pentaprism. Without this setup you would see an upside-down, incorrectly read image.

All 35mm SLRs share common components. These include a viewfinder, film chamber, pressure plate, film take-up spool, film advance and rewind mechanism, a shutter and shutter release, and a coupling device for attaching a lens. Depending on your camera system, you may also have a number of dials, pushbuttons, and displays that give you control over how the camera functions and how you can make creative exposure and focusing decisions.

THE LENS MOUNT

One major advantage of an SLR is the ability it gives you to change lenses without affecting the film. This creates a wide range of shooting options. On the front of the camera body is an opening surrounded by a metal ring. This is the **lens mounting area,** where you can mount any number of interchangeable lenses to the camera body. This ring usually has contact points or pins. These link the camera operating system, including autofocus and exposure controls, to the lens itself.

Every brand of camera has a distinct mounting system. This means that you must use a lens designed for a specific camera, one made by the camera company itself or an independent lens maker. Using an incompatible lens is impossible because it will simply not mount on the camera body.

Camera makers may change the coupling system when they bring out new camera models, but this happens rarely. While some older lenses from a manufacturer may fit on a newer model body, they may not be able to deliver all the latest exposure or focusing features. Except for one camera company, Nikon, manual-focusing lenses made years ago do not even fit on newer autofocus models. Before you purchase a lens, make sure it is compatible with your camera.

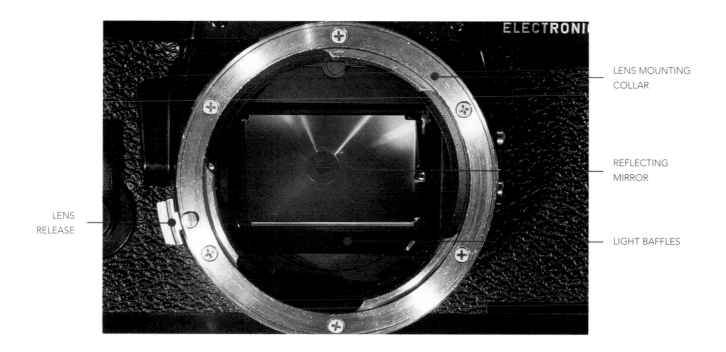

LENS MOUNTING COLLAR

REFLECTING MIRROR

LIGHT BAFFLES

LENS RELEASE

The open front of an SLR body without lens reveals the lens release, lens mounting collar, reflecting mirror, and light baffles. These features allow you to change lenses even when film is loaded in the camera, a distinct advantage of working with a 35mm SLR.

To mount and disengage a lens, you must first push a lens release button, usually located on the lower left-hand side of the camera body. This releases the linkage points and should make for a smooth interchanging operation. Never force a lens on or off a camera body. If it doesn't go smoothly, try pushing the lens release button again.

Before you mount your lens, look inside the open front of the camera. The first thing you'll see is a mirror angled at 45 degrees. This mirror reflects light coming through the lens toward the viewfinder screen and/or the metering and focusing cells. When you take a picture, the mirror snaps up and out of the way, allowing the light to pass through the opening shutter and strike the film.

The opening in the front of the camera might also contain some baffles or other light-insulating material. These help seal the camera interior against stray light and form part of the protection that allows you to remove the lens even when film is in the camera. Don't tamper with these delicate casings or play with the mirror, as you might disturb the delicate balance of light protection.

THE VIEWFINDER

When you mount a lens onto the camera, you can see images through the camera's viewfinder. This allows you to see what will be recorded on film, usually minus a small area at the edges of the frame. Viewfinders also serve as the information center of the camera's operating system, where a host of numbers and icons tell you about light levels, aperture and shutter-speed settings, flash readiness, focus confirmation and other important matters. The amount and type of information displayed varies from camera to camera. The viewfinder display gives you plenty of operations information without requiring you to take your eye from it. This is essential, especially when action is unfolding quickly, as you want to be able to shoot without having to wait.

Some SLRs also allow for interchangeable focusing screens. A focusing screen is the glass on which the image appears. Some screens come with grids, a great compositional aid, while others may have a microprism grid for critical focusing work. The grid is made of tiny beads of glass that break up the flat viewfinder surface so unsharpness is more apparent. Focusing screens in autofocus cameras contain rectangular brackets or small squares. These are the autofocusing targets on which the camera will set focus. In many cameras, you have a choice of targets to use, meaning you can set focus at various points around the viewfinder. By default, most start with the center target as the main focusing point. If you only have one target in the finder and your subject is off-center, you place the target over the subject and use the autofocus lock, located on the camera body or as part of the shutter release button, then recompose and shoot.

THE CAMERA BACK

The camera back is hinged to the body and opens when you release a safety catch button. Some older backs open when you lift and turn the film rewind dial. Professional SLRs have removable backs that can be replaced with either Polaroid film holders (for instant proofing of images) or data backs that can be used to expand the camera's functions or work as intervalometers, a setup that fires the shutter at a preset interval.

You open the camera back to load film. Place the film cassette on the left-hand side of the camera. Inside the chamber is a set of gold pins, which are **DX-coding** reading contacts. Nearly every film today is DX-coded. When you place a roll of film into the camera, the pins read out the film speed, or light sensitivity of the roll. This eliminates the need to manually input the film speed into the camera. Some older cameras do not have this feature. If you're working with such a camera, note the film speed designated by the ISO number on the film box and input it on the ISO dial of your camera. You must be sure that the film speed you set matches the film in the camera. If you do not do this, you risk poor results.

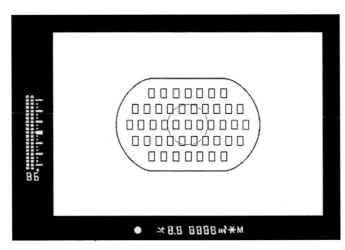

This modern SLR viewfinder model shows what you might see if all the indicators are illuminated. Only the essential information shows at any one time. This viewfinder model shows the potential autofocusing sites, here 45 in total. You can select any or a group of these sites for virtually every picture-taking situation. The scale on the right side is for metering. The number at the bottom shows the frame count. At the base of the finder are indications of aperture and shutter speed and whether you have set any exposure override functions. It also shows if flash is ready and if focus has been confirmed on your subject.
Courtesy: Canon USA

Attached to the camera back is a metal plate that sits above the back itself. Film has a natural curve that is more or less emphasized by temperature and humidity. The pressure plate plays the critical role of keeping the film flat as it passes through the camera. Avoid touching or playing with this plate since any misalignment can cause problems with film flatness and thus sharpness of the image. If there is any dust or grit on the plate, clean it with compressed air or a soft cloth. Any grit left on the plate can scratch film, so check it after photographing at the beach or in dusty environments. Also, be very careful when loading or unloading film or changing lenses in such places. Sand and dust can wreak havoc on a camera's insides.

The Shutter

While you have the camera open, inspect the shutter curtain, the bladed rectangle that sits in the middle of the film channel. When the shutter is released, this curtain or set of curtains—(an opening-and-closing, or "following" curtain)—opens and travels across the film plane for a set period of time. The light passes through the opening and exposes the film. The duration of this operation depends on the shutter speed, from as long as a few seconds to as little, in some cameras, as 1/8000th of a second. The shutter curtain is quite delicate, so avoid touching it when loading film.

The shutter is cocked whenever the film is advanced. Cameras with motorized advances do not require you to cock the shutter. With manual-advance cameras, you advance the film and cock the shutter by stroking a lever that surrounds the shutter release button. After you release the shutter, the next frame of film is automatically advanced behind the shutter curtains. Some cameras allow you to make multiple exposures on the same frame of film, but to do so you have to disable the normal sequence by pushing a special multiple-exposure button.

Framing Rates and Shutter Release

Motorized-advance cameras give you different release options and framing rates. If you choose single release, you take one picture when you press the shutter-release button. Continuous advance means that the camera will keep taking pictures when you keep pressure on the shutter release. **Framing rates,** known as frames per second (fps), can range from three to eight or even ten frames per second, depending on the camera model. At a rate of 6 fps, you can finish a roll of 36 exposures in 6 seconds, perfect for sports and action photography.

Located on the inside back of the camera, the pressure plate keeps the film flat as it passes through the camera. If dust or grit get on the plate clean it carefully. Pressurized air is a good way to remove particles without damaging the plate.

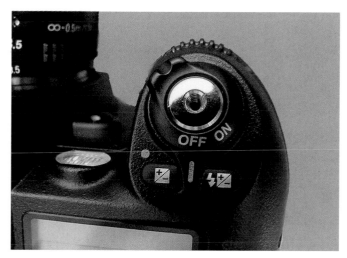

The power switch on this camera is located on a ring surrounding the shutter release button. Note the inset thread on the shutter release. This allows for a cable release. The plus and minus buttons on either side of the release collar are for exposure control. The left side buttons allow you to override the automatic exposure system and to add or subtract exposure from what the camera recommends. The plus/minus switch on the right allows you to add and subtract flash exposure. With these controls allow you to use the automatic exposure system and still have creative input on the exposure. Note the knurled ring right in front of the on/off switch. This is the command dial where you make selections for aperture and shutter speed and input various modes in conjunction with the menu or function dial.

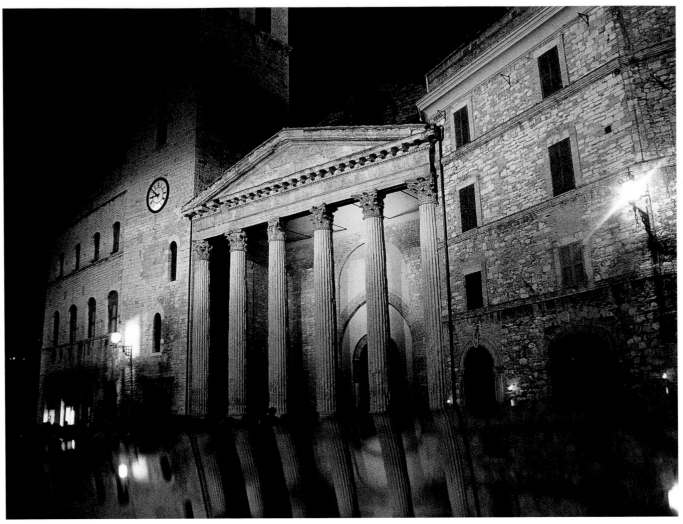

A cable release is a good accessory for making long exposures. The cable helps keep the vibration down when the shutter is released. This photograph was made by steadying the camera on the roof of a car and working with aperture priority mode. The exposure was 1 second, too long to hand-hold.

Some shutter release buttons have a threaded inset into which you can screw a cable release, which is a pin attached by a covered wire to a plunger. When you press the plunger, the shutter is released. The cable comes in handy when you want to maintain camera steadiness, an important part of working with long exposure times. Many cameras have electronic cable releases, remote-control releases, or radio transmitter releases that you fire from far away. This can come in handy for nature photography, but is also used by studio photographers who want to move away from the camera position when they work.

Most SLRs have a two-stage shutter-release button. Pressing all the way down releases the shutter and takes the picture. Halfway pressure can perform a number of functions. It may signal the exposure system to take readings, set the focusing point, or do both in combination. Some cameras have a more sensitive release than others. Working with the camera will give you a quick sense of its touch.

THE LCD PANEL

The LCD panel on an SLR serves as another center of information. The LCD panel shows both current camera settings and works as a guide for making additional settings. Often, settings are chosen from a set of options presented via a menu or a set of buttons or dials. The LCD panel is the display area where the readout of the settings made is shown. It can also tell you battery condition, the number of frames left on the film, and the film speed.

ANATOMY OF AN LCD PANEL

Some LCD panels are more complex than others. The panel shown here displays all potential settings for an SLR. It does not indicate what you would see on a typical display at one time.

We'll begin our tour in the upper left corner. The battery cell symbol indicates battery condition. It may flash or show a fuel gauge indicator. To the right, the next group of symbols, including M, TV, DEP and AV, indicate exposure modes. M is for manual, where you set the aperture and shutter speed after considering the camera-recommended exposure. TV is for time value, where you set the shutter speed and the camera sets the aperture, and AV is for aperture value, where you set the lens aperture and the camera picks the shutter speed for you. DEP is for depth-of-field mode, a unique feature of this Canon camera that helps you make images with a pre-determined zone of sharpness. All these exposure modes are covered in depth in the "Exposure" chapter in this book.

Reading to the right, a a set of numbers is next. This is where the actual or set shutter speed and aperture value are displayed. The ISO number refers to the speed of the film in the camer, or to the speed you have chosen to assign. The box reading "One Shot" and "Servo" refers to autofocusing modes. In One Shot the camera will not allow you to fire the shutter unless it has confirmed focus on a subject. In AI Servo, the camera will fire when you command. The former mode is best for stationary subjects, while the latter is often necessary for moving subjects.

Under the battery is an ID # symbol. This camera allows you to assign it a particular identification number. To the right, the eye symbol is your metering pattern indication. Metering patterns define how the camera's exposure system reads light and where in the viewfinder the light information will be gathered. The eye symbol indicates evaluative metering, also called Matrix or intelligent metering. Other metering options include center-weighted averaging and spot metering, subjects covered in the Exposure chapter. The plus and minus symbols with the lighting bolt indicate the camera/flash control called flash exposure bracketing. which allows you to modify the flash output to your taste.

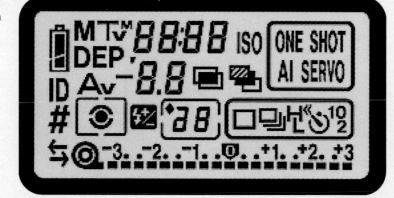

The center area marked with a black diamond indicates two functions. One is the self-timer countdown. The self-timer holds off the shutter release after the shutter is pressed. When activated, the self-timer can work in a 2-second or 10-second delay. The 2-second delay is usually used when making pictures on a tripod or when the camera has to be steadied during slow exposures. The 10-second delay is for when you, the photographer, want to get into the picture yourself. This indicator also shows how many multiple exposures you have chosen to make on one frame of film. Multi-exposure techniques can be used for creative collage work.

To the right, the next frame indicates the drive modes, which are they ways the film is transported through the camera. The single box shows that one shot will be taken when the shutter release is pressed. The multiple boxes mean that the shutter will keep firing as pressure is maintained. The H and L indicators are for high and low continuous advance, high meaning a fast clip (with this camera, up to 10 frames per second) and low meaning a more measured rate of about 3 or 4 frames per second. The last indicator is for setting the self-timer, as described above.

The arrows at the bottom left show whether the film is being transported from frame to frame while pictures are being made or whether the film is being rewound. The concentric circles to the right indicate whether film has been properly loaded and is winding correctly. The scale with the plus and minus numbers is an exposure indicator. At 0, or null, the selected exposure that is being used agrees with the camera-recommended exposure. If you change that setting through exposure compensation, bracketing, or when working in manual exposure mode, the scale will display the change. A similar scale can be found in the camera viewfinder.

Courtesy: Canon USA

LOADING AND REWINDING FILM

35mm film sits in a light-tight cassette. This protects the film before and after exposure. The one time when the film is vulnerable to light is when it is loaded in your camera. For that reason, film loading and rewinding is an important aspect of 35mm photography. Every photographer, including the author, has made the mistake of opening a film back before the film was rewound, often after leaving the camera inactive for a few days or weeks. You will probably share this experience. To help prevent its frequent occurrence, and to protect your film in general, learn good film handling techniques.

To load film into a camera, first open the back. Most camera backs open with locking levers or some unobtrusive pushbuttons that take conscious effort to use. Older cameras are often unlocked by pulling up on the film rewind crank. Once the back is opened place the film upside down (the plastic nib should point downwards) and fit it snugly into the film chamber on the left side of the camera facing you. Make sure that the spindle on the top fits snugly into the spool. If the film is properly positioned the darker, often shinier side will be facing you.

Next, pull the film leader, the cut portion of film that protrudes from the cassette, until it reaches the other side of the opened camera. Extend the leader until it reaches the red mark on the right side. Make sure the film is flat and the cassette fits well into its chamber, then close the back. You should hear the film advance. Confirm advance by looking at the camera LCD to see that frame "1" appears, or that the advance confirmation mark is not blinking or issuing a warning. Those with motorized advance cameras are all set.

If you have a manual-advance camera (one that has a cocking mechanism on the right side) you must take the film leader and thread it through the take-up spool on the right side of the camera. Before you close the camera back, advance the film by cocking the shutter/film advance mechanism and advancing the film until the take-up spool is fully wound with film. Make sure the film cassette is snug and that the sprocket holes mesh with the sprockets in the take-up spool. Advance the film by cocking and releasing the shutter once or twice; be sure that the film is secure and snug around the takeup spool. Close the back. Lift the rewind crank and turn it clockwise carefully and slowly. Stop when you feel a slight tug or pressure.

Now advance the film one frame and be sure that the rewind crank turns as you do. This ensures that the film is properly loaded. Now advance one or two frames, firing the shutter between advances, until you reach frame "1" in the frame counter window.

After the film is exposed it is time to get it back into the cassette **before you open the camera back to remove it.** This is called film rewinding and for most camera owners it's automatic. When the camera senses the end of the roll, it sets the rewind into motion. Wait until the whirring sound stops before you open the film back.

You may have an automatic rewind camera that still requires you to activate it to rewind the film. There may be one or two buttons that need to be pressed. This allows you to determine when you want the film rewound, something that is often appreciated by those attending the same wedding, school play, or formal speech.

You may also have a choice of winding the film with some leader remaining out, or with the leader fully enclosed within the cassette. You might want to keep the leader tip out if you like to swap film in the middle of rolls, for example, if you change film speeds or color for black and white before the roll in the camera is finished. If you do this, carry a permanent marker pen with you to indicate the frame number of the film that you've swapped for. This helps prevent unintentional double exposures when you reload the film.

Those with manual-advance cameras will have to rewind the film into the cassette themselves. The roll is finished when you can no longer advance the film, or when you have gotten to the frame number indicating the end of the roll. Find and press the film rewind button. This disengages the forward gear of the advance and allows you to rewind freely. Raise the film rewind crank but do not lift it. Turn the crank counterclockwise and you will hear and feel the film being rewound. Turn the crank until there is no more pressure or tension, and then give it one more crank for good measure. Once the film is rewound you can open the back.

Film loading, advance, and rewinding are tasks that should come as second nature to you. You don't want to be caught without film or struggling with film handling matters when great picture opportunities arise.

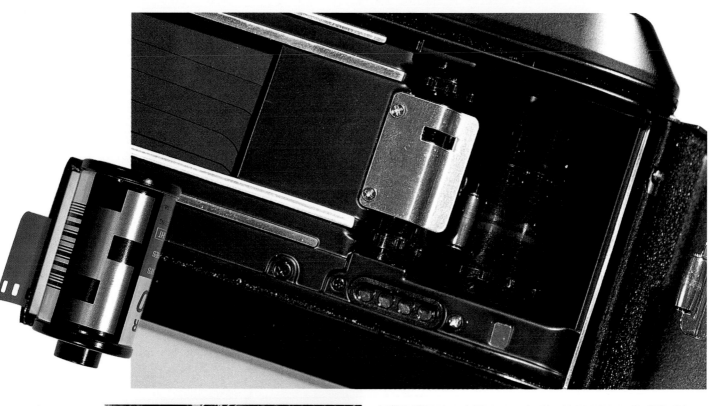

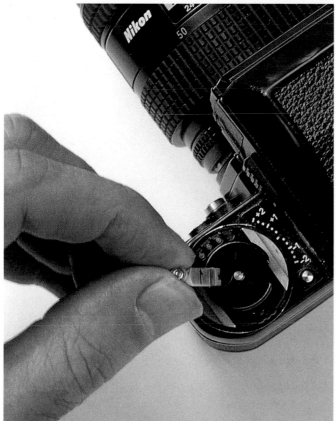

Camera Controls

Camera controls are located in different places on different cameras. These controls may be dials that you turn or pushbuttons that work in conjunction with dials. Modern SLRs also have LCDs on their top plate. The LCD display is where you see the many options offered and where you can program the camera to operate in different ways. Some of the information displayed on the LCD may also be shown in the camera's viewfinder, but it is more often used for choosing exposure modes, frame-advance speeds and autofocusing modes, matters we will cover shortly.

CONTROL DIALS AND SETS

Depending on your camera, you usually a have a number of ways to set critical camera controls. We'll cover each of these controls separately. You should follow along with your instruction book to identify their location on your camera. Modern SLRs work with menus that you select by pushing a button and turning a dial. Older SLRs have dials on which you set options. We'll discuss these controls without going into too much detail about image effects, which we cover in depth later.

The exposure mode selector is how you select the way the exposure system operates. Four exposure modes are common to most SLRs, three of which are automatic. This means that the camera will select what the metering system considers the best exposure for you. The fourth mode is manual—the camera recommends an exposure, and you set the exposure-controlling dials yourself. The three automatic modes commonly found in most SLRs are program mode, aperture-priority mode, and shutter-priority mode. The mode where you make the settings is fittingly called manual mode.

Program mode is the point-and-shoot exposure system. You set "Program" when you want the camera to make all the exposure decisions for you. This can be convenient, but it also eliminates any decision-making on your part on how you want the image recorded. This is fine for parties or social events, but is not the best for creative photography. Some program modes allow you to shift values from what the camera selects, and this is called program shift mode or option. This mode is usually identified as P, for program.

Aperture-priority mode allows you to set the size of the **aperture,** or lens opening. The aperture, the size of the opening inside the lens, is one of the light-controlling parts of the camera that also affects how you treat the sharpness of foreground and background subjects. Once you set the lens aperture, the camera's automatic exposure system selects the best shutter speed for the correct exposure. This mode may be identified by AV, which stands for aperture value.

Shutter-priority mode is what to choose when you want to select the shutter speed yourself and have the autoexposure system set the aperture for you. You choose different speeds to affect how motion will be recorded on film. A fast shutter speed, such as 1/2000 of a second, freezes the action of a fast-moving subject, while a slow shutter speed records motion with a blur. This mode may be identified as TV, or time value.

You can also choose **manual exposure mode.** The camera's light-metering system recommends an aperture and shutter speed for the best exposure, and you set them yourself using dials or knobs. This mode is often identified as M, for manual.

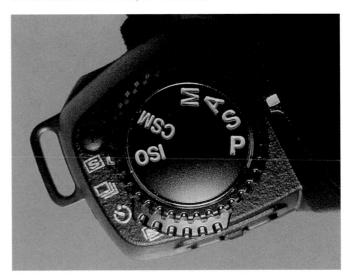

This function dial allows straightforward access to both drive and exposure modes. The exposure modes are indicated by the M, A, S, and P symbols. The CSM symbol refers to custom settings. These are both the picture modes and special ways that you can customize your camera. The ISO is for overriding the DX code on the film. The drive modes are located around the selector function dial. S is for single, which means that one picture is taken each time you press down on the shutter release button. The multiple frame means that pictures will keep being made if you keep pressure on the shutter release. The framing rate varies with each camera. The clock symbol stands for the self-timer function.

Aperture priority mode is best used when you want to have control over the depth of field. This allows you to set the aperture and shooting distance so that you will know what will be sharp and unsharp in the picture. At times you might want everything sharp from foreground to background; at other times you might want the foreground sharp and background unsharp. The feeling is quite different when you have a shallow depth of field (left) and a deeper zone of sharpness (right). Aperture priority mode and an application of depth-of-field-techniques give you control over this creative choice.

You may have other available exposure modes. These are identified by icons that represent different types of picture scenarios. Among the most popular of these are the following. Landscape mode sets the exposure system for maximum sharpness from foreground to background. The depth of field, or the zone of sharpness, is dependent on the focal length of the lens you are using, the aperture setting, the distance from the camera to the foreground subject, as well as the overall brightness of the scene. As you gain experience and as you read on through this book, you will be able to predict exactly what will and will not be sharp and unsharp in your final picture by the way you make your camera settings and lens choices. This automatic exposure mode cannot always get you what you want, but it will help you get the maximum depth of field for the conditions at hand.

It is usually indicated by an image resembling a set of mountains, small and large, sitting next to one another.

Another automatic-exposure mode icon you may have on your camera is a figure with lines coming off its back. This icon indicates a runner and signifies what is sometimes called action mode. In this automatic exposure mode, the camera's metering system measures the light and maximizes the shutter speed (that is, picks the fastest posssible shutter speed) to help freeze moving subjects.

You may also have an icon resembling a silhouette of a face. This stands for portrait mode, and sets the camera up to work with a shallow depth of field so that an out-of-focus background offsets the person being photographed. You may not want this effect for all your portraits, but that's what portrait mode will produce.

This control dial shows a full catalog of exposure modes and functions. Counterclockwise from the bottom are the displayed the four icon or picture modes: action mode (the runner), macro or close-up mode, landscape mode, and portrait mode. The green box is a fully automatic mode that resets any options chosen. L is for lock, which turns the camera power off. P is for program mode, the point-and-shoot SLR mode. TV is for shutter priority, and AV is for aperture-priority. M is for manual exposure mode. A-DEP is a special mode on this Canon camera where you select two focusing points. The system then selects an aperture to cover them both in a zone of sharpness. The next symbol is for turning on and off the sound reminders of slow shutter speed and focus confirmation. The ISO selection lets you override the ISO set by the camera. The last symbol is for film rewinding. This is a very complete, easy-to-use command dial.

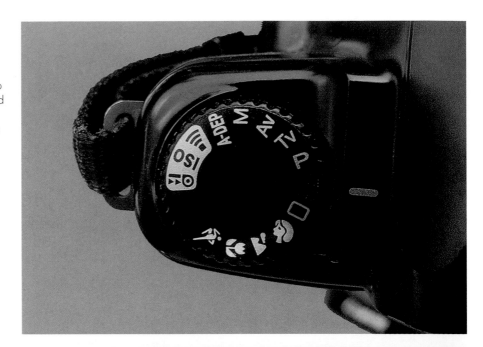

Manual exposure mode works with camera recommended exposure time that you can choose to follow or not. The camera's exposure system here recommended an exposure of f/16 at 1/125 of a second. Working in manual, it was easy to intentionally underexpose to heighten the dramatic sense of light in this late afternoon scene.

Picture modes are preset combinations of aperture and shutter speed that can be used in certain situations. As you learn about aperture and shutter priority modes you'll have less need for the picture modes. Landscape mode, for example, sets the exposure system up to emphasize as deep a depth of field as possible for sharpness from the foreground to the background of the scene. This photo was made in Landscape mode, although setting a narrow aperture and using depth of field preview would have been a more certain way of getting the results you desire. Here, focus is sharp from the tree to the mountain on the horizon.

AUTOFOCUSING MODES

If you have an autofocusing model camera, you can also choose among several autofocusing modes. These choices are subject- and action-dependent. You have the option to turn off autofocusing and work with manual focusing, which means you adjust the lens yourself and focus visually through the viewfinder. Autofocusing does not always work well or at all, and that's when manual mode comes in handy.

There are two main autofocusing modes identified as **AF**. **Single (S)** or single-servo autofocus mode, seeks out a subject and will not allow the shutter to be released until the system has confirmed a focused target. This mode works well for still life or for scenic portraiture with no action. With **C**, or continuous autofocus mode, the camera will allow you to make a picture even though the subject focus has not been confirmed. This is best for action photography. Modern AF cameras have sophisticated autofocusing systems that can follow subjects moving through the picture space or viewfinder frame and lock onto and maintain focus on a subject, even if something else comes between you and it momentarily.

EXPOSURE CONTROLS: USING AUTOEXPOSURE LOCK

The way you read light has a profound effect on your images. There are many different ways to interpret light and to move light values around when you make an exposure. As you learn how your metering system works you'll begin to appreciate how "placing" certain light values on the film's recording scale can change the relationship of light values in the final picture. The autoexposure lock is a valuable ally in this process. You can read certain values and use them as the foundation for your exposure decisions. The autoexposure locks allows you to hold onto readings even if you decide to change the composition or the light changes.

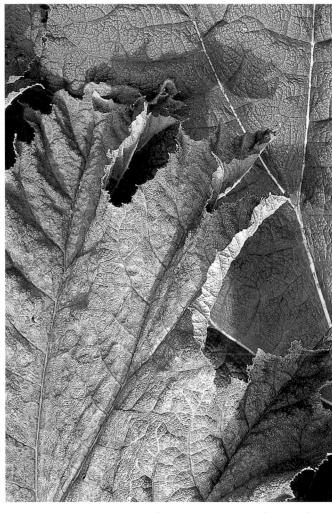

Here, a reading was made of the brighter part of the leaf and then the picture was recomposed to include a broader area. By holding onto or locking the bright area reading the other light values arranged themselves in a certain way.

Here exposure was locked on the darkest light value in the scene, the brown door. This brightened the lighter values and gave an ethereal and open look to this picture.

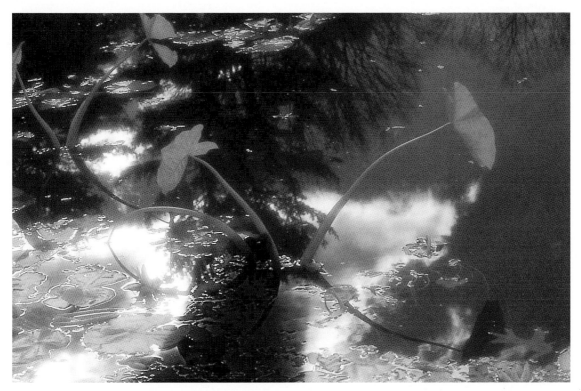

This pond also benefits from the exposure lock technique. The light was read from the brighter part of the scene and then the exposure was locked. Without locking, the mood of the photograph would have been brighter and less effective.

Autoexposure lock was applied in this photograph of an antique store's porch. A spot reading was made of the reflective chair in the background, then locked, and then the exposure was made. All the other values then went darker.

ESSENTIAL CONTROLS

You may have numerous other controls on your camera. One might be a depth-of-field preview button. This is usually found on the right-hand front side of the camera body near the base of the lens mount. When you are focusing and composing your picture, you look at the scene through the widest aperture or opening the lens offers. This lets in the greatest amount of light. When you take a picture, however, the lens automatically stops down to the aperture you or the camera has selected. For example, you may have a lens with a maximum aperture of f/2.8, but when an exposure is made, it is with a smaller opening or aperture, say f/8.

When a lens aperture is made smaller, (stopped down), the amount of light coming through the lens is changed, as is the way that light is focused on film. The sharpness throughout the picture is quite different when photographing at f/8 than it is at f/2.8. One way to see the difference in this effect is to use the depth-of-field preview button before you take the picture. This gives a good indication of the zone of sharpness throughout the picture. This control is unique to SLR cameras.

Another control button you might encounter is the **autoexposure lock** button. This may also be built into the shutter release and be activated by partial pressure. Using this control keeps the camera on a certain exposure

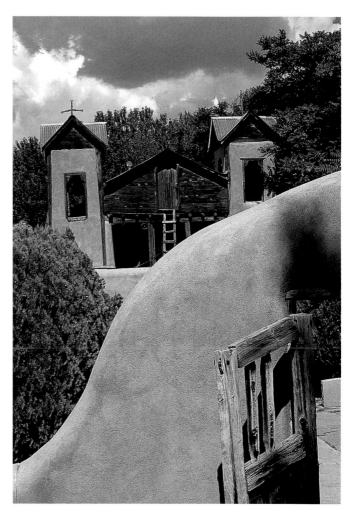

The depth-of-field preview function shows you in the viewfinder what will be sharp and unsharp before you take the picture. This is an essential feature in an SLR, as it gives you complete control over sharpness effects. Here, a narrow depth of field is chosen to help isolate the fiddlehead ferns in the foreground, giving a more dimensional field to the picture and helping eliminate what might have been a distracting background.

Deep depth of field was used here to keep both the arch and doorway and the chapel in the background in sharp focus. Without the depth-of-field preview you might not know just what effect your sharpness settings have.

setting and prevents the exposure from changing, even if you alter the composition or if the light changes. Locking the exposure is handy in high-contrast lighting conditions, and you want to capture a subject that sits in either very bright light or in shadows.

Another control button is the **autofocus-lock** button. This works in a fashion similar to the autoexposure-lock button, but locks on a certain subject as the point of focus. Use this control when you want to maintain a certain distance setting or if you want the camera to set a focus that sits outside its autofocus-detector range in the viewfinder. All autofocus 35mm SLR cameras have autofocus detectors that are indicated by boxes or squares in the camera viewfinder. In order for the camera to find a focus, these detectors must sit on the subject in the finder. If the subject is at the corner of the frame, for example, and you want to maintain the composition, you place the detector over the subject, activate the AF lock button, then recompose to the original scene.

COMMAND DIALS AND BUTTONS

Your camera may also have a set of command dials. These knurled rings are set into the body or sit on the back of the camera. Command dials input the aperture settings, shutter speeds, exposure modes, and special functions that allow you to customize the camera to your liking. Other cameras have an analog dial approach, where you define your settings by turning to a number, letter, or even a pictograph code.

The midroll rewind, or the rewind button, releases the forward gear within the film transport mechanism so you can rewind the film into its cassette. 35mm film is protected by a cassette and is then wound out of it onto a take-up spool inside the camera body. If you open the camera back before you have rewound the film, you will probably ruin all or most of your roll. Some cameras automatically rewind when they sense the end of the roll. Others require you to push one or two buttons to initiate the rewind process.

The rewind button also comes in handy for changing a roll before you have finished photographing all of it. This might occur when you want to switch from color to black-and-white film or when you find that you have to put a more light-sensitive film in the camera. Some cameras allow you to program the rewind so that the film leader remains out after rewind, making the film available for reloading later. If you do this, note the number of frames exposed on the film cassette and advance the film just past that number when reloading.

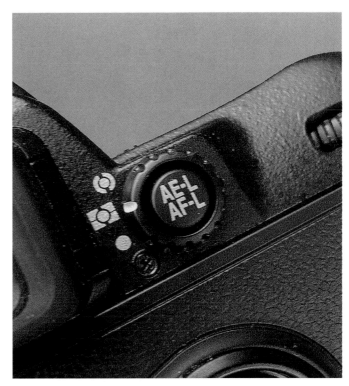

The autofocus lock (AF-L) and autoexposure lock (AEL) buttons are located on the back of this camera model. AEL is for locking the exposure reading at one setting, even if the camera is moved or the light changes. AF-L holds focus on a particular distance even if the picture is recomposed and the autofocus detector is covering another subject distance. The selector around the collar is where you choose metering patterns. The top selector is for center-weighted metering; the center is for Matrix (this being a Nikon model) or microprocessor metering. The dot is for spot metering. Each metering pattern changes the area in the finder as well as the way the exposure system reads light.

TRIPOD SOCKET

At the base of the camera sits a threaded inset. This socket allows you to attach a tripod, an excellent aid when photographing pictures in dim light or when you are photographing at a slow shutter speed. Most photographers can get a steady picture at 1/30 or 1/60 of a second shutter speeds. If you are working with a long telephoto lens or at slower shutter speeds, a tripod is recommended to prevent a picture problem known as camera shake.

There may be more or fewer control buttons and dials on your camera. Obviously, not every model can be covered here. As we go through use of the lens, shutter speeds, and other creative photographic controls, we'll most likely cover all the special functions your camera provides.

FOCUSING MODES

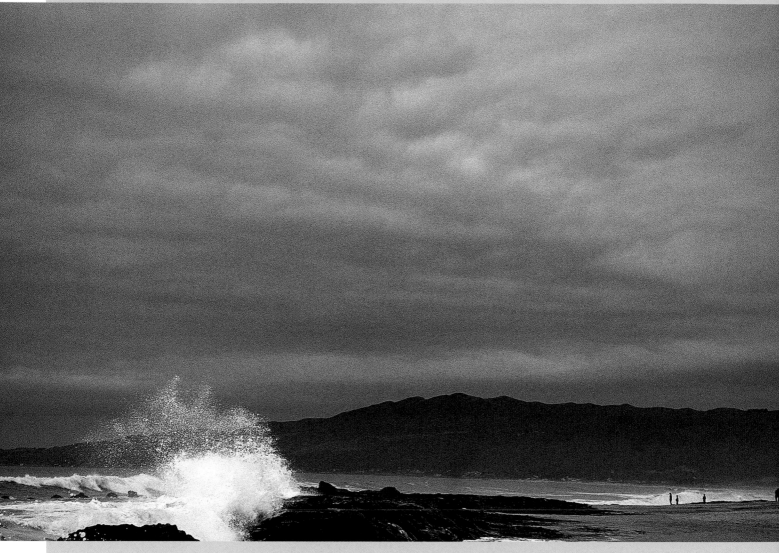

Above: Manual focus is best when the scene has little or no contrast. If your camera cannot find focus in single or continuous mode, simply switch to manual and focus by hand and eye. Some autofocusing cameras with a single detector area might not be able to focus on this type of scene with its low-contrast sky.

Opposite page, top: Experiment with autofocus modes to define how the camera's AF system works. Single AF mode is best for stationary subjects and helps you confirm focus on every picture. Single AF was used to ensure focus on these colorful dance costumes. (Photo by Grace Schaub)

Opposite page, bottom: Use C or continuous AF when shooting sports or fast-moving subjects, such as this basketball game. The camera will allow you to photograph even if focus is not confirmed; however, a focus indication light tells you when you have achieved focus. You would be hard-pressed to get any autofocusing action in single AF mode at such an event.

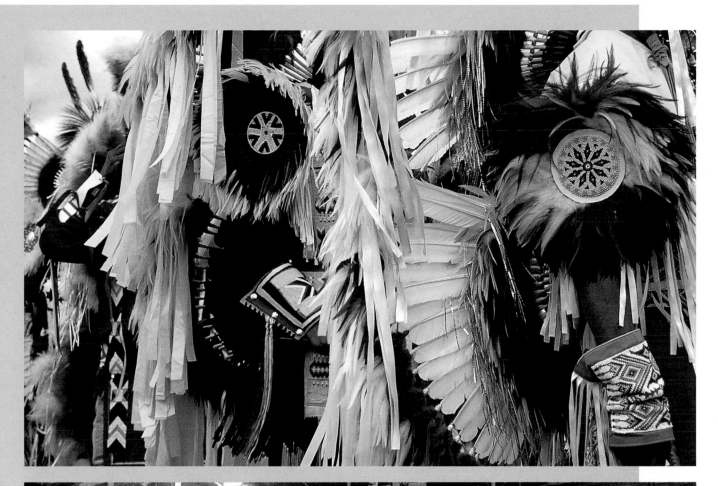

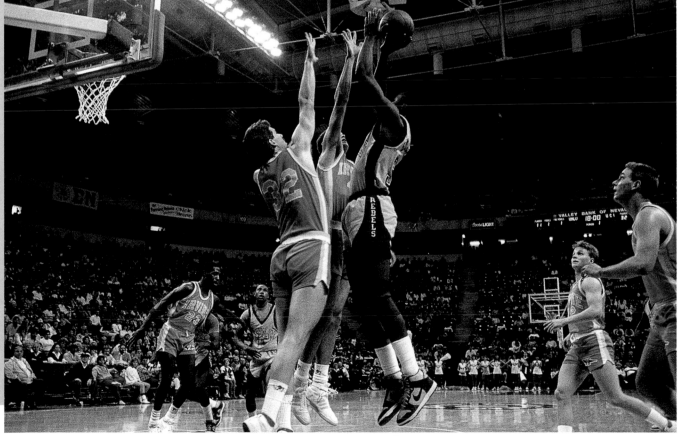

PHOTOGRAPHIC TERMS

When you go to buy a camera, you may be confronted with a number of unfamiliar terms and features. These terms generally describe how the camera operates and what you can expect when working with it in the field. Here is a quick summary of some terms you will encounter.

AUTOFOCUSING

Most modern SLRs have autofocusing systems. Some work with a single focus spot in the center of the viewfinder. This means that the subject focus must be set by placing the centered autofocus detector over the subject. Composition can be changed with an autofocus lock button that holds focus even if the subject is off-center in the frame. More sophisticated SLRs have multiple autofocus detectors in the viewfinder. The system usually prioritizes the subject closest to the photographer. Some SLRs have autofocusing systems that follow moving subjects or predict motion to help maintain focus in action sequences. Every SLR with autofocus has both single and continuous autofocus modes. Single means that the camera will not allow exposure until focus has been confirmed. Continuous is used with moving subjects. The former is best for portraits and still life photography, while the latter is used for nature, wildlife, and sports work.

The speed of the autofocus system is key. Some high-end cameras offer autofocus tracking as fast as 10 frames per second with certain accessory battery packs. If speed and action photography is for you, then consider one of these fast-tracking SLRs.

CUSTOMIZATION

While most SLRs are pretty impressive right out of the box, some cameras allow you to customize their settings to your own way of working. On-board microprocessors can be programmed through push-button menus on the camera. Some SLRs can be patched to a computer with even more customization options or support remote operation of the camera. This customization can be applied to the way the camera focuses, exposes, and even to how certain buttons and dials on the camera perform.

EXPOSURE-METERING MODES

Many SLRs today have very sophisticated metering systems that analyze a scene and make calculations based on algorithms that have been preprogrammed into the camera. This may be called Matrix, evaluative, or intelligent metering, or something to that effect. More experienced photographers and those who want to expand their photographic knowledge should look for the full host of metering system options, which includes center-weighted and spot metering. Respectively, these take their exposure information either from the viewfinder center or from very discrete areas in the finder (about 2 percent of the area) respectively.

EXPOSURE MODES

An exposure mode is a way that your camera's exposure system can be set up. Most SLRs today offer automatic exposure, the option where the camera sets aperture and shutter speed for you. The most important

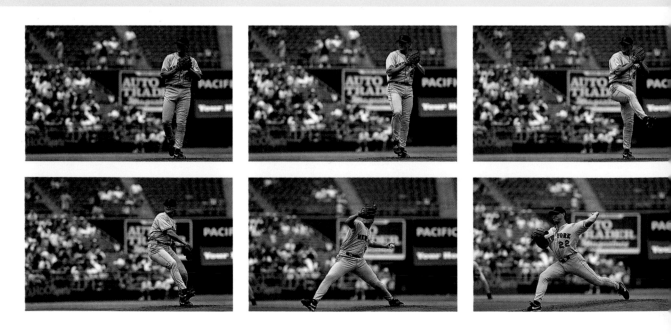

options within auto exposure include program (where the camera makes all the exposure decisions); aperture-priority (where you set the aperture and the camera selects a shutter speed); and shutter-priority (you set the shutter speed and the camera sets the aperture).

FRAMING RATES

Framing rate is a measurement of the number of frames per second (fps) the camera will fire. Framing rates range from 1 to as many as 10 fps. If you photograph sports, action, or wildlife, the higher framing rates definitely come in handy.

FULL-SYSTEM APPROACH

An SLR body can be an investment. Explore the system of lenses, flash, accessories, and other features that surround it. When you buy any one manufacturer's SLR, you also buy into their system. A full-system approach ensures that there are lenses for many purposes, a dedicated flash system, a coordinated system of accessories for close-ups, a selection of filters, and a set of power options.

PICTURE MODES

Some cameras also offer picture modes, (preprogrammed solutions to exposure situations). Portrait mode, for example, sets a wide aperture for minimum depth of field; action mode selects the fastest possible shutter speed for freezing motion; and landscape mode sets a narrow aperture for maximum depth of field. If you're just learning about photography, these modes can help you maximize your photographs. As you learn how to make settings that accomplish the same image effects, you won't need to work with these modes.

MANUAL FOCUS AND EXPOSURE

Some teachers feel that students should begin with a manual focus and exposure camera to learn the basics of photography. These cameras have exposure systems, but they suggest rather than set the actual exposures. The user must make the settings. The same goes for focus. This approach is not universally accepted. If this appeals to you, there are a number of excellent manual focus and exposure cameras on the market. These cameras are usually less expensive but generally have fewer options in lenses and accessories. Some accept older lenses and accessories, making the used equipment market a source for additional gear.

USER INPUT

Perhaps the most important feature in your choice of an SLR is the way the camera is designed for user input. Because an SLR is a creative, picture-taking machine, the user should be able to work nimbly with all controls. For example, many SLRs allow for **exposure compensation,** a way to override the camera-recommended exposure for a creative or interpretive touch. Some cameras have handy dials for this input, while others may require more extensive workarounds. This idea extends to viewfinder information. While too crowded a viewfinder will be confusing, the photographer should have all the information required at eye level, rather than have to look at on-camera dials or a body-mounted LCD.

Motor drives or built-in advance motors allow for some incredible framing rates. These rates are measured in frames per second (fps). Many SLRs today give at least 2+ fps. This sequence, photographed with a Canon EOS V SLR, was made at 6 fps. To access the higher framing rates, choose continuous shooting mode. Your camera may also have two speeds of framing rates, one slower than the other. This may mean one rate of 2 fps and another as high as 8 fps.

A 35MM SLR FEATURES CHECKLIST

Modern 35mm SLR cameras are highly sophisticated instruments that offer a wide variety of picture-making options. If you are thinking of purchasing an SLR camera, you should know about the many features important for creative control. Although most 35mm SLRs incorporate these features, some do not.

Virtually every 35mm SLR sold today has automatic exposure control. Most also allow control over very fine nuances of exposure through **overrides**, compensation and other built-in features. Some exposure control systems are highly sophisticated, relying on computers to do virtual scene and lighting evaluation. Automation is now tied in with flash exposure as well, opening up many new possibilities for creative photography. Many 35mm SLRs also offer high framing rates, with some high-end models delivering up to 10 frames per second. Others offer extremely fast shutter speeds, of up to 1/12,000 of a second.

In short, the latest 35mm SLR displays the height of technology in photography today. Microprocessors, micromotors, and finely tuned sensors that analyze scenes and subjects are often integral to these cameras. While automation does cover many shooting situations, your 35mm SLR should allow you to override or have control over creative picture-making decisions.

Keep in mind that buying a certain brand of SLR means buying into a system, with all the lenses, accessories, and options that open the door to virtually every type of image and subject matter. This full-system approach is what puts the 35mm SLR in a class by itself. When you buy an SLR, find out what accessories, lenses, and other special equipment the camera allows you to use. You do not need to buy the most expensive model in a manufacturer's line to have access to this equipment. But make sure the camera you buy does not limit your options either.

The wide appeal of the 35mm SLR means that there are many models from which to choose. Options range from 35mm SLRs that are like point-and-shoot cameras with interchangeable lenses to highly sophisticated instruments that offer superb automation coupled with photographer customization. There are also many manual-control cameras available that offer a more basic—some would say more direct—route to photographic technique.

You have many options to explore. In many cases your budget will help narrow the field, but you shouldn't base your buying decision on price alone. If you can get all the features you want for a few extra dollars you won't regret it, as you probably will be working with the camera for a very long time. Many photographers limit their choices unwisely, finding out that they want a more sophisticated camera later as their experience and understanding of photography expand.

With that in mind, here's a checklist of features that you should look for when buying a camera. These features and controls are important in exercising creative controls.

☐ Readouts of aperture and shutter speed in the viewfinder. It is important to know these settings in order to make informed decisions about how you want to expose the image. Without this information, you will not be able to work with selective focus or shutter-speed techniques. It may seriously hamper your work.

☐ Manual and automatic exposure capability. When an in-camera meter reads the light in a scene, it converts that light energy to exposure information in the form of aperture and shutter-speed settings. In manual-exposure cameras, you follow a needle or LED and set the aperture and shutter-speed yourself. If you're working with an automatic-exposure camera, you can select one of the values and the camera will select the other value. For example, with automatic aperture priority mode, you set the aperture and the camera selects an appropriate shutter speed. If you are buying a camera with an automatic exposure system, do not buy a camera that only offers what is called a program mode. This usually does not allow you to make aperture or shutter-speed decisions. You do not need a host of exposure modes. A camera that offer, aperture priority and shutter priority exposure modes will suit you fine.

☐ Exposure lock. This is a button or switch that allows you to hold onto an exposure reading in automatic exposure even when the camera is pointed at a light value different from the one in which the original

exposure reading was made. This becomes very helpful when reading light in high-contrast situations or when you want to make creative exposure decisions. The lock is often located in the shutter release button. A slight pressure on the button activates it.

☐ Manual or autofocus? Autofocus can be convenient but is not necessary for learning photography. In fact, it can get in the way of some focusing techniques. Many makers today only sell autofocus models. When working with these, you can simply turn off autofocus and work in manual-focus mode, if desired.

☐ Manual ISO setting. Many cameras now read the coded film cassette and set the film speed for you. There are times, however, when you will want to photograph at a speed faster than the film rating your camera reads. Those who do sports, photojournalism, and travel photography will find this technique, known as pushing, quite handy. This feature is also known as ISO override.

☐ Depth-of-field preview button: Usually, when you look through your viewfinder, you are viewing the scene using the maximum aperture of the lens. Aside from light control, one of the effects of stopping down the lens is to change the depth of field, or the relative sharpness of subjects from near to far. Depth of field increases as the diameter of the opening in the lens narrows from the maximum to smaller apertures. Thus, subjects at greater distances from one another appear sharper in the image. The depth-of-field preview button stops the lens down from the viewing to the picture-taking aperture, giving you a preview of what will be unsharp and sharp in the image before you take the picture. We'll cover this in greater detail later. Depth-of-field preview can be a great help in seeing what you'll get on film. Unfortunately, many inexpensive 35mm SLRs lack this important feature. My advice is not to buy an SLR that lacks a depth-of-field preview feature.

☐ Shutter-speed ranges. Most cameras have a range of 1 to 1/1000 of a second, as well as a **bulb (B)** setting. The B setting allows you to keep the shutter open for

as long as pressure is maintained on the shutter release by either your finger or a **cable release.** Those who want to photograph sports or action should look for a camera with a faster shutter-speed capability, say 1/8000 of a second.

☐ Camera durability. Camera bodies are made from plastic, metal, and polycarbonates or from a mix of materials. Generally, professional-level cameras are more durable because they are meant to take more punishment than amateur models. Professional-level cameras should not be treated roughly; however, they are built to withstand more abuse. Some have titanium bodycores or reinforced materials that can take a drop or bang. The sturdier the camera, the more expensive it is.

The degree of a camera's weather resistance may also play a part in your choice. Some cameras cannot withstand even a light mist, while others have O-ring seals and weather-resistant construction that lets them function in the rain.

☐ Other options. Other options that you should consider include the camera's ability to use a dedicated flash system that coordinates exposure directly with the in-camera meter. This makes flash exposure a much easier matter. The camera should also offer what's known as midroll rewind, the capability to rewind a roll before it's finished and to leave the leader of the film out for easy reloading. Midroll rewind is handy when you want to switch to another film to handle different lighting conditions. Another option is spot or partial-frame metering, a feature that helps you work in difficult lighting conditions by making exposure calculations from a small part of the viewfinder frame. The usefulness of this and other items listed here will be discussed in detail later in the Lens and Exposure chapters.

Last, but not least, is the feel of the camera in your hands. Controls should be easy to locate and operate and the camera should have the right weight and balance for you. Some cameras just feel right in your hands. The ergonomics should make operation easy and allow you to do what you want when you want.

THE LENS

Today's camera lenses are technological marvels responsible for the important tasks of focusing images and controlling light. Some lenses contain micromotors for autofocusing and microcomputers for delivering image information to the camera's exposure-control systems. Aided by computer design techniques and a long history of optical and electronic development, modern lenses are considerably lighter, shorter, sharper, and available in a wider range of focal lengths than ever before. Zooms and specialty optics for close-up (macro) and super-telephoto photography are all part of the mix.

By definition, a **lens** is ground glass that alters the direction of light passing through it. You bring a subject into focus by moving the lens different distances from the film-plane. Lenses used in photography are complex and are composed of groups of glass elements arranged very carefully within the lens barrel, or housing. Because light is altered when it passes through glass, lenses must both correct any of those alterations, called aberrations, and incorporate particular optical formulae for every focal-length design. Some lenses work in conjunction with computerized cameras and respond to commands that are input from the camera body itself.

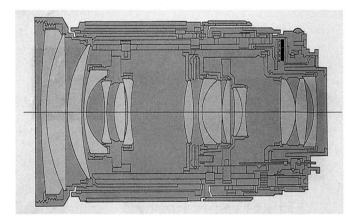

A lens is a complex assembly of glass, gears, metal, and plastic that serves as our eye in the photographic realm. This cross-section rendering shows the individual glass elements put together in groups. Modern lenses are based on complex optical formulas that allow us to focus near and far.

On a practical level, the lens is our photographic window onto the world. It offers us views that range from super close-up to super-telephoto. A lens can expand our peripheral vision, or it can creatively distort our view. Depending on the lens, subjects at different distances from the camera can be made to appear closer together or farther apart.

Lens selection and the creative use of lens controls are two key tools in photographic expression. The lens we choose to mount on our camera has a great deal of influence over the way we see and also establishes the visual relationship we have with our subjects.

MOUNTING THE LENS ON THE CAMERA

On the back of every lens is a coupling ring that serves as a link to the camera. In addition to ensuring a proper fit, this ring contains mechanical and electronic links that unite the brains of the camera with the lens. The coupling ring is the contact point for the signals that may change the aperture setting or the focusing distance.

The coupling ring aligns with the mounting flange on the camera body. Every camera has a distinct mounting setup; different mounting systems cannot be mixed or matched. Compatibility is a must. Any attempt to mount a misfit lens will certainly damage the camera body and lens itself. If the mount does not seem to fit, do not try to force it.

Generally, a red or white dot on the lens and camera body shows where to begin the mounting process. Align the dots, push the lens in slightly toward the camera body, and turn clockwise or counterclockwise, depending on your camera make. Do not release the lens from your hand until you hear a definite click. The click indicates that the lens and camera are engaged.

To ensure that the lens is working with the camera body, turn on the camera and move the command dial to see that the aperture numbers change. If you have a manual-focus lens, turn the aperture ring and make sure the movement from aperture to aperture is smooth.

To remove the lens, locate the lens release button on your camera. It usually sits on the lower portion of the front of the body close to the lens mount. When you push in this button, the lens mount releases the lens and you can turn it to remove it. Remember that the film is safe from stray light when you change lenses, so you can change them whenever you require. Just to be safe, however, always do so in shaded light and be sure that no dust or dirt are being swirled about by the wind.

The aperture is an opening in the lens that can be set variably to allow in more or less light. The smaller the aperture setting (*f*-number), the wider the lens opening, and thus the more light coming through for any set period of time. The higher the aperture setting, or *f*-number, the narrower the aperture, and thus the least light coming through. This series shows an aperture setting of A) *f*/16, B) *f*/8 and C) *f*/2.8. Aperture settings also affect the depth of field, (a range of distance in which subjects appear sharp), in a photograph. The narrower the aperture, the greater the depth of field with any given lens at any given distance.
Courtesy: Minolta Corp.

Lens Terms and Descriptions

The opening in the lens that allows light to enter is called the **aperture**. The diameter of the aperture determines how much light enters—wider apertures allow more light through than narrower ones. The aperture setting also has a profound influence on the **depth of field**, or the zone of sharpness within the picture space. Light and depth-of-field controls are accomplished by changing the size of the aperture.

Lenses are categorized by **focal length**, a measure of the distance from the center of the lens to the film-plane when the lens is focused at infinity. More importantly, the focal length indicates the angle-of-coverage of the lens and the apparent **perspective**, or relationship of near to far of different subjects in the recorded scene. Lenses must be compatible with the camera in use, as each lens has a specific mount that will only fit onto a specific brand or type of camera.

LENS CONSTRUCTION

Inside the protective outer shell, or lens barrel, lenses have individual glass elements. These elements are gathered in clusters, known as groups. The reason for the complexity of photographic lenses (some lenses, for example, are constructed with 13 elements in eight groups) is that light goes through a number of changes as it passes through glass (or any other medium, for that matter). Each lens is made so that it will correct some of the changes or aberrations that occur in the light before it strikes the film.

These aberrations can affect color, contrast or even the sharpness of the image itself. In its totality, a photographic lens is a finely balanced set of compromises, each one made to correct or redirect the light as it passes. With the advent of computer-aided design, photographic lenses have become more highly corrected, with the optics more finely tuned and the lens quality improved.

There are two external glass surfaces on a lens—the front and rear elements. The front element faces the subject; the rear element is where the light exits on its way to the film. The surface of the front and back elements is coated with a substance such as magnesium

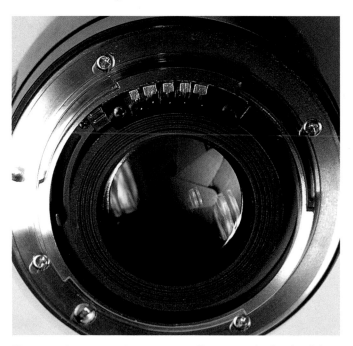

The rear element and mounting collar sits at the back of the lens. A set of pins may serve as a communication junction between camera and lens. A lens must be compatible with the camera to work. Incompatible lenses will not fit on the camera.

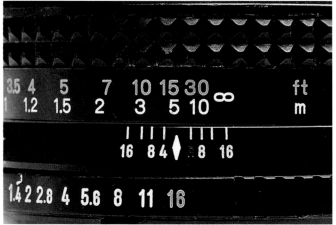

On some lenses you'll see a set of scales or markings. Generally you won't see these scales on autofocus lenses or zoom lenses. From the base, the lens indicates the aperture that is set (here, f/16), the depth-of-field scale, and the actual focusing distance. The point of the diamond indicates the specific settings. The depth-of-field scale shows you what will be sharp and unsharp in the photograph. Here the lens is set at f/16. Follow the marks coming from the depth-of-field scale upwards. The marks encompass a distance of about 8 feet (between two and three meters) to infinity. That means that at this setting every subject in the viewfinder that sits between eight feet and infinity (forever) will look sharp in the picture. Subjects closer than that will appear unsharp.

fluoride that helps to reduce reflections and the loss of contrast, thus sharpness, in the transmitted image. Repeated cleaning or abrasion can wear off this coating. For that reason, many photographers mount a clear glass filter, such as an ultraviolet (UV) blocking or Skylight 1A, over the front element and leave it there.

AUTOFOCUS LENSES

Autofocus lenses either have a motor mounted inside or are driven by a motor in the camera to automatically focus on a targeted subject. Manual-focus lenses require focusing by eye and hand. Autofocus lenses will only focus automatically if mounted on an autofocus-type camera body. Only one 35mm camera brand—Nikon—allows use of their older manual-focus lenses on their autofocus camera bodies. All other brands require that you use distinct lenses for both their autofocus and manual-focus cameras.

When you use an autofocus lens, the autofocus indicators—usually indicated by squares or brackets in the viewfinder—show you where focus will be set. The scene in the viewfinder will go in and out of focus. To attain focus on a subject, place a bracket or focusing point over the subject and apply light pressure to the shutter-release button. This usually results in the subject snapping into focus in the viewfinder.

Some cameras allow you to choose from a number of focusing sites in the viewfinder. With others, there is only one focusing bracket located in the center of the viewfinder. If you want to maintain focus on the subject with a centered focusing bracket, but want to place the focus off-center in the actual composition, you must use a function called **focus lock.**

After you've locked focus on the subject, you can then recompose and shoot. Camera models with multiple autofocus indicators make it easier to focus on subjects in different parts of the viewfinder frame.

Autofocusing works with a target system. You align the autofocusing detection site in the finder with the main subject. The camera then sets the focusing distance for you. You get a confirmation of focus by what you see in the viewfinder. Some SLRs have multiple detection sites; others have a single target located in the center of the viewfinder. With a single-site system, you have to lock focus to keep from composing with the in-focus subject always in the center of the frame. This close-up is a good example of when to use focus lock. The petals at the base of the frame are out of range of the AF target in the center of the viewfinder. The camera was moved so the target in the center was right over the foreground flower. Focus lock was activated and then the scene was recomposed. The subject-distance was then locked into the focusing system.

FOCAL LENGTH AND MAXIMUM APERTURE

Lenses are generally described in two ways: in terms of their focal length and in terms of their maximum aperture. Focal length affects the angle of coverage as well as the apparent distance from the camera to the subject, or perspective, the visual relationship between the camera and its subjects both near and far. Maximum-aperture defines the lens's largest possible opening. We'll cover focal length first.

Practically speaking, the focal length of a lens is a guide to the lens's angle of view, or field coverage. The lower the focal-length numbers, the wider the angle of field coverage. For example, a wide-angle lens, such as a 24mm-for-35mm format, encompasses more of a scene than a telephoto lens, such as a 200mm-for 35mm-format, when the scene is viewed from the same position.

Focal length also affects a lens's visual relationship with a subject. Simply put, a telephoto lens brings subjects closer, while a wide-angle lens makes subjects seem farther away than they actually are (see the discussion on focal length that follows). The respective result of each is a compressed perspective and an expanded perspective. To gain a sense of the affect of focal-length changes, try out different lenses on the same scene from the same point of view. While differences between a 35mm and a 50mm might not seem so great, the difference between the look you get with a 24mm and a 150mm is profound.

The focal length of a lens defines both the angle of view (the peripheral vision) of the camera when the lens is mounted and the sense of perspective or scale we have with subjects at different distances from the camera. These two photographs were made standing in the same spot. The photo on the left was made with a 17mm (super wide-angle) and on the right with a 50mm (normal) lens. The different visual effect of these lenses is startling.

Choose different focal length lenses for different visual effects. This was photographed with a 70mm lens at a distance of about 12 feet from the subject. It has the look and scale of what we normally see.

This photo was made with a 24mm lens photographing close to and up at the statue. The camera is about two feet away from the statue. It's the same subject and the same type of light, but using different focal length lenses from different points of view makes for a big change in how we portray the subject.
Photos by Grace Schaub

FOCAL LENGTH CHOICES

Focal length choice affects both the **angle of view** (how much field-of-view coverage is afforded) and the sense of perspective the lens yields. Wide-angle lenses tend to expand the sense of space, making subjects appear farther away and covering a wider field of view. Telephoto lenses tend to compress the sense of space, making subjects appear closer than they really are and covering a narrower field of view. While there are no hard and fast rules, this chart describes some of the more common uses of these lenses.

Super wide-angle lenses (16–24mm)

Landscapes, travel, intimate candids, special effects (such as making a close object appear large in relation to the background), panorama subjects, images where a deep depth-of-field are desired

Wide-angle lenses (28–45mm)

Travel, still life, group portraits, nature, interiors, editorial photography, architecture (PC lens version), images where a broader field-of-view without exaggeration or edge distortion is desired

Normal (50–55mm)

Images where a "normal" sense of perspective is desired (the relationship and size of subjects near and far are close to the relationship perceived by the human eye/brain)

Short-range telephoto (70–135mm)

Travel, single-subject portraits, nature, candids, fairly distant landscapes, shows and concerts (in the middle-to-front seats)

Telephoto (150–300mm)

Travel, sports, nature, some wildlife, long-range candids and landscapes, news

Super Telephoto (300mm +)

Wildlife, some sports, distant seating for concerts and shows, news, very long range candids and landscapes

APERTURE CONTROLS

Aperture settings affect your light and depth-of-field control. The aperture is a variable opening within the lens itself that ranges from very small to wide open. The maximum aperture is the largest opening, and the minimum aperture is the smallest opening available on that lens. Apertures are designated by **f-numbers** and are known as f-**stops.** When an aperture is expressed it reads *f*/2.8, *f*/8, etc. Because the aperture is variable, it can be used in conjunction with shutter speed as a way to control exposure, or the amount of light reaching the film.

The *f*-number is the proportion between the diameter of the opening of the diaphragm in the lens and the focal length of the lens itself. Thus, if the diaphragm opening is 10mm, and we're working with a 110mm lens, the aperture is *f*/11. With any given lens, the lower the *f*-number, the larger the aperture, or opening. And naturally, the larger the opening, the more light that passes through the lens.

Aperture settings also play a role in the depth of field in the picture space. As the aperture narrows, the depth of field increases. This relationship allows for discrete manipulation of sharpness and unsharpness in a scene. Controlling depth of field is an important creative tool in photography.

When the light is bright, we can work with a fast shutter speed and a narrower aperture, as in this photograph taken of the steps of a museum.

The aperture plays an important role in picture-taking. It works together with shutter speed to determine how much light reaches the film. The combination of a particular aperture setting with a particular shutter speed is referred to as "film exposure." In some cases, such as this night scene in Las Vegas made without a tripod, we might have to use a wide-open aperture and a fairly slow shutter speed.

APERTURE-SETTING EFFECTS

Using a narrow aperture with a wide-angle lens produced a photograph in which each of the carousel horses is sharp. When the light is low, you can still get a deep zone of sharpness, but you may have to mount your camera on a tripod to keep it steady.

This photo was made at a narrow aperture (f/11) to ensure sharpness from front to back. The shutter speed was 1/4 of a second, too slow to hand-hold the camera without shaking and causing a blur.

Note the difference between these two images. The photo on the left was made with an aperture setting of f/8, while that on the right was made with f/4. The effect is much better at f/4 because the flower stands out in almost 3D fashion against the background.

The aperture setting of the lens in part controls depth of field. Also known as the zone of sharpness, depth of field allows you to define image effects that can make a big difference in how your subjects stand out or blend in with the background. Photographed at a wide-open aperture with a telephoto lens, this bird stands out against a painted background.

SPECIALTY LENSES

Specialty lenses can be used to serve special functions or to produce exotic effects. The so-called "fisheye" lens yields a very wide angle of view, from 146 up to to 220-degrees. The technique may yield some rather severe distortion in the bargain. So-called "mirror" lenses bend the light path via an internal mirror, thus offering very long focal lengths in fairly compact packages. While this method does not deliver the optical performance of a conventional 500mm lens, it is certainly an inexpensive way to get extended focal lengths.

Macro lenses are corrected to perform best for close-up work, specifically the recording of images at the rations of 1:1 to 1:3 life-size. For example, a 1:1 photograph of a dime produces an image on film the same size as the original dime; a 1:2 ratio produces an image half the size of the dime, and so forth.

Another specialty lens is the perspective control, or PC lens, that has a "shift" control to correct for line convergence. This is very useful for architectural photography with 35mm cameras.

Super wide-angle lenses include the fisheye lens. One type of fisheye lens yields a circular image. Edge distortion can be quite severe.

A rectilinear fisheye has the same field of view but works with the standard rectangular frame. The typical fisheye curvature is evident.

Macro photography allows us to observe and record images we usually do not see. It also opens up a whole new way of seeing. This is a photograph of staples left in a torn poster on a telephone pole.

Some super-wide lenses have rather severe edge distortion. The church building on the left appears quite normal, but the bent steeple of the church on the right shows evidence of a distorted edge.

Zoom Lenses

The most popular type of lens sold today is the **zoom lens,** which offers a range of focal lengths in one lens. (Lenses that yield a single focal length are known as fixed-focal-length lenses.) A zoom allows you to compose and crop, or change the angle of view on a scene without altering your shooting position. It is also of great benefit when traveling, as it helps to cut down on the number of lenses required. For example, a 70–210mm lens offers every focal length within the range: 70, 71, 90, 95, 150, 180, 210, and so forth. Carrying around separate lenses for each of those focal lengths would be inconvenient, to say the least.

Although modern zoom lenses have excellent optics, it's generally agreed that with all things being equal, very critical eyes find that a fixed focal-length lens at any focal length is better than a zoom lens at the same focal length. As I've mentioned, a lens is a complex set of glass elements designed to solve a particular optical formula. Because a zoom is used at many different focal lengths, it must be able to solve numerous optical formulae. Frankly, some lenses solve more effectively than others within their range.

A zoom lens allows you to work with many different focal lengths or angles of view in one lens. It is an excellent travelling companion since it cuts down on the weight and bulk that other lenses would create. Zooms come in many varieties. This set shows wide-to-telephoto zoom coverage, from 28–200mm.

The Memorial Day service shown here was photographed with a moderate wide- to telephoto-zoom, a 28–200mm. A zoom lens allows you to consider different compositions and to change the feeling of perspective in a scene. The wide-angle setting shows the entire scene, while the telephoto setting allows you to isolate select subjects within the scene when working from the same shooting position.

FOCUSING DISTANCE

Lenses all have a set minimum focusing distance, the closest distance at which a subject can be focused. Generally, the shorter the focal length the closer the minimum focusing distance. Some medium-range telephoto and zoom lenses have special close-focusing settings. This works with a button or click stop sometimes designated as "macro" on the lens. This may limit the focusing range within a few feet, but it does allow you to focus closer than usual with the lens.

LENS OPERATION

The focusing collar on most lenses is a knurled ring that surrounds the lens barrel. On some autofocusing lenses the ring is quite small and sits more toward the front of the lens. With manual-focus lenses, and with autofocus lenses in manual-focusing mode, movement of this ring clockwise and counterclockwise changes the distance between the glass elements, element-groups, and the film, thus shifting focus from one part of the scene to another.

Zoom lenses change the focal-length setting of the lens by changing the relationship between the elements and groups in the lens. Focusing at any one focal length, however, remains as it would with a non-zoom lens.

A zoom lens generally has two controls on the lens barrel; one is the already described focusing ring, the other is the focal length, or zoom control. On some

One of the most creative aspects of 35mm SLR photography is the total control it gives you over what will be sharp and unsharp in the photograph. Every focal length you choose gives you more options. This photograph was made with a 24mm lens at a narrow aperture (f/22.) The sharpness was checked using the depth-of-field indicator so that the angel four feet away and the top of the building hundreds of feet away are both sharp.

zooms, pulling back this zoom control ring increases the focal length of the zoom [and usually increases the size of the lens extension—though internal focusing (IF) lenses do not do so]. This narrows the angle of view and brings your subject closer. Pushing the zoom ring toward the end of the lens barrel decreases focal length, thus yielding a wider angle of view and moving the subject farther away. In some lenses the order of control is reversed. Some autofocus lenses have rotating rather than push/pull zoom control.

DEPTH OF FIELD

As focus is shifted in an SLR, the effects of the action are seen on the camera's viewfinder screen. However, with most cameras, the scene is viewed at the maximum aperture (which, being wide open, lets in the most light for viewing the scene). If the exposure is made at an aperture narrower than the maximum aperture (known as the taking aperture), the effect of that aperture on depth of field will not be apparent on the screen.

Some cameras have a depth-of-field preview function that actually shows the depth of field that will result when shooting at the taking aperture. Lacking this feature, depth of field may be ascertained by consulting the depth-of-field scale on the lens barrel itself. Unfortunately, zoom lenses and many types of autofocus lenses do not have this depth-of-field scale.

The opposite effect is achieved with this shrine, where a telephoto lens (150mm) is used with a wide aperture (f/5.6) to make the statue sharp and the writing in the background unsharp.

LENS-SETTING INDICATORS

At the base of some fixed focal-length lenses sits a series of interconnected markers and scales; these are the distance marker, the depth-of-field scale, and the aperture setting ring. These scales are vital to many of the focusing operations and serve as the information center for many creative choices. Some lenses lack these markings and display set distance only. Autofocus cameras will usually display the set aperture in the viewfinder.

The distance marker reveals the actual distance at which the lens is focused. This is also called the point of critical, or sharpest, focus. The distance marker is a rangefinder; when focus is set on a specific point, it reveals exactly how far the film plane is from that point. It is also the point of departure for any decisions about maximizing depth of field for the aperture in use. And it's very useful when working with manual electronic flash settings because it pinpoints one of the key figures in calculating correct flash exposure.

Directly behind, or sometimes incorporated within the distance marker, is the depth-of-field scale. This indicates the zone of sharpness available at whichever aperture the lens is set. As mentioned, some lenses lack this scale. The aperture ring shows the aperture setting. On some lenses, there is no aperture-setting indication. In such lenses, aperture settings are indicated within the camera's viewfinder and LCD panel.

A number of symbols may be part of the lens designations that refer to specific lens characteristics.

IF: This stands for internal focusing, meaning that focus is achieved by internal movement of the elements and groups within the lens, rather than by extending or shortening the lens barrel. This makes for more compact lenses in all focal lengths, especially long range zooms.

ED: This stands for "extra-low dispersion" glass, a formulation that improves the contrast and sharpness of images and eliminates any color fringing that might occur in long telephoto lenses. This specific code refers to a Nikon brand glass. Other lenses may have special glass formulations indicated by other code letters.

IC: This designates integrated coating, which means select elements within the lens have a multi-layer coating that aids in uniform light- and color-transmission.

Some of these features are found only in more expensive lenses, although competition has forced their incorporation into virtually every major lens brand, sometimes under different names or codes.

LENS AND FOCAL LENGTH

Technically, the focal length of a lens is the distance in millimeters from the center of a simple lens to the film plane (where the film sits in the camera) when that lens is focused at infinity. Lenses and their focal lengths are more practically categorized by the angle of view they yield. These divisions include super-wide (the 16–24mm group), wide (28–45mm), normal (50–65mm), portrait (80–110mm), moderate telephoto (150–300mm), and super-telephoto (300mm–1000mm and longer).

ANGLE OF VIEW

Wide-angle lenses deliver a wide angle of view, while telephoto lenses yield a narrower angle of view. Normal lenses are so described because they yield a perspective equivalent to the eye's normal way of seeing. Portrait lenses sit somewhere between normal and moderate telephotos and are so called because they are most often used for portrait photography.

PERSPECTIVE

Along with the change in the angle of view, using different focal-length lenses can cause an alteration in the sense of perspective or relationship of near to far in the picture. Perspective is the spatial relationship between one object and another and between the elements in the scene as a whole. Logical perspective gives us a way to deal with the near and far and the big and little, using familiar objects for scale and a sense of depth as our guidepost. Skewed or forced perspective turns these relationships on their ear and can be used as a way to create unusual visual relationships within a scene.

Actual scene perspective does not alter when we change focal lengths. This can easily be proven by cropping (or changing the frame around) the scene made with a wide-angle lens down to the angle of view of the telephoto. However, when viewed as a whole, a false perspective is set up because of the context of the spatial relationships. These effects can be seen by comparing the view of the same scene made with a super-wide and a telephoto lens. The characteristics of these focal lengths make for perspective-altering opportunities.

Super wide-angle lenses (24mm and wider) cover a very broad field of view. They also offer very deep zones of sharpness at narrow apertures (with depth of field possible from 1 foot to infinity), and allow for very close minimum-focusing distances. Because we can focus closer, we can get very close to foreground objects. This tends to exaggerate their size. When put

This set of three images made with a 28mm lens shows the possibilities of working with depth of field. The first and second were made with the aperture at the same setting, f/5.6. What has changed is the point of focus, with the first focused on the foreground and the second on the background. This shows a fairly shallow depth of field. The third was made from the same distance but the aperture was set at f/16 and the focusing distance set on the foreground clump of leaves. Every part of the photograph is now sharp.

ANGLE-OF-VIEW CHART

Angle of view is the degree of field coverage a particular focal-length lens provides. Arms stretched straight out describe a 180-degree angle of view; half of that would be 90-degrees, and half of that would be 45-degrees. The groupings of focal lengths—ultra-wide, wide, telephoto, etc.—are actually descriptions of the angles of view those lengths cover.

For example, ultra wide-angle lenses cover an 84–72 degree angle-of-view range, while moderate wide-angle lenses include those in the 65–49 degree range. Telephotos offer a range of between 26–13 degrees, while a super-telephoto can restrict the angle of view to 7-degrees or narrower.

Despite the difference in angle of view, the same amount of coverage can be obtained with virtually any lens if shooting distance is changed. For example, if you want the scene offered by a 200mm lens, but you only have an 80mm lens on your 35mm camera, you simply move closer to your subject. However, using the two lenses at the same distance from the same subject will alter the look and the relationship between the scene's foreground and background. This change might also affect your ability to attain a certain depth of field. These illusions of space and spatial relationships make your choice of lens a truly creative opportunity.

Horizontal Angle of View	Focal Length 35mm lens
65	28
54	35
40	50
24	85
15	135
10	200
7	300

in relationship with distant objects in the background (which, because this is a wide-angle lens, appear farther away than they actually are), the foreground object seems to take on even greater visual importance. The ability to get a very deep zone of sharpness allows us to carry the illusion even further.

For example, look at the face of a wristwatch at arm's length. It looks about the same size as a silver dollar. Now move the watch so that is is a few inches away from your face: in relation to the background, it now dominates the field of view. The watch hasn't grown in size. It has merely come to take up most of the field of view. This forced perspective, or foreshortening, is what happens when you set up shots with near/far relationships using small apertures on an ultra-wide angle lens.

Long telephoto lenses can also be used to alter spatial relationships, but with quite the opposite effect of a wide-angle lens. Because long telephoto lenses yield a very narrow angle of view and bring distant subjects closer, they tend to flatten space rather than expand it. This compression is shown best in the relationship of subjects that ordinarily sit some distance from one another. When compressed, they seem to sit right next to or on top of one another.

Perspective is how we relate to scale and distance through point of view and the size relationships between subjects. When you work with different focal length lenses, you are presenting the viewer with a worldview that is shaped by those choices. When you combine focal length with depth-of-field techniques and a particular point of view you can approach and record a scene in many different ways. This street artist is first photographed with a 50mm (normal) lens with the lens at his head height and the camera pointed straight ahead.

The lens for the second photograph is a 24mm aimed slightly above the street artist's head with the camera pointed down to include more foreground in the frame. The light, distance, and subject remain the same as in the picture above, but the two photographs look very different.

Photography allows us to play with scale for some visual tricks. This letter "R" was photographed on the third floor of a parking garage. The letter is about four feet tall, but because of where it is placed in the frame and how depth of field is handled it is as tall in the photograph as the twenty story building behind it. The photograph was made with a 24mm lens set at f/16.

This effect, called stacking, (also discussed below in the telephoto lens section), can make crowds look denser, buildings look closer, and boats in a marina seem as if they are piled on top of each other rather than in their separate moorings. Stacking can also be used to accentuate patterns for a more intense visual experience.

Thus, choosing different focal lengths is not merely about using a telephoto lens to bring far-away objects close, or using a wide-angle lens to bring more of a horizontal or vertical plane into view. While these are some of the reasons to choose one lens over another, the true character of focal length can be exploited by creating many other unique spatial arrangements within pictures.

DEPTH-OF-FIELD EFFECTS

The aperture setting has two functions: controlling the amount of light coming through the lens by means of its variable opening and helping you control what will be sharp and unsharp in the picture. Both functions are vital to photography and offer highly creative options that can be used for each and every subject and scene.

Your first instinct may be to get everything within the picture space sharp. Upon reflection, however, you will see that unsharpness can be just as creative as sharpness. It can add dimension to the main subject, eliminate cluttered backgrounds, and add an aura of mystery to certain scenes.

The three major influences on depth of field—lens focal length, aperture setting, and distance from camera to subject—can be combined to find the exact degree of sharpness or unsharpness desired. Using a wide-angle

lens at a narrow aperture can yield sharpness from as close a distance as 1 foot all the way to infinity; with long telephoto lenses and wide apertures, the zone of sharpness can be sliced as thin as a few inches.

SUPER WIDE-ANGLE LENSES: DISTORTION AND EXPANSION

Super wide-angle lenses are those that offer an angle of view right at the limits of or beyond that of normal peripheral vision. The ultra-wide lens family includes the 24mm, 20mm, 17mm, and wider-angle lenses. Lenses wider than 20mm may be of the fisheye or rectilinear type (fisheye lenses yield a round image; rectilinear lenses yield the usual rectangular frame.) Aside from their field of view, the ability of super-wide lenses to focus quite close offers a unique take on scenes. They offer tremendous potential for deep depth-of-field techniques. In addition, their tendency toward edge distortion makes them both difficult and fun lenses to work with as well.

Because super wide-angle lenses can focus close and because they offer a deep depth of field, the foreground subject can be exaggerated in size while the background can be made to sweep away, reinforcing the dominance of the foreground subject. This visual effect can be quite comical and is often used to throw off the usual sense of scale. Small objects can appear to dwarf large buildings or a flower can seem as big as a mountain.

The edge distortion of these lenses can throw straight lines into curves or exaggerate the sense of depth in an image. For example, when shooting verti-

cally, sky can be made immense by tilting the lens back from the vertical axis. By tilting the lens forward, the ground can be made to stretch all the way to infinity, with distant subjects made minuscule in the process. You can create the same effects when shooting horizontally. Any straight lines off the center axis that rise from the horizon become bowed.

All wide-angle lenses offer wide fields of view and expand space by making the background seem farther away from the foreground. Super-wides do the same, but to a more exaggerated degree that can be used to create fascinating effects. Of the lot, the 24mm is the most normal and is often the choice of photojournalists, and candid and travel photographers.

Our choice of lens determines how we render the relationship of subjects within the frame. Wide-angle lenses, that is, those in the range of 20mm to 35mm, tend to expand space and make subjects at different distances from the camera appear farther away from one another. These lenses can also help us expand space and elongate subjects. The distance these rooftop tiles cover was exaggerated by focusing close to the foreground tile and using a narrow aperture to get a deep depth of field. The tiles seem to stretch into the distance, with those in the foreground larger than those in the background.
Photo by Grace Schaub.

TELEPHOTO LENSES: STACKING

A telephoto lens brings subjects closer, thus eliminating the need to get physically close in order to fill the frame with a distant subject. The same lens can change the sense of perspective (relationship of the near to far) in scenes. This characteristic is known as stacking. It gives the sense that disparate subjects sit atop one another. This quality can be used to distill an image down to its essential elements, giving the overall scene a denser look.

Effective stacking begins to occur at focal lengths above 150mm (for a 35mm camera) and becomes more intense as focal lengths increase. The impact of this effect often relies on sharpness throughout the image space, so as focal length increases, depth of field becomes more critical. This is especially true when the first subject within the frame is closer than the lens's infinity distance marking. This approach requires exposure with small aperture settings which, in many scenes, will mean fairly slow shutter speeds. Unless the light is very bright and you have a fast film loaded, use a tripod to keep the camera steady.

Stacking can make a small gathering of people seem large, a street seem more crowded, or a stand of trees seem like a forest. It imparts an intense quality to scenes because our normal sense of scale is thrown off by the unusual relationship between subjects near and far.

This harborside market is made into a collage of shapes and colors with a 210mm lens.
The compression of forms at different distances creates the effect.

MACRO PHOTOGRAPHY

Macro, or close-up photography, offers a unique view of the world around us. It allows us to see in ways our unaided eyes cannot and brings us into worlds we generally don't have the time or disposition to contemplate. It unveils patterns and designs that compose the sometimes hidden intricacy and beauty of both the natural and manufactured worlds. An entire range of tools is available to the macro photographer to make viewing the minuscule an easy matter.

LIFE-SIZE RATIOS

Optics play a major role in macro work. The macro lens is optimized for close-focusing work, though it can be used as a general purpose lens as well. A lens is considered macro if it can focus as close as 1:3 lifesize, that is, if the subject on film is one third the size it is in real life. A 1:1 life size ratio, for example, means the image of a dime on film would be the same size as the actual dime. Many specialty macro lenses allow for focusing as close as 1:2 (half the actual size), and offer 1:1 focusing with the addition of an extension tube that fits between the lens and the camera mount. In macro terminology, a 1:2 ratio means half the actual (life) size; a 2:1 ratio means doubling the object's actual size on film.

CLOSE-FOCUSING OPTIONS

Lacking a macro lens, a number of paths are available for attaining close-up images. Close-up "filters," essentially glass magnifiers, screw onto the lens like any filters. They come in various powers and can be used with virtually any lens. Extension rings mount between the camera and lens to help enhance the reproduction ratio. The effect becomes more apparent with shorter focal length lenses and longer length extension tubes. With most camera systems, these options work with the autoexposure and sometimes with the autofocusing system. Image quality is best when a prime macro lens is used, but the attachments and close-up auxiliary lenses I have described can be a low-cost entry to the exciting close-up world.

For critical work, an accessory bellows attachment for 35mm cameras allows for reproduction ratios as high as 11:1. The unit is mounted on a rail and sits between the camera and lens. Other attachments allow for lens reversal, which can double the magnification ratio of the unit. Perhaps the ultimate lighting accessory for macro work is a ring light, a flash that mounts around the lens rather than on top of the camera. This gives even light to the subject and eliminates the loss of light that usually occurs when top-of-the-camera mounted flashes become obstructed by the lens itself.

Macro work can be clinical and exacting, with the use of tripods, special lighting, and sets, or it can be casual, with a close-up lens and fast film in a handheld camera. Depth of field is extremely critical at close-focusing distances and can be set at less than an inch even at small aperture settings. But unsharpness can be a creative technique in this work—it can reinforce designs and patterns that might otherwise be caught up in the tangle of the close-up world. Picking a composition among the myriad offered in one scene is often the most fun and challenging part of macro work.

The beauty of the macro world is very exciting. This photograph was made at a 1:1 reproduction ratio with a 100mm macro lens.
Photograph by Grace Schaub

FILM: PHOTOGRAPHY'S RECORDING MATERIAL

Film is composed of light-sensitive grains, known as **silver halide crystals,** suspended in an **emulsion** coated on a clear plastic base. The shape of the grains can be random or uniform, depending on how the film is built. The important thing about these grains is their efficiency in capturing light. This efficiency determines a film's light sensitivity, called its **speed,** which is expressed as an **ISO number,** a prefix on film speed ratings that stands for International Standards Organi-zation. This group standardizes, among other things, the figures that define the relative speed of films. (The older designation—ASA—has been replaced world-wide by the new rating system.) Generally, the faster the film, the larger the light-gathering crystals. Larger grains are capable of capturing more light. Faster films have grains with greater areas than those of slower films. The higher film speeds are signified by higher ISO numbers.

The negative/positive process has been at the heart of photography ever since its invention more than 160 years ago. The negative on the right is on a glass plate negative probably exposed in the 1890s. The positive print reveals the gentleman holding his newspaper. Collection: Grace Schaub

IMAGE FORMATION

Light is a form of energy that can influence and change matter. In photosynthesis, the energy of light serves as a catalyst for the complex reactions by which a plant creates its own nourishment. In photography, light acts upon film grains and causes them to change. This process of change creates what's called a **latent image,** or invisible film record. When, through the development process, the film is subjected to a series of chemical baths, the image appears and becomes visible to the naked eye.

All exposed film begins as a **negative**—a reversed record of the intensity of light values in the scene being photographed. The intensity of light in a scene is proportional to the **density** of silver buildup on the film. A high density of silver buildup indicates a great intensity of light striking the film, which is indicated on the negative by a darker area. Less density, thus a lighter area in the negative, indicates less light striking the film. This may seem counterintuitive, but keep in mind that light intensities in the negative are reversed when a print is made. When you look at a negative, the dark areas you see were areas of brightness in the actual setting, while bright areas in the actual negative were dark in the actual setting. This range of densities, from darkest to brightest, or thinnest to thickest, constitutes the tonal scale of the photographic record.

This system, in which the range of brightness values in a particular scene is represented by a range of tonal values on film, is at the heart of photography. In negative films, the tonal values are reversed when a print is made. In slide films, the reversal of tonal values occurs—via chemical or physical means—when the film is being processed, and the "positive" image develops on the slide film itself. In both cases, negative becomes positive when the cycle of processing is complete.

This negative/positive developing process also works with color recording. In color film, the light-sensitive silver halide crystals are suspended in various color-recording layers. When light of a certain color strikes the film, the grains in that respective color-recording

The structure of modern film is extremely complex with recording layers that capture and eventually create color images. Think how thin film is in your hands and compare it with this diagram that shows the various layers.
Courtesy: Eastman Kodak Company

layer react. During development, those grains work with color-couplers to produce dyes that emulate the colors in the scene, but in reverse. Thus, what was a red area in the actual scene will be reproduced as green in the negative, and what was a yellow area in the actual scene will be reproduced as blue in the negative. Like tonal values, color rendition is reversed when a positive print (or slide) is made.

As you learn about light-metering and film's ability to capture a certain range of a scene's brightness values, the concept of tonal scale will make more sense. The process has been refined through the years to the point that we can now predict with some accuracy just what we will be capturing on film when we make a photograph—regardless of the scene, subject, or lighting conditions at hand.

Reading color negatives can be difficult because when we look at the film, we see colors opposite of those we saw in the original scene. Match the colors of this fruit stand in the positive and negative to get a sense of how the color reversals work when a print is made.

Film Variety and Choice

Currently, over one hundred specific types of film are available from five major manufacturers, not counting similar film types made only for specific camera formats or films made by smaller manufacturing firms. At first glance, the array of films may be confusing. On a pragmatic level, the choice becomes clearer when you consider the levels of film speed, which are measures of their light sensitivity.

When light is low and you're shooting without a steadying device, a fast film offers greater sensitivity. When light is bright, a slow film offers better overall picture quality. On an aesthetic level, different films offer choices for creative scene rendition through their different personalities. These distinctions may be manifest in higher color saturation, a certain color bias, or the amount of grain the final image exhibits. Your recording material, film, can therefore become both a practical and a creative choice.

NEGATIVE AND POSITIVE FILM

Film comes in two major types: negative film for prints and transparencies, and slide or positive film for projection, commercial reproduction, and prints. Transparency and negative films are available for both black-and-white and color photography. There are also specialty films for high-contrast rendition, copying, and scientific uses. The greatest variety of film today is available for 35mm cameras.

LIGHT SENSITIVITY: SPEED

The speed of a film indicates how sensitive it is to light in relation to other films. Speed is expressed as an ISO number. ISO numbers are relative, but in the world of photography, they tell us how each recording material fits into the sensitivity scheme.

The higher a film's ISO number, the faster, or more sensitive the film is to light. For example, a film with an ISO number of 200 is twice as sensitive to light, thus twice as fast, as an ISO 100 film. The same ISO 200 film is half as sensitive to light, and half as fast, as an ISO 400 film. In terms of exposure, ISO 200 film is one stop faster than ISO 100 film and one stop slower than ISO 400 film.

Today's films range from speeds of ISO 50 to ISO 1600. In general, the amount of light where you're shooting is what dictates your choice of film speed. For example, ISO 100 is perfect for a sunny day, while a super-fast film, such as one with an ISO 1600 rating, is made for shooting in low light without flash. In short, there's a time and a place for every film speed.

One obvious question is this: if a fast film allows for shooting in nearly every lighting condition, why not choose the fastest film for general use? The reason for matching film speed to lighting conditions is that as film speed goes up, overall picture quality tends to diminish. Grain increases, sharpness decreases, and colors may become less true. There may not be a dramatic change when switching from ISO 100 to 200, but you can see a definite difference between an ISO 50 and ISO 1600 film. Films of all speeds deliver good pictures when used appropriately, but to the critical eye, a slow film delivers quality superior to that of a fast film every time. Thus, whenever possible, choose the slowest film speed you can to cover the lighting conditions at hand.

Uses of Different Film Speeds

To get a sense of the photographic options any one film speed offers, compare the conditions under which an ISO 50 and ISO 1600 film might be used and the trade-offs you'd encounter. ISO 1600 film is 5 stops faster, or 32 times more light sensitive, than ISO 50 film. ISO 1600 film can photograph a child blowing out birthday candles in a darkened room, a basketball game in a high school gym, or a carnival ride at night, all without flash and usually without worrying that the shutter speed will be too slow for handheld shooting.

Conversely, the ISO 50 film requires fairly bright lighting conditions in order to avoid using a tripod or some other steadying device. This is also the case when working with this film and a large, long-range telephoto lens, even under normal lighting conditions. ISO 50 film is simply too slow to allow for the use of a long lens without a tripod.

In general, for shake-free, handheld pictures with slow film, set the camera shutter speed at the inverse of the lens's focal length. For example, when using a 200mm lens, set the shutter speed at a minimum of 1/250th of a second. If you are using a zoom lens, apply that guideline to the longest focal length in the zoom range.

ISO 50 and ISO 100 speed films offer the sharpest,

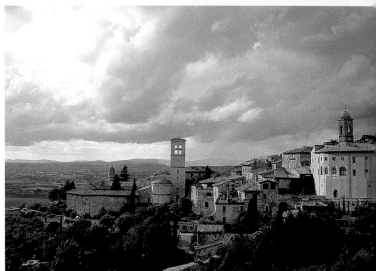

A medium-speed film such as an ISO 200 or 400 is best when you are photographing in dim lighting conditions, when you don't want to or can't use flash, or when you just can't predict what the lighting conditions will be. Both speed films work well in both daylight and dim conditions. This photo of a tanker in New Orleans (upper left) was made right after dawn with an ISO 200 film. Enough light filled the sky so that the camera could be handheld at 1/30 of a second at f/4. The Hong Kong scene (upper right) was made with an ISO 400 film right after the sun set below the horizon. Color remains in the sky even though the light is fading. When the sky is overcast stick with an ISO 200 or 400 film, as it will give you more exposure leeway. This view of Assisi, Italy (above) was made on ISO 200 slide film. This shop window was photographed with an ISO 400 film (left). The available light may be of varying intensities as you travel, so always carry a mix of fast and slow film, especially when touring far away from home.

finest-grain images of any film. This might not be obvious in snapshot-size prints, but when big enlargements are made the differences between slow and fast films can be startling. The slow film will have crisp edges, virtually no grain and, if it's a color film, bold, rich colors. Faster films may in comparison appear grainy, seem less sharp, and yield less color richness.

This is not to say that ISO 400 or ISO 800 speed films do not have admirable qualities. The tradeoffs among speed, sharpness, and grain have been reduced considerably over the past few years. Current ISO 800 films have the image quality of ISO 200 speed films of the recent past.

How do you choose among the many films of the same speed that any one manufacturer offers? Each film-maker has at least one, and some have quite a few offerings in the ISO 100, 200, 400, and 800 ranges. The truth is that it comes down to a matter of taste. Competition has kept manufacturers on their toes, and none can afford to fall behind in its product quality. Manufacturers do vary slightly in the way their films record color (such as skin tones) and in the way they render grain. Testing each film and matching it to various subjects and lighting conditions will be the best way to guide your selection.

FILM GRAIN

Grain is the visual manifestation of the light-capturing material, (silver halide crystals), in film. When exposed and processed, those light-sensitive grains are reduced to metallic silver. Greater light sensitivity and thus greater film speed is obtained by using larger grains in film construction. These larger light-capturing grains, however, show up in the negative as visible grains and become more apparent when the negative is enlarged to make a print. In slide film, the grain is also apparent in the positive image. Grain becomes emphasized further under the following conditions: when the film is developed for a longer time than normal; when the image is printed with higher contrast than appears on the film; or when the image is greatly enlarged.

Grain is present in all film. Because grain size relates directly to film speed, you should make it your rule when going for the finest grain to choose the slowest possible film speed. "Possible" takes lighting conditions into consideration and whether the camera is handheld or mounted on a steadying tripod. Slow film can be used in dim lighting conditions, but the film's lower light sensitivity usually requires an exposure with shutter speeds that are quite long, thus forcing you to use a steadying device. While grain in modern high-

FILM-SPEED CHOICES

The higher a film's ISO rating, the greater its sensitivity to light. Faster films are useful for low-light scenes when a flash or tripod or other camera-steadying device cannot be used or is unavailable. Low-speed films yield the best color and sharpness and the least "grainy" appearance. Film-speed selection is often a tradeoff between the desire for the best quality and the need for a more light-sensitive material due to lighting conditions. This chart recommends film-speed choices for a variety of lighting conditions.

Low-speed films (ISO 50-100)
Outdoors on sunny to moderately bright days; interiors with flash when subjects are within a fairly close range; when the richest colors possible are desired; when fine grain is desired.

Medium-speed films (ISO 200-400)
Outdoors on overcast or dim days; well-lit interiors without flash, or for dim interiors with flash; at well-lit concerts or sporting events where flash is prohibited; when film speed (sensitivity) is more important than rich color or fine grain.

High-speed films (ISO 800 and faster)
Indoors without flash or when flash coverage needs to be maximized; dimly-lit concerts or events; night photography with or without flash; when film speed must be the highest, even though that means sacrificing color richness and fine grain.

The illusion of a continuous-toned image called a photograph is produced by the close packing of millions of microscopic metallic particles that are the light-sensitive element in film. In color film, these grains reside in color recording layers. The silver is eventually replaced by color dye, but the record of the grains can sometimes be seen in a print or slide, especially when it is magnified or enlarged. The portrait above was made on a high-speed film and enlarged. Although the grain is evident it actually adds an emotional extra to the image.
Photo by Grace Schaub.

Compare it to a portrait made in open shade with a fine grain film (ISO 100) and the differences become obvious (left).

The same grain effect is evident in this floral closeup (right), also made on high-speed film and enlarged. Here again the grain adds to the overall emotional effect. Today, excessive grain is no longer a problem unless you are working with very fast films and making big prints.
Photo by Grace Schaub

speed films is of excellent quality, slower films invariably have finer grain, thus less visual "noise" in the final image.

In general, too much grain in an image is bothersome. For intentional graphic effects, however, grain can be enhanced. You can boost it by any of the following methods: shooting with a fast film or films with inherently high grain; overdeveloping your film; printing on high-contrast papers; or enlarging the image as much as possible. Enhancing or even adding grain can add a nostalgic, mysterious, or even an ominous note to an image.

We see, with film and with our eyes, in two different ways: color and contrast. This photograph serves as a sort of catalog of effects that can occur when photographing with regular film under artificial light. The people on the moving escalator are lit by daylight from a glass skylight above. The color is correct in terms of what's seen and remembered by the eye. The reflection on the right of the escalator base that's coming from a fluorescent-lit area has a green cast. The area on the left looks amber. Its refeflection comes from an area lit by conventional incandescent bulbs. Film is made to record correct colors in standard daylight illumination. Because artificial light is deficient in some colors (such as the lack of blue in incandescent bulbs) film records it as if it is seeing with daylight (full spectrum) vision. The eye usually corrects for any color deficiencies and sees color as balanced and as if lit by daylight.

COLOR BALANCE

Color balance refers to the type of illumination under which a film will render "true" colors. The majority of films are **daylight-balanced** and deliver true or "memory" colors under daylight illumination. Electronic flash also delivers light that is daylight-balanced. Slide film users can work with a specialty film called **tungsten-balanced** film that delivers true colors under artificial lighting conditions, specifically those lit by tungsten light. These films also offer truer color under incandescent lamp illumination, such as that from regular household lightbulbs. The film actually has a blue filtration built in to make up for the deficiency of blue in the artificial light source. Daylight-balanced films can be made to yield truer colors under artificial light with the use of a blue color-balancing filter that is placed over the lens.

KELVIN TEMPERATURE SCALE

Both daylight and tungsten films work with **color temperature**, a scale for measuring the color of light, whether the light is daylight (which has different colors throughout the day) or an artificial light source.

Kelvin temperature is based on light emitted in a controlled experiments by a heated material in a scientific lab. As the material is burned at higher temperatures, the light becomes progressively bluer. The practical use of the Kelvin scale in photography is to determine the color of the prevailing light and to determine what filters or film will bring the subject under that light back to normal rendition on film. For example, daylight film is manufactured to deliver true color under normal sunlight conditions, about 5500 degrees Kelvin. If that film is used when photographing indoors with only tungsten light illuminating the scene, it will record with an amber cast. That's because the light source—with a Kelvin temperature of about 3200 degrees—is deficient in blue light. To counter this yellowish cast, two things can be done. You can use a special tungsten-balanced film (which is manufactured to deliver true color under 3200 degrees Kelvin) or place a blue filter over the camera lens.

On an overcast day or in high altitudes, when the ambient light is of a higher Kelvin temperature (about 7000 degrees Kelvin), daylight film may have a blue cast. You can use a light yellow filter to deliver more natural colors. For exact results, professional photographers often work with a color temperature meter that gives them an exact Kelvin temperature of the prevailing light. They then use filters over the camera lens to balance the light for use with their film.

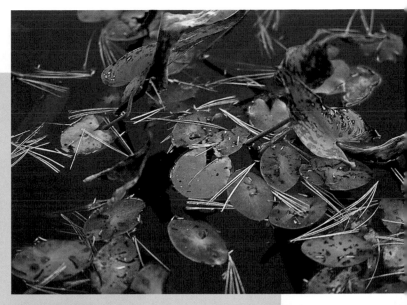

Color films are balanced to deliver correct color when the color temperature of the prevailing light is 5500 degrees Kelvin. When the ambient light differs, we get a color differential in our images. Often this adds a certain mood and an emotional bonus to the pictures. The top left photo was made in the deep shadow of New York streets and shows a strong blue cast. To the eye, at the time the photo was made the street was merely dark and not in blue light. The same effect occurred in this photo of a pond in deep shade (upper right). Some films turn bluer in shade than others. These flowers (right) were photographed late in the day. They also pick up a warmer color than was seen when the photograph was made. The opposite effect occurs late in the day when the light from the sun is warmer or more yellow. The sunset light makes this adobe wall glow (above). When prints are made from color negative film, much of this cast can be removed, although these color moods can add much to a picture.

TUNGSTEN-BALANCED FILM

For those who photograph with slide film under artificial light and do not want to use a flash or a color-balancing filter, tungsten-balanced slide films are an alternative. These films have a built-in blue cast that compensates for the deficiency of blue in the light source.

Tungsten-balanced slide films come in handy when photographing sports or concerts where a flash is prohibited and where the arena is lit with tungsten light. Another film would have recorded this seene with a yellow cast.

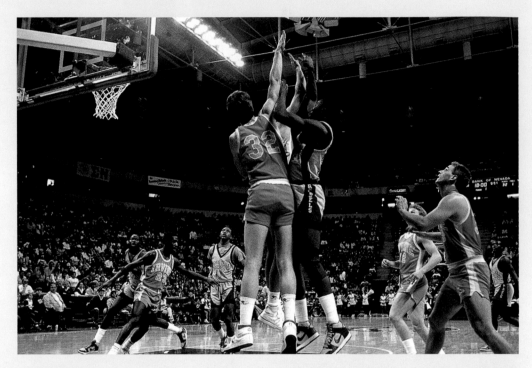

You can also use a tungsten-balanced slide film outdoors for a special mood. This scene of midtown New York was made with tungsten balanced film on an overcast day

COLOR SENSITIVITY

Color sensitivity is pertinent when you're working with black-and-white film. Virtually every black-and-white film is panchromatic, which means it is sensitive to all wavelengths (colors) of visible light and suitable for all types of work. There are two other black-and-white film types to consider: orthochromatic and infrared film. Orthochromatic (ortho) films are sensitive to ultraviolet, blue, and green light; they are *not* sensitive, and are thus blind to, red light. Ortho films are oversensitive to blue and will "block up" blue sky, meaning they record it very densely. Ortho film is primarily used to make copies of text and line drawings because it is a black-and-white film with no shades of gray. A panchromatic film would not yield a purely black-and-white image.

Ortho can also be used for special-effects darkroom work. It is often used to convert a full-scale negative or slide to just black and white, thus giving a pen and ink effect.

Infrared film has a heightened response to the higher end of the spectrum. It "sees" just beyond red where the invisible infrared light begins. This film is made for scientific work, but it can be used to give an ethereal and sometimes eerie look to images. A red filter must be placed over the camera lens for the best effect (this blocks out the ultraviolet, blue, and green light so the image is formed only by the red and infrared light). The result is a near-black sky (in areas of blue) with stark, white clouds, glowing, live subjects, and a feeling that the image was made in the light of an eclipse—in short, a most interesting film choice.

One type of specialty black-and-white film is infrared film. This records all colors but is also sensitive to an area of the spectrum we cannot see, the near-infrared. The result is always unpredictable and often quite exciting. A red filter must be used over the lens, and the film must be loaded and unloaded in total darkness.

COLOR BIAS

You should consider one other aspect of film when making a choice—its color "bias." A film's color bias is usually described by the terms warm or cool, which, respectively, define a slight yellow or blue rendition in the film. Bias is more pronounced and evident in color-slide film, where there is no intermediate printing step during which any bias the film may have can be balanced. These biases are not severe, but they can certainly be observed when comparing one type of slide film to another side-by-side. Cool films are geared toward the commercial studio market, while warm films are generally the choice of landscape and people photographers.

A warm film, for example, will enhance fall landscapes or even cut down on the bluish cast of distant scenic elements in a photograph (caused by ultraviolet light and haze). A cool film will add an extra edge to scenes in the city, or create a more graphic feel in commercial work. These are not hard-and-fast rules of film-use, but they do reflect general practice. As you gain experience with different films, it will become apparent when to match a specific type of slide film with the scene or subject matter at hand. This knowledge can greatly enhance the visual feel and emotional content of the image. Color-negative films may also have a bias, but in truth, this is more determined by the photo-lab printer than any specific characteristic of the film.

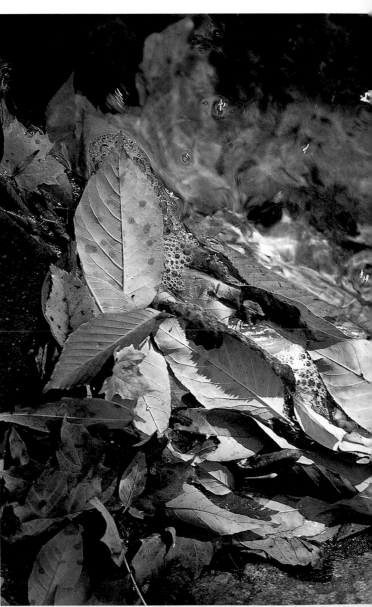

You can match a film's personality to a subject to enhance its mood and feeling in your photograph. These fall foliage scenes were photographed with a warm film (above and right). Cooler, more neutral films were used for the images shown on the opposite page. Today, color-slide films are sold in saturated and more neutral color renditions. As you gain experience with a variety of films, you'll be able to mix and match for any desired result. Note that color-print films may have a slight color bias, but generally the final color rendition will be more a matter of how the lab prints your film than any inherent characteristic of the film itself. Some color-print films, however, are more saturated than others.

Film Types

COLOR-NEGATIVE FILMS

The majority of photographs today are made with color-negative films. The chief use of color-negative film is prints. For color prints and enlargements, color-negative film, rather than color-slide film, will yield the best quality results. Color-negative films are available in virtually every speed, from ISO 50 to ISO 1600.

Color-negative film has an orange cast integral to the processed film. The cast is called a mask and is incorporated in the film material, or emulsion, to correct for some color deficiencies caused when unwanted colors are absorbed by the cyan and magenta dyes. This mask complicates the reading of color subjects in negative film. However, it doesn't adversely effect the color rendition, as color printing systems take it into consideration.

Every major film manufacturer makes color-negative film. There are also so-called private label films that carry a store or outlet branding, which are generally repackaged films from the major manufacturers. Each company has at least one type of film in virtually every speed. There are also premium films, priced to match, and specialty films made for the professional and amateur photographer.

Even with the minor differences in film brands, color-negative films generally have less of a distinct personality than color-slide films. These differences in brands are muted further when prints are made. The color-printing process usually has more of an effect on the look of the final image than does the film's inherent personality. Thus, choosing one brand over another is often a matter of personal taste and sometimes of price. All color-negative films on the market today are very good.

The end result of color-negative shooting is color prints. If you are shooting for snapshot-size prints — 3½ x 5 or 4 x 6 inches — most color-negative films will deliver good results. However, if you are shooting for big enlargements, the slower-speed films provide the best results.

All color-negative films available today are developed in what's called a C-41 process, or the equivalent. Film processing is available through one-hour photo labs and via wholesale labs throughout the world. Small home-developing kits are available, but with one-hour or overnight service available nearly everywhere, there's little reason to go to the trouble. The developing process itself is strictly controlled in labs and automation has made it fairly easy for even the most basic laboratory operation to deliver good work. Competition is quite intense in the film processing business, so if a lab delivers less than excellent results, do not hesitate to find another. The print processing stage is a key element in determining the kind of quality any film delivers.

DISTINCT PERSONALITY

One of the most interesting aspects of working with slide film is that each speed and brand has its own character. Slide films vary in their rendering of color. One film may yield more color saturation than another. Color saturation refers to how the same or similar hues reproduce in varying degrees of color vividness. Others films may exhibit warmer or cooler characteristics, be slightly more yellow, neutral, or even blue in overall color bias. These differences of character allow you to match films with different types of scenes. For example, when shooting fall foliage, a warm, vivid, color saturation film will enhance the leaves' colors. If you're taking a portrait, you might want a more neutral film for accurate rendition of the subject's fleshtones. If you're photographing a landscape, you might want a warm film to counteract some of the bluish haze in the scene, but you don't want a film that has so much color saturation that it alters the scene's naturalness. The slide film "boutique" allows you to practically customize the way color is rendered in particular scenes and for specific subjects.

COLOR-SLIDE FILM

Alternately called transparency, chrome, or positive film, color-slide film is used when images for projection or commercial reproduction are desired. Prints can be made from color slides. However, unless handled by a custom lab, prints from color slides are rarely as good as prints from color negatives. Why? One reason is that color slides tend to have more density than color-negative films. This is because slides are usually viewed via transmitted rather than reflected light. As a result, the prints from slides tend to exhibit more contrast than prints made from color-negative film, and generally have less subtle color reproduction. In truth, most labs are set up mainly for color-negative printing and simply don't deliver prints of equal quality from slides.

Although color-negative film is by far the most popular type, color-slide film still maintains a loyal following. Many people prefer seeing the positive image on film and enjoy projecting large images on a screen. Although newspapers are now using color-negative film, most publications still prefer color slides for reproductions. The slide allows them to see a visible proof that can be used to match the image on the page. Increasingly, digital-image files are being used for reproduction. These files can come from any type of film or even from a digital camera. This may result in a further decline of slide film usage, although today, many professionals and some amateurs still photograph primarily with color-slide film.

BLACK-AND-WHITE FILM

Black-and-white film for general use is known as panchromatic film. It is sensitive to all colors of light. As with other film types, slower speeds offer finer grain and better general image-sharpness. Prints are the end product of black-and-white negative film, and they can be produced on a wide variety of paper surfaces with varying contrast renditions. Black-and-white slide film is also available, although few labs process it.

Black-and-white photography continues to attract many people because of the way it renders scenes and the ease with which the prints can be manipulated to produce many different effects. We see a black-and-white print as somehow more real, but at the same time more abstract, than a color print. The true charm of black and white is that it focuses more attention on the design of an image. It can also make us more aware of texture and tone without what some consider the distraction of color. Black and white is an essential part of photography—one that you should experience as a unique way of portraying and seeing the world.

SLIDE FILM IMAGE-FORMATION

After it is exposed, the latent image in color-slide film is essentially the same as it is in color-negative film. After the first steps in the developing process, a metallic silver negative image is formed. This image is then, in essence, re-exposed so that the negative metallic image "prints" onto the previously unexposed silver-halides remaining in the film. The positive image is then developed in a color developer, which exchanges the metallic silver in the film's different color-recording layers for color dye. This produces the positive image. The silver from both the negative and positive exposures is then cleared away during processing and only the dyes remain.

The majority of slide films available today are categorized by the name of the process used to develop them—E-6. **E-6 processing** is fairly simple and is available in many labs. Slide film can also be processed at home with a simple three-step kit. Kodachrome is an "older" generation slide film still manufactured by Kodak. It is only processed by specialized labs and is only available in some locations.

Slide films come in a wide range of film speeds. Overall, slide films are available in speeds ranging from ISO 50 to ISO 800. Special purpose slide films include those that record color faithfully in tungsten light without filtration (dubbed "tungsten-balanced"), those made for low-light photography (speed ratings can be altered with specialized processing), infrared color-slide film (used mainly for scientific work), and black-and-white slide film.

Black and white has many moods that can be explored in the camera or later in the darkroom or digital desktop darkroom. In this interior photograph, (right), black and white is used to evoke a mood and sensibility about a special place. A higher key mood is evoked in this black-and-white photograph (opposite, above) of a house in Elba, Italy. The subtle transition of tones is one of the pleasures of the black-and-white medium. In a more abstract vein, (opposite page, lower right), black and white can be used to explore tonal values and the relationship of shape, shadow, and form. The photograph was made at the side door of an adobe church. When working in black and white, the photographer has a wide range of choice about how scene brightness values will be translated to tonal values on the print. This photograph (opposite, lower left) of ice on a spring stream is made into a more graphic rendition.

PRINT AND FILM STABILITY

Photographs can be fragile things. Paper prints can be bent or torn. Color slides and all film can be ruined by mold and mildew. Color dyes change and prints fade. Black-and-white prints can tarnish or stain. Photographic memories, despite what the ads may promise, do not last forever. Part of the fault lies with manufacturers. For many years, they produced materials that faded or stained after only a few years. Photo labs are another part of the problem. Poor processing procedures may leave chemical residues that attack prints and film. Some fault also lies with the photographer who fails to store photo materials properly.

Anyone who has photographed with color film in the last fifty years has seen evidence of this problem. There is more consciousness about photo stability now than ever before, but that doesn't mean that images can now last forever. It's best to check photographs every few years and make sure they haven't begun to fade. If precious images have started to turn, the best course of action is to have them either copied photographically or scanned digitally. This will, in essence, renew their life cycle. The old image will still fade away, however.

You can also help stave off the inevitable by taking proper care of your images. Keep them away from high heat and humidity, and store them in **archival** quality books and pages, which are acid and contaminant free. If you display a photograph, keep it out of the direct sun. And when you work with your image, take care to avoid getting dust or dirt on it.

There's no magic formula for making old images last forever. Vigilance will help you maintain your treasured photographs and care now will help preserve the images you make for future generations.

This photograph was made in 1969 with a notoriously unstable color-slide film. The color shift is evidence of dye fading, the first stage of image deterioration. Modern digital scanning methods can help save this image, although the original slide may soon fade away.

This slide was also made in 1969, and it has colors as rich as it had the day it came back from the lab. It was made on Kodak's Kodachrome slide film, one of the most stable color photographic films available.

Those with old family photo albums may see evidence of the images fading or tarnishing. This turn-of-the-century photograph is undergoing major fading at this point. When you see this type of detioration, it is a good idea to make a copy of the image and restore it.

FILM DEVELOPING

Many labs offer black-and-white film processing. The three-step chemical process, however, can be easily done at home, and many black-and-white photographers choose to process their own film for both quality and process-control reasons. Because the film developer can have an important effect upon the film's result, individual photographers usually go through a rigorous testing procedure to find the right combination of developer and film. Processing time and temperature can also have an effect on the film, so it is wise to follow procedures consistently and carefully.

PROFESSIONAL AND AMATEUR FILMS

There is a class of films dubbed "professional," a description that distinguishes them from all other films, which are generally referred to as "amateur" products. Professional films come in all types—color negative, color slide, and black and white. Generally more expensive than their amateur counterparts, professional films include those with unique characteristics geared to meet specific shooting needs and those which have been tested prior to shipment to guarantee carefully controlled color and speed performance.

Professional films are tested and released to market with very specific speed and color balance tolerances. These specifications may be printed on the instruction sheet accompanying the film. For example, though a film is rated at ISO 100, the instruction sheet may state that the speed of the film in hand is actually ISO 64, 80, or 100. That's why it's important to read the instructions with all professional films before you use them.

To maintain those tolerances, most professional films should be refrigerated by the dealer and, after purchase, should be kept refrigerated until they are used. They should also be processed immediately after exposure to maintain their speed and color specifications. Photographers often buy quantities of the same film (with the same manufacturing date and emulsion batch number) and test it for color and speed so they can accurately predict its performance in critical shooting situations.

Amateur films are released to market with the expectation that the film will sit in the user's camera for a while. As the dyes and overall response of the film will change over time, an amateur film will be in prime condition a month or more after its release to market. This does not mean that its performance is or should be considered sub-par. It does mean that some slight variations will be found on a roll-to-roll basis. The main things to remember with amateur film are to keep it out of areas with excessive heat and humidity and to avoid film that is near or past its expiration date.

Does all this mean one should only buy professional film? Not at all. So-called amateur films are amateur in designation only and are of no less quality than their professional counterparts. They also tend to travel better. For example, if you were planning a long vacation or

FILM AND AIRPORT INSPECTION

Film is sensitive to changes in heat and humidity. That's why you should keep all your film in a cool, dry place whenever possible. X-rays, gamma rays, and any form of electromagnetic radiation can also affect film. This becomes a real issue when traveling on airplanes with film. In general, the inspection machines at security checkpoints will not harm most film. If you are traveling with fast film, such as ISO 800 or above, you should request that the security people inspect the film by hand. If you arrive early enough and avoid the crowds, security will usually oblige. In any event, you should always hand-carry your film and keep it with the carry-on luggage. Recent changes in airport security devices for checked baggage pose a real threat to film. If passed through these inspection devices, the probing rays may very well damage film. For that reason, do not put film in your checked baggage.

trip it would be better to take amateur film, as professional film usually requires refrigeration and should be processed promptly after exposure. However, if you require the specific performance characteristics of a professional film, or if film-testing and predictability are important to you, then professional films are the best choice. Professional films are sold at a premium price, so choose the type of film to match your actual needs and practices.

FILM AND THE EYE

We count on film to deliver a record of what we see when we snap the shutter release button. A picture is usually a close-enough representation of our memory of a scene that we accept it as such, but there may be times when film and our eyes see quite differently. We've already discussed the idea of color balance, in which daylight-balanced film will "see" differently than the eye does when the scene is illuminated with artificial light.

Different light levels also provide instances where film and our eyes may see differently. The way the eye and brain can adjust to changes in light levels—especially in high-contrast lighting conditions that combine deep shadows and bright, reflective highlights—is amazing. High contrast occurs when the difference in brightness between the darkest and lightest part of the scene is extreme. For example, think of the difference between brightly-lit snow and the shadows beneath snow-covered trees, or between a sky at sunset and the horizon line. Our eyes can adjust to these differences quickly and make out detail in both areas of brightness within the scene. Film, however, often cannot.

Contrast is the difference between light and dark. In photography, contrast can be expressed as f-stops and can be measured with the camera's light meter. For example, an overcast day usually has less contrast than a bright, sunny day. When clouds cover the sky, you might move the camera meter around the scene and pick up less than one f-stop's difference between the brightest and darkest areas. On a sunny day, that range may be as much as three or four stops. If you're in a place where a lot of light is reflecting off bright surfaces (like a snowy field surrounded by forest), you might see as much as a five or six stop difference between the shadowy and bright areas.

The range of light on an overcast day is much easier to record on film than the full range of light on a bright day. In fact, when contrast is quite high, you may have to sacrifice details in darker parts of the scene on film. If you're photographing with slide film, you will probably have to sacrifice even more of that range than you would if you were photographing with print film. By its very nature, slide film has less of a contrast-range recording ability than negative or print films do.

Negative films also have greater exposure latitude than slide films. **Exposure latitude** is the ability of a given film to deliver good images when over- or under-exposed. Overexposure means too much light has struck the film, which results in partial or substantial loss of detail in the brighter areas of the scene and poor color or tonal reproduction. Underexposure usually means loss of detail in the darker, or more shadowed areas of the film record and some loss of color fidelity and richness. The greater the exposure miscue, the more image information you will lose.

Greater latitude in negative films means that these films are more forgiving of exposure mistakes. This does not mean, however, that we can use this as an excuse to use poor technique. Although a film may have greater exposure latitude, you will get the best results from proper exposure, a subject we'll cover in a later chapter.

BUYING ACCESSORIES

When you purchase a new SLR, a camera body, battery, strap, and perhaps a zoom lens are generally included. You might even get a camera with a built-in flash. Although this basic kit can take you through many photographic adventures, you may want to experiment and explore other lenses and photographic accessories. You may want to try out a super-telephoto, wide-angle or macro lens, or work with a more powerful flash.

Let your interests and your budget guide you. If you enjoy photographing sports or nature, you might want to make your first purchase a telephoto lens. If you are attracted to floral photography and want to do close-ups, then a macro lens might tempt you.

There are catalogues filled with photographic accessories geared to every personal and professional interest. We'll cover some of the more essential and interesting categories here.

ACCESSORY CHECKLIST

As you progress in photography, the accessories you buy will be determined to a large degree by the kind of photography you like to do. Although many photographers use certain standard accessories such as a flash and a wide-angle or telephoto zoom lens, those with special areas of interest often work with specific gear. This checklist, is meant to be a starting point for matching accessories with certain kinds of photography. Each photographer, of course, will come to discover his or her own favorite accessories.

SPORTS PHOTOGRAPHY
☐ Film speeds: ISO 400, 800, 1600; slide and color-negative film
☐ Lenses: 300mm and above; 24–85mm wide-angle zoom
☐ Tripods and monopods: Monopod with Ball, Pan and quick release heads
☐ Flash: Handle mount flash; ability to use flash away from camera body
☐ Filters: Color conversion (for different arena light sources)
☐ Carrying Case: Quick access, large capacity

PHOTOJOURNALISM
☐ Film speeds: ISO 400, 800, 1600; color negative film
☐ Lenses: 300mm and above
☐ Tripods and monopods: Tripod, tripod with flex legs
☐ Flash: Rare
☐ Filters: Polarizer, red, orange, yellow, neutral density, graduated neutral density, color correcting
☐ Carrying case: Backpack

TRAVEL PHOTOGRAPHY
☐ Film speeds: ISO 50, 100, 200, 400
☐ Lenses: 17–35mm zoom; 70–210mm zoom
☐ Tripods and monopods: Monopods
☐ Flash: Shoe mount
☐ Filters: See nature photography
☐ Carrying Case: Backpack, roller bag

FLORAL PHOTOGRAPHY
☐ Film speeds: ISO 50, 100
☐ Lenses: Macro 100mm, with extension tubes
☐ Tripods and monopods: Tripod with flex legs
☐ Flash: Multiple flash setups
☐ Filters: See Nature photography
☐ Carrying Case: Shoulder bag

PORTRAIT PHOTOGRAPHY
☐ Film speeds: ISO 50, 100, 200
☐ Lenses: 85mm f/2, 70–210mm, 35–105mm
☐ Tripods and monopods: Tripod
☐ Flash: Off camera, with reflectors
☐ Filters: Softening, diffusion
☐ Carrying Case: Light case along with camera case

Lenses

When you purchase a lens, keep in mind that it must be compatible with your specific type of camera body and lens mount. Just because your lens is made by the company that made your camera does not necessarily mean that the two will be compatible. Some camera companies have switched lens mounts or sell lenses that may or may not allow for all the features that your camera is capable of delivering. This is probably more important to remember when buying a used lens at a store or an online auction. If in doubt, contact the camera manufacturer.

If you can try out a lens before you buy, do so. This will ensure compatibility and allow you to check sharp-ness and contrast. Use a strong side or back light source when you shoot pictures to see the degree of **flare,** or how the lens handles bright, directional light. In most cases, flare or ghosting can be cut down by the use of a lens shade. Photograph a subject with fine detail and see how sharp the lens is. If the lens is auto-focus, make sure it achieves focus without a lot of "chatter," or noise as it moves back and forth. And be sure that you are willing and able to handle the size and weight of the lens.

Many people enjoy the convenience of working with zoom lenses because, in one lens, they get so many different focal length possibilities. This should

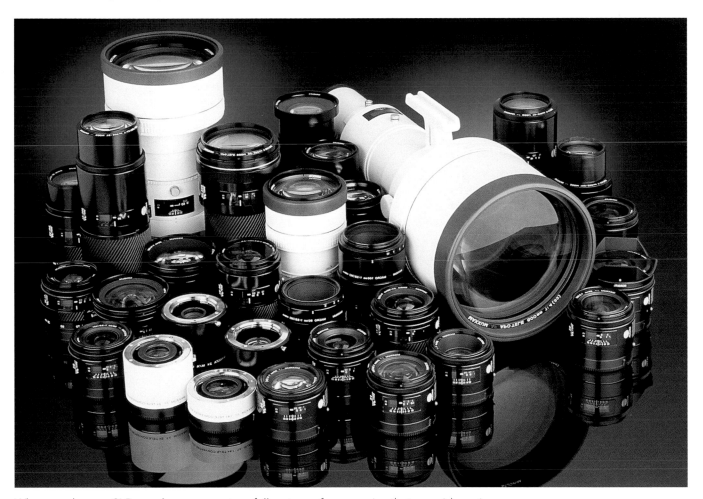

When you buy an SLR, you have access to a full system of accessories that can aid you in your photography. Every SLR is supported by a full complement of lenses in every focal length range and end use. There are lenses made especially for sports and wildlife, closeup and botanical, architectural and photojournalism and for general-purpose photography.
Courtesy: Minolta Corp.

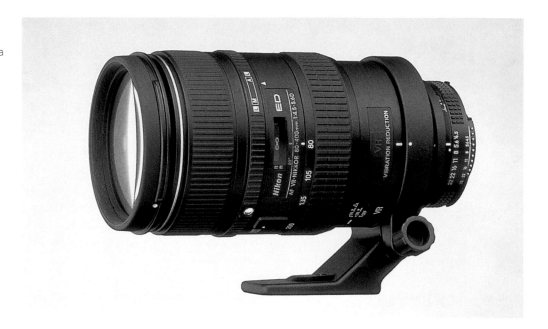

Zoom lenses give you great facility when on trips and covering events. They offer a wide range of focal lengths that allow you to make compositional and perspective choices without changing lenses or carrying extra weight. This zoom has an 80–400mm range.
Courtesy: Nikon USA

not eliminate your consideration of a fast (wide maximum-aperture), fixed focal-length lens in your kit. These lenses allow you to shoot handheld in lower light levels and often have depth-of-field scales right on their barrels.

Whatever lens you buy, keep in mind that the lens you mount on your camera offers you a new way of seeing and changes the way the subject and context relate in the frame. A macro lens can bring you into contact with previously unseen or unnoticed details. A super-telephoto lens allows you to record images that would be impossible to capture with a normal lens.

Changing lenses just for fun is a good way to reawaken your sense of visual play. For example, with a super wide-angle lens you can actually see beyond the edge of your normal peripheral vision. And with a super-telephoto, you can capture close-up action at sports events, unlike 99.5% of the people sitting in the stands. Although most photographers eventually find one or two focal lengths or zooms that become their walk-around lenses, renting or borrowing other lenses is worth a try.

FILTERS AND THEIR USES

Filters are lens accessories that alter the character or quality of light passing through the lens. They attach to the front of the lens with a threaded collar or bayonet-type mount. Each filter is matched to a lens according to the lens diameter; thus, a 49mm filter matches a lens with a 49mm diameter (not to be confused with the lens's focal length). Some super-wide (such as 17mm focal length) and long-range telephoto lenses

(such as 400mm focal length) may take filters in a slot within the lens itself, precluding the need for filters with very large diameters. Filters are also available as sheets that mount in a matte box you attach to the front of the lens with a threaded adapter. This allows use of the same filter sheet for various lens diameter, given that only different diameter adapters are required.

FILTER TYPES

Filters can be divided into a number of categories, including: lens protecting, color correcting, color balancing, contrast controlling, light reducing, light enhancing (diffusion, diffraction), and special effects. There is also a filter for polarizing light. Your 35mm SLR works with **TTL** (through the lens) metering, so it will automatically read the light for the exposure when a filter is used.

Lens Protection

Lens-protecting filters are colorless and do not affect the intensity of light passing through the lens. Common filters of this type are referred to as **UV** or Skylight 1-A. Although they can cut down on the effect of ultraviolet light in daylight scenes (useful for reducing the blue cast common in color landscape photography), their more practical use is to protect the lens from bumps and scratches. The front element of the lens is coated with a chemical that affects the contrast of the image. Repeated cleanings, especially with the wrong materials (such as a necktie), can abrade that coating and deteriorate the performance of the lens. Cleaning thumbprints

and other minor defects from the filter, rather than from the lens itself, is much safer. Thus, these filters can be left on the lens when in use or in storage.

Color Correction

Color-correcting filters are used to balance color, or to add a slight color cast to a scene. Many photographers use such filters when, after testing a film and a particular lighting condition, they find that the color rendition is not to their liking but that a slight "tweaking" of color will make it so. These filters are available in discrete steps of color intensity, expressed as, for example, CC10Y (very light yellow), CC 20M (light magenta), or CC80Y (deep yellow.) The higher the number, the greater the color intensity. CC filters can also add a slight cast of color to a scene. For example, a CC10Y filter can add a touch of warmth to a photograph of autumn foliage and enhance the mood.

Color Conversion

Light-balancing and **color-conversion filters** are used to match the color sensitivity of a film with a light source. Tungsten-balanced films are often used for studio work lit by tungsten lights and to make copies of color "flat art" (such as paintings, drawings and color prints) illuminated by tungsten bulbs. The film requires no filtration because the tungsten lights are made to match the film's color balance. If tungsten-balanced film is exposed in daylight, an 85B filter counterbalances the blue cast inherent to these films. Conversely, a daylight-balanced film under tungsten illumination (bulbs that emit a color temperature of 3200K) requires an 80A filter to replace the blue deficiency of the light source. Note that these filters are made to balance color when used under light sources with specific color temperatures; any deviation of the light source from that color temperature will result in less-than-correct color balancing.

In some cases, color-negative film can be rebalanced, or made to exhibit less color shift, when a print is made. This requires extra darkroom work, but commercial labs and experienced printers can bring the color back from a bias to a more neutral rendition. Of course, the best bet is to match a film's color sensitivity with the light at hand or to use color-conversion and balancing filters.

Color correcting filters can be used to add a slight color cast to an image or to make up for some color deficiency in the available light. A slight yellow filter is a great ally for both floral and autumn photography. A light yellow filter was used for the photograph (left) of a red rose. A deeper yellow filter was used for this photograph (above) of beach grasses.

ND Filters

Light reducing, or neutral density (ND), filters cut down the amount of light coming through the lens. They are useful when a slower shutter speed is required in bright light. For example, say we want to shoot with a slow shutter speed to create a smooth look in flowing water, or that we want to pan along with the moving action in a scene to create a background blur.

When an exposure reading is made, the aperture may be at its smallest, but the shutter speed is still too fast for the desired effect. Placing an ND filter over the lens reduces the amount of light without affecting color, allowing the use of slower shutter speeds. ND filters come in densities that block one, two, three, or more stops of light.

A neutral density (ND) filter does not alter the color of light but does cut down on the amount of light coming through the lens. ND filters come in various powers, with higher powers serving as greater light blockers. An ND filter is often used when photographing water outdoors, as it makes for slower shutter speeds. Without an ND filter, the slowest shutter speed in this light was 1/30 of a second with the aperture at its narrowest. An ND filter that held back two stops of light was placed over the lens so the resulting shutter speed was 1/8 of a second, slow enough to record this water as a flow rather than drops. This photograph was made with the camera mounted on a tripod, an excellent idea for any image exposed at less than 1/30 of a second shutter speed with any lens.

Filters for Black and White

Color filters can also be used for contrast control and color differentiation with black-and-white films. Because color filters block their complementary colors and allow their own colors to pass, image effects in black and white can be altered by placing yellow, orange, green, or red filters over the lens. A yellow filter will block some blue, thus will deepen the blue of a sky and enhance the contrast between it and the clouds. A progressively darker sky can be captured by using orange or red filters. If you are shooting foliage, a green filter will pass the green along and enhance every vein and color nuance in the leaf. If we want to brighten red (which records quite darkly on black-and-white film), we can use a red filter. (Red filters are also necessary to get the full effect when working with black-and-white infrared film.) Many black-and-white photographers wouldn't dream of shooting outdoors without these filters that they use for both dramatic and subtle effects.

Oddly enough, using color filters with black-and-white film often yields much better image results. The filters can be used for color differentiation and for contrast control. This red poppy (above left) is easy to differentiate from the green leaves in a color photograph. When photographed unfiltered with black-and-white film (above), however, it is hard to tell the tonal difference between the red and the green. If we put a red filter over the lens (left), it blocks the green and passes the red color. If we had put a green filter over the lens the opposite effect would have occurred.

If you work with black-and-white film, you should get acquainted with filter effects. All these images were made with a filter over the lens. When you photograph landscape scenes with clouds and blue sky, use a yellow, orange, or red filter. This photo (right) was made with a yellow filter over the lens. If you work with infrared film (below), a red filter is a must to get the best effects. A red filter was used to make this photograph (opposite) of a tulip. Can you guess the color of the petals? Photo: Grace Schaub

Polarizing Filters

A **polarizing filter** is useful for both color and black-and-white photography. Made of a static sheet of polarized glass and an outer ring that can be turned to obtain different degrees of effect, polarizers are used to eliminate surface reflections (in windows and water) and deepen sky (by enhancing the difference between the colors of the clouds and the blue sky). The filter is colorless and does not affect color rendition. It does affect how light is reflected from objects, so you may see the color differently in the viewfinder than you do with your unaided eye. You can preview the filter's effect right in the viewfinder. Autofocusing cameras and certain metering systems require the use of a circular-polarizing rather than a linear-polarizing filter. Check the camera instruction book for recommendations. Note also that polarizers will not eliminate glare or reflections from metallic objects. In some instances, polarizers may need some exposure correction, even when used on a camera with in-camera metering. Test the filter with your camera to see the effect and compensate accordingly.

There are literally hundreds of special-effect filters that diffuse, diffract, or otherwise alter light. Graduated filters go from clear to color or neutral density and are used by landscape photographers to add color or tone to blank sky. Softening filters add diffusion to portraits or nature scenes. Diffraction filters break point sources of light into multiburst stars. While these effects can be visually interesting when matched to certain subject matter, overuse yields cliché. Use them with discretion to add an occasional special effect to images.

FILTERS AND THEIR USES

Filter Type	Use
Color Conversion and Balancing	To allow the use of color daylight-balanced film in artificial light or tungsten-balanced slide films in daylight
Color Correcting (CC)	To add or eliminate color cast
Contrast Control	For black-and-white photography, to pass or block various colors. These can be used to deepen sky contrast or to differentiate color subjects in a black-and-white image
Light Reducing (ND)	To decrease the amount of light coming through the lens, usually for slow shutter-speed techniques
Polarizing	To reduce or eliminate reflections or deepen a blue sky
Special Effects	To alter the light through diffusion, diffraction, or color-shift effects

A polarizing filter can eliminate reflections or deepen blue sky and, in some cases, intensify color. Note the difference between the nonpolarized (left) and polarized (below) rendition of this scene. You can see this effect through the viewfinder as you rotate the filter.

Other Accessories

FLASH

Electronic flash works by the same basic exposure principles as natural light, except that it gives the photographer more control over the light balance in a scene. Modern flash units coordinate directly with the camera's exposure system. Even without total automation, working with flash is as easy as plugging a few numbers into a basic exposure formula. Flash can be used indoors and outdoors. Indoors, flash brings light and richer color to interiors. Outdoors, flash can be used to solve high-contrast problems or just to add a touch of light to bring greater detail into a scene.

The electronic flash, also known as a speedlight, is created by an electrical charge that passes through a coil inside a sealed, gas-filled tube. The burst of light is instantaneous and, unlike the continuous light emitted by filament bulbs, has a peak of somewhere between

Electronic flash is an integral part of 35mm SLR photography. Many cameras now come with a small flash unit built in. These small flashes (above) are effective from about 3 to 10 feet. For greater coverage you can buy an auxiliary flash that mounts in the camera hot-shoe or, as shown here, (top right), so-called handle-mount flashes that mount via a bracket to the camera's tripod socket and connect via a PC cord to the camera body (Photos courtesy Pentax Corp., Minlota USA, Bogen Photo Corp.)

1/300 and 1/1000 of a second. Flash is balanced for daylight-type film, so with most films, pictures with flash will usually display natural colors.

The power of a flash, thus the distance it can cover, is determined by the following factors: the amount of the charge it can accumulate in the capacitor, the size of the flash tube, and the type of reflector used. A flash's power is expressed either as a **guide number (GN)** or as a **watt/seconds rating**—the former is used for smaller, on-camera units while the latter is more commonly used for studio strobes.

Guide Number

The guide number (GN) system is used to define the potential power of a particular flash and as an aid in making exposure calculations when there is no through-the-lens metering available. To obtain a recommended *f*-number, the guide number should be divided by the distance (in feet) from the light source to the subject. The GN is based upon the use of ISO 100 film and the measurement in feet of the distance from the subject to the camera and flash. The GN changes when a film faster than ISO 100 is used in the

Electronic flash has many uses. Here, a flash was used in bright daylight to illuminate these subjects that would otherwise be in shadow. This technique is called daylight fill flash.

Photo by Grace Schaub

Daylight flash was used to add light to these horses standing under a shade tree. The camera's automatic exposure system balanced the flash illumination with the bright light in the background. Flash can also be used to enhance color when the sky is overcast or in shade. The colors of these flowers (right) "pop" when illuminated by flash.

Direct flash is also used in dark interiors or outdoors at night. These Mardi Gras paraders were photographed at night using a flash and a telephoto lens from about 30 feet away.

camera. GNs can be as low as 40 or as high as 160 in accessory shoe-mount flashes, with the higher number representing more power. A more powerful flash allows for greater distance coverage and for the use of smaller apertures at greater distances.

A flash may be mounted on the camera via a set of contacts, known as the **hot shoe,** or connected via a sync cord so the flash may be fired when mounted on a bracket or stand. Adapters also allow some flash units to be fired remotely via a radio transmitter. Multiflash automatic exposure systems are becoming fairly common in modern 35mm cameras. These systems allow you to use two or more flashes controlled directly from your camera.

DEDICATED FLASH

A flash is said to be dedicated when it acts in concert with the camera. Dedicated flash varies in its features, depending upon the model of flash and camera. This dedication may include automatic exposure and the ability to add or subtract light from the flash output right from the camera body. At the very least, dedicated flashes work in conjunction with the camera's autoexposure system, using the light reflected back from the subject as the basis for exposure control. Dedicated flashes may be the same brand as the camera or may be made by an independent company with connectors and electronics that link with a particular camera. Get a dedicated flash. It makes for easier and more spontaneous flash photography.

TRIPODS

Another accessory worthy of consideration is a **tripod.** This is a very useful item for doing close-up photography, working with long telephoto lenses for nature or sports photography, and for preventing camera-shake when working at slow shutter speeds. Remember, most of us can hand-hold a camera to about 1/30 of a second shutter speed. If we work slower or with a long lens that might throw off our balance, we probably need to work with a tripod. A tripod almost forces you to work more slowly and to think more about your composition. This can be helpful, especially in these days of six to eight frames-per- second shooting speeds.

Don't skimp on your tripod purchase. There is almost nothing worse than a wobbly tripod that fails to give you steady camera support and makes you worry about it tipping over. Look for a tripod whose legs extend and lock easily. This will aid your setup and breakdown in the field. Also, be sure to try out the various tripod heads. The head attaches the camera to the tripod itself. Some tripods have integral heads or platforms. A panning head is used mostly for video work but can be great for photographing motor sports or track events. A ball head has great flexibility, as it allows you to easily turn the camera for both vertical and horizontal compositions.

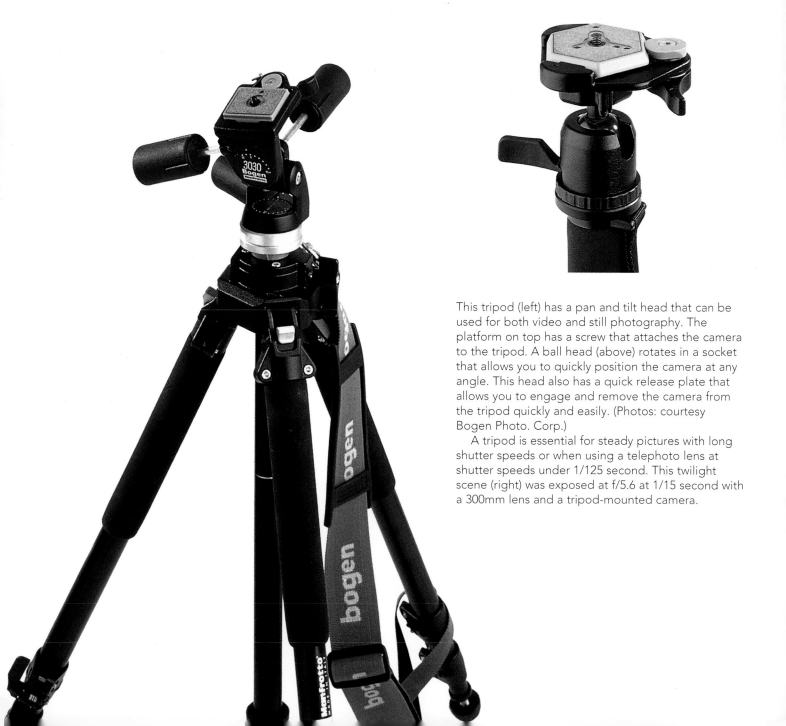

This tripod (left) has a pan and tilt head that can be used for both video and still photography. The platform on top has a screw that attaches the camera to the tripod. A ball head (above) rotates in a socket that allows you to quickly position the camera at any angle. This head also has a quick release plate that allows you to engage and remove the camera from the tripod quickly and easily. (Photos: courtesy Bogen Photo. Corp.)

A tripod is essential for steady pictures with long shutter speeds or when using a telephoto lens at shutter speeds under 1/125 second. This twilight scene (right) was exposed at f/5.6 at 1/15 second with a 300mm lens and a tripod-mounted camera.

Most tripods have straight legs, while some allow you to flex the legs at the joints. This flexibility may be handy when working on uneven terrain. At the tip of the legs, you can get rubber "feet" for indoor work or spikes for secure ground gripping.

When you buy a tripod, you should also purchase a **cable release** for your camera. Some cameras have threaded cable release sockets so you can attach the cables right into the camera's shutter-release button. Others require electronic releases that fit into dedicated sockets on the camera. The cable release allows you to fire the shutter without directly touching the camera. This aids greatly in further decreasing the possibility of camera-shake.

Another support option is a monopod, a single-legged stick with a head to attach it to the camera. Sports photographers who often have to run after or avoid the action favor monopods. They are also a favorite of hikers as they usually weigh less and take up less space than a tripod. Although the monopod does not provide the long shutter-speed stability of a tripod, it comes in handy when working with long telephoto lenses at even moderate shutter speeds like 1/125 of a second.

CARRYING CASES

Once you have purchased a few extra lenses, a tripod, and a variety of filters, you will need a secure place to stow your gear and a way to carry it when you travel. Keep in mind that cameras and lenses are delicate pieces of equipment and that any mishandling may cause problems. Part of the care you give your equipment should be to store it in a good carrying case for the road and in a secure case for storage at home.

I suggest getting two more cases, one for short trips and one for longer voyages. Usually on short trips, you know your subject matter and shooting conditions and might not need every piece of gear. For these trips, a belt pack or small shoulder bag for your camera, a lens and a few rolls of film is enough. On longer trips you will probably want to carry more lenses and film. That's when a larger bag comes in handy.

There are hard cases available, some of which you can even use as checked baggage. I did this once and was so nervous for the entire flight that I resolved never to do it again. I do use the hard case for storage of equipment at home, or for when I take a car trip to various photographic locales.

FOCUSING

At first glance, **focusing** seems like a simple matter. You look through the lens, press the shutter-release button to activate the autofocus mechanism, and make the photograph. Or, when using a manual-focus lens, you merely turn the focusing collar on the lens until the image seems sharp in the viewfinder, and then you press the shutter release. This would work well enough if we lived in a two-dimensional world. However, subjects in most scenes sit at different distances from one another. Some may be close together while others may be miles apart. Working with focusing techniques, you can either make subjects at great distances appear sharp within the picture or you can have a background as close as 1 foot from your subject appear unsharp.

Focusing is one of the most important creative options in photography, as well as a necessity when we want our subjects sharp. The techniques we use for creative focusing are called **selective focus** or depth-of-field techniques. Before we discuss these techniques, let's look at how focusing works.

These carnival lights illustrate how an image is perceived as sharp or unsharp. In the photograph on the left, the focus is set on the bulbs. Although there may be some softening of distant bulbs we see them as points of light with edges and defined shapes. In the above right photo, the lens has been defocused and the image of the bulbs is unsharp. They now begin to form circles rather than points of light. In the above left photo, we are even more unfocused and the circles become evident. Sharpness in a photograph is a matter of whether the light from the subject forms as points or circles of light. This closeup of a tree (top) illustrates this further. Note how every line and edge of the bark can be seen in the foreground. The background leaves of the tree, however, do not form any definite shape and image as circles. We assume they are leaves but on film and on the print they are circles or "blobs" of color and light.

Lens Operation

The focusing collar on most lenses is a broad, knurled ring that surrounds the lens barrel. On some autofocusing (AF) lenses, the ring is smaller and sits more toward the front of the lens. With manual-focus lenses, and with autofocus lenses in manual-focusing mode, movement of this ring clockwise and counterclockwise changes the distance between the glass elements, element groups, and the film, thus shifting focus from one part of the scene to another. Zoom lenses change the focal-length setting of the lens by changing the relationship of the elements and groups in the lens to one another. Focusing at any one focal length, however, works the same way.

Autofocusing in a 35mm SLR works with a passive AF system, one that relies on contrast between adjacent subjects to set focusing distance on the lens. The passive system works well in most situations but has some failures, mainly because it relies on contrast to make decisions. If, for example, you point the camera at a blank, gray sky, the lens will rack back and forth in a futile bid to find focus. The best bet in such situations is to switch to manual focus.

POINTS AND CIRCLES

Think of a magnifying lens slanted toward the sun and a piece of paper receiving the rays of light through the lens. As you move the lens back and forth, the rays from the sun change to form a circle or a point on the paper. When a lens is mounted on a camera, it directs light toward the film. Those rays that converge on the film at a point, or at a near point, are what we perceive as sharp in the image. Those that form a circle beyond a certain diameter are perceived as unsharp in the image. Our eyes tolerate a certain diameter of circle, or "blob," as being sharp. We do this at a certain distance and with a certain degree of magnification of the image. Change the viewing distance and/or the magnification, and what appeared as sharp might later seem unsharp. That's why when we enlarge prints that looked good in a snapshot size print (4 x 6 inches) to 11 x 14, certain areas of the print may look slightly unsharp. Close inspection of negatives and slides before enlargement can help prevent this problem.

VIEWFINDERS

The camera viewfinder works as a center of operations. Its most important task is helping you frame and focus a scene. When you look through the viewfinder of an SLR camera, you are seeing the scene through a lens at its maximum aperture. That aperture may be $f/2$, $f/4$ or even $f/5.6$. That's the widest opening the lens affords. The reason cameras and lenses are designed to work that way is that this opening naturally allows in the most light, thus makes it easier for you to view and focus the scene.

When you first look through the viewfinder you may have trouble seeing the image clearly, especially if you wear glasses. Many SLR models offer diopter adjustments that you can change to fit your vision. If you still have difficulty, consult an optometrist or talk with your camera dealer. They may be able to get a special visual adapter for you.

The viewing portion of the finder may have different configurations, depending largely on whether it's an autofocusing camera. In manual-focus cameras you may have a split-image or microprism center area. These areas are focusing aids. When using the split-image center, you line up the center on the subject or the distance you wish to get focus on, then you turn the lens until the two sides of the split line up. The microprism screen breaks the scene into finer areas and acts like a magnifier.

Autofocusing viewfinders may have quite a few different configurations depending on the camera model and its focusing setup. In some autofocusing cameras, a bracket sits in the center of the frame. This autofocusing detection site indicates the area in which the camera and lens get information to set focusing distance. You place the subject in the center of the frame, activate the autofocus (AF) by pressing lightly on the shutter-release button, and the AF system detects and sets focusing distance.

Some models may have a number of focusing detection sites. These are arrayed in the viewfinder in any number of patterns and configurations. Some may be indicated by small boxes that are arranged throughout the viewfinder. These cameras allow you to select any

single box or group of boxes as focusing targets. You use the selected site or sites to search for and select a subject. Left to its own devices, in most cases the AF system will select the subject that is first, covered by an AF site and second, sitting closest to the camera. This is called closest-subject focus priority.

Although this proliferation of focusing sites might be confusing at first, the intent is to provide more focusing targets and a wider area of AF coverage. In single, narrow-bracket AF systems, the danger of losing focus or relying too much on centered composi-

tion for proper focus is great. This places great reliance on proper use of the AF lock. The more targets and the broader coverage offered in current models means the greater the likelihood of attaining focus faster.

Focus lock comes in handy with both single and multiple AF target systems. Say you wanted to compose so that your main subject sat at the side of the frame. If you used autofocus and shot straight ahead, the focus detector would go right by your subject and focus on the background, leaving your subject

The point of focus in each of these photographs is off center. If you were working with a single-centered AF detector site, you would place the single site over the subject, lock focus, and then recompose. Cameras with multiple sites may have a better chance to lock focus where you wish without the use of focus lock. In some cases, however, the cameras are set up to seek a subject in the center of the frame unless you change their programming. Changing from default settings is usually quite easy.

unsharp. The solution is to move the camera so that the AF bracket sits over the subject and the lens moves accordingly. The subject will be sharp in the viewfinder. You then set the AF lock by either pushing a button or, with some models, keeping pressure on the shutter release button. You then recompose and shoot, and the subject at the corner will stay focused. You can use this technique with multidetector AF systems as well.

AF systems used to have a major problem tracking moving subjects. This is less of a problem with multipattern or site autofocusing cameras, which can pass the focus from one box to another as the subject moves through the frame. This happens rather quickly, although some AF systems may lag a bit if the subject motion is very erratic. Some AF systems also follow a subject even when there is a brief visual interruption between the camera-tracking and subject.

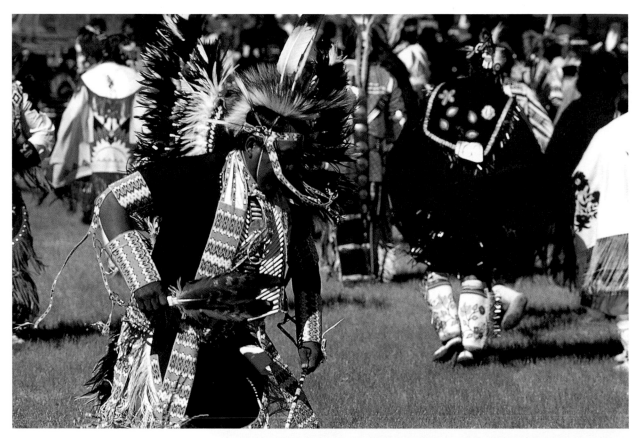

Use continuous AF mode when you are photographing a subject in motion. Modern AF systems can track subjects as they move through the frame and "hand them off" from one AF site to another. This dancer (above) was kept in focus using AF-C mode, as were these cyclists as they pedaled down the beach. Single AF mode (AF-S) is best used with still life or landscape photographs, such as this cityscape and tapestry (opposite page).

FOCUSING MODES

You have two main settings or choices when using an autofocusing system. The settings are called autofocusing modes. With single, or focus-priority mode, the camera will simply not allow you to make a picture unless it has a confirmed autofocusing target and that target is sharp. Single mode is a sort of autofocus safeguard against unsharp pictures. It works well for still life, landscape, portrait, and other stationary subjects. Although single mode is a great aid in getting sharp focus, it can be frustrating to use when subjects are in motion or the scene is changing rapidly, as the camera will not allow you to work.

That's when continuous mode comes into play. In continuous AF mode, the camera is always tracking the subject or changing the focus settings in response to camera or subject movement. Unlike in single mode, you can take a picture any time you like when working in continuous mode. You might not always get a sharp picture, but you can at least give it a try.

If, however, you're in a situation where the camera simply can't get any kind of fix on focusing, switch to manual-focus mode. You'll know soon enough when you're in this situation because the focusing mechanism will rack back and forth and the viewfinder will go in and out of focus.

AUTOFOCUS FOIBLES

Although autofocusing may seem like a dream come true for everyone who wants to make spontaneous photographs, and certainly for those who have trouble focusing manually, there are some conditions under which autofocus will not function properly or at all. In these conditions, the best course is to switch off the autofocus and rely on manual focus. You can tell when this is necessary if the lens racks to and fro seeking focus.

Another problem can occur when the focus mechanism "grabs" focus on the wrong part of the scene and won't let go, or will suddenly pull away from the subject you're focused on just as you're about to take the picture. This may occur with slight movement of the camera. When this occurs, you might be better off using manual focus, or you can use autofocus in con-junction with the autofocus lock, which holds focus at the point you press the AF lock button.

The main cause of autofocusing problems is a lack of contrast in the subject. In some cases, repeating patterns (such as those of a fence) will also throw the detector off. Erratic motion of any subject can also be a problem, although the latest AF detectors do a much better job of tracking subject motion than prior models.

If you insist on not switching to manual focus, there are still ways to overcome these problems when they occur. If a subject such as a blank wall or the sky resists autofocus, focus on a subject that is "focusable" (in other words, one that has contrast) at a similar distance, lock focus, and then recompose on your original subject. For example, if you are photographing a sky at sunset and can't get the AF to kick in, lock focus on

Autofocus may have trouble with certain types of scenes or levels of illumination. The main problem is with low contrast. These are typical scenes that will give AF systems fits. The AF system will rack the lens back and forth seeking focus. You could set the AF detector site on the horizon line and lock it and recompose before you make the picture, or you can just switch over to manual focus mode and focus by hand and eye.

the horizon line and then recompose and shoot. Both the sky and horizon line are at an infinity distance setting, so focusing will be the same. Similar solutions can be found for less distant subjects. To be sure that the unit will not move off focus right before the shot, lock focus whenever it lands on your main subject and keep it there until you release the shutter.

Some newer camera models allow you to adjust focus manually after autofocusing. This can be a great way to avoid using the focus lock and to try different focusing points than the one selected by the camera. This is very useful for close-up photography. **You cannot do this with some models because you may strip the focusing gears.** Check your camera instruction book. If you feel any resistance when you try to focus manually when in autofocus mode, just stop and switch to manual-focus mode. Never force anything when working a camera, especially a lens in AF mode.

At times the AF detector might snag on the wrong subject as you search for focus or, even more frustrating, might do it just as you're ready to make the picture. That's what happened here (left) when making pictures behind the batting cage before a baseball game. Switching to manual focus solved the problem (below).

Some cameras allow you to select a specific focusing detector site within the viewfinder. This can be a great help when photographing wildlife where you can't move or when there are a lot of possible distracting elements in the frame. The focusing site here was in the upper center of the frame. This avoided snagging focus on the leaves and grabbed sharp focus on the bird.

The Focus Assist Beam

Given the right subject, an AF system will focus more quickly than the manual hand/eye method. Most autofocus systems are very responsive. Focus seems to pop into the viewfinder.

Autofocus can be a real advantage in low light. When lighting conditions are dim, we may have trouble finding focus with our eyes. Often, we seek focus by concentrating on a light or any reflective object. Many autofocus cameras, and almost all autofocus cameras when used with flash, have a focus assist beam that seeks distance-focus by emitting light, reading it off the subject, and setting the focusing distance on the lens. Other systems may work with an active infrared beam that bounces off the subject and returns to the camera, to then be read by a ranging system. A few systems use the light from the flash as a guide. With a high-tech assist beam, you can shoot in virtual darkness, although a more practical use is for working in dim rooms and on streets at night.

Autofocus can make photography a very spontaneous affair. Keep in mind, however, that it cannot always perform as well as your hand and eye do. For years, professional photographers spurned autofocus cameras. Now, sports, news, and feature photojournalists use them every day. Their acceptance of this amazing technology says much about just how well it works.

This flash photograph was made under lighting conditions so dim that it was virtually impossible to focus by hand and eye. The focus assist beam on the flash ensured that focus would be sharp.

DEPTH-OF-FIELD EFFECTS

The aperture setting on the lens has two functions: to control the amount of light coming through the lens, and to help determine what is sharp and unsharp in the picture. In photography, the image's depth of field, or zone of sharpness, defines what is sharp and unsharp. Depth of field is the distance from the subject on which focus has been set to the points in front of and behind the subject where the eye perceives sharpness in the picture.

Your first instinct may be to try to get everything sharp within the picture space. Upon reflection, however, unsharpness can be just as creative as sharpness; it can be used to add dimension to the main subject, to eliminate cluttered backgrounds, or to add an aura of mystery to certain scenes.

Given the right conditions, any lens can give you a deep depth of field. That said, wide-angle lenses offer a greater potential for deep depth-of-field effects in a greater variety of shooting conditions. The camera was placed directly on the road surface and pointed up.

Made with a 24mm lens set at f/16, the depth of field yielded sharpness from the bottom of the steps to the sky.

This architectural study counts on a deep depth of field. The tiles and building were photographed with a 50mm lens set at f/16 with focus on the foreground tile.

DEPTH-OF-FIELD EFFECTS

Use this chart to find ways to create either a deep or a shallow zone of sharpness. Each factor (focal length, distance, and aperture) enhances the depth-of-field effect.

Effect	Focal Length	Distance	Aperture
Greater Depth of Field	Shorter Focal Length (use wider angle lenses)	Greater. Increase distance from camera to subject	Narrow. The narrower the aperture the greater the DOF
Shallow Depth of Field	Longer focal length (telephoto lenses)	Closer to the foreground subject	Wide. The wider the aperture the shallower the depth of field

You might be tempted to always shoot at a minimum aperture to get a deep zone of sharpness in every shot. In actuality, an effective use of background—aside from images where the context is as important as the subject—can involve softening it through the use of wider apertures on longer focal-length lenses. This is true of close-up portraits, floral, and nature studies. A shallow depth of field can be used to place more importance and visual attention on the main subject.

There are three rules of thumb that affect the actual depth of field: the focal length of the lens, the aperture setting of the lens, and the distance from the camera to the subject. When combined with skill, these three factors allow you to create virtually any focal effect in any picture. Use a very wide-angle lens at a narrow aperture, for example, and you might be able to achieve sharpness from as close as 1 foot to infinity. Use a long telephoto lens and a wide aperture, and the zone of sharpness can be sliced as thin as a few inches. When working close up, depth of field can be as small as the width of a blade of grass.

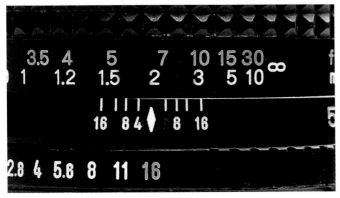

You can set a fixed focal-length lens aperture to attain a set range of sharpness without having to focus the lens visually. You do this by working with the depth-of-field scale on the lens barrel. This lens is set at f/16, and the depth of field is from 5 to 10 feet (above). This 50mm lens (below) offers a minimum aperture of f/22. The lens is set at its hyperfocal distance. Any subject within a range of about 7 feet to infinity will appear sharp. Subjects within that range of distance from the camera will appear sharp on the print even if they do not appear sharp in the viewfinder.

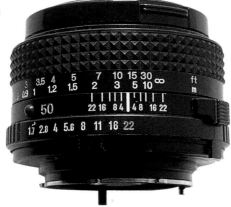

DEPTH-OF-FIELD PREVIEW

One of the handiest functions on an SLR camera is the depth-of-field preview button. As I've mentioned, when you view the subject through the viewfinder you are seeing it at the maximum aperture of the lens, thus the shallowest depth of field of the scene. But the aperture at which you make the picture is, more often than not, narrower than the viewing or maximum aperture. It is this narrower aperture that affects the depth of field. To see this effect before you take the picture, use the depth-of-field preview button. This stops down the lens to the "taking" aperture and lets you see the effect. It really is amazing to be able to see what is sharp and unsharp in the picture before you take it.

Your camera may not have a depth-of-field preview feature. If you are thinking about getting another camera body, make sure it includes this feature. If you don't have depth-of-field preview, just keep in mind that if you follow the guidelines discussed for increasing and decreasing the zone of sharpness, then you can at least get a sense of how to work with sharpness and unsharpness in your pictures.

Another way that you can judge depth of field is to work with the depth-of-field scale on your lens. Again, your lens may not have this feature. In fact, most zoom lenses do not. If you do have this inscribed scale on your lens, here's how it works. Look on the lens barrel and follow the diamond mark to help you determine the focusing distance and the aperture in use. Now look at the depth-of-field scale, which has aperture numbers running left and right from a central mark. Note the distance numbers that sit within the set aperture. This is the depth of field for that scene.

If you have this scale on your lens, you can also work with a focusing technique known as **hyperfocal distance settings,** which is very handy when working with manual-focus cameras. You note the set aperture on the lens, and then move the infinity number to within the outer indication of the set aperture on the depth-of-field scale. You then note the distance that sits within the aperture number on the opposite side of the depth-of-field scale. This is your zone of sharpness in the image. Some photographers set hyperfocal distance and do not even bother focusing the lens when they shoot within the set range. Hyperfocal distance settings can come in handy for photojournalism and for capturing fast action when there is no time to focus.

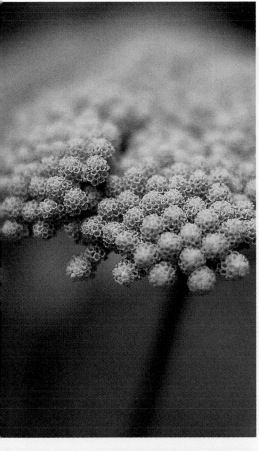

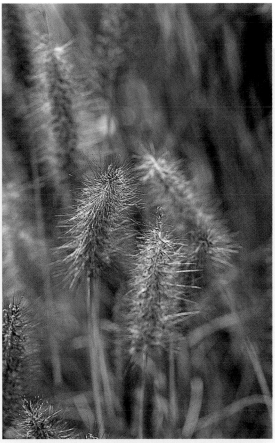

Shallow depth of field is an excellent way to highlight or add dimensionality to foreground subjects and to create painterly backgrounds. The backgrounds can reinforce the subject matter by echoing their pattern and design. Close-up photography often benefits from this effect. Picture these nature studies with every area within the frame sharp. The soft background and at times foreground lends an ethereal, almost abstract quality to these images. This child was photographed with a very wide aperture setting, and thus a very shallow depth of field. This gives the scene a 3D feeling and concentrates attention on the child without the distraction of the background.

Photo of child by Grace Schaub

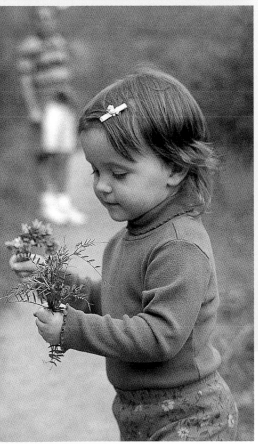

UNDERSTANDING EXPOSURE

As a photographer, when you consider light and exposure, you begin to deal with both the amount and quality of light. The ability to measure *quantity* of light is what allows you to translate light's energy onto film. Being able to perceive the *quality* of light is a photographic way of seeing. It leads you toward an understanding of how light affects subject matter itself, and how it can impart emotion to a photograph. Dealing with light as both a quantity and a quality is an important part of seeing like a photographer. Think of working with light as a blend of science and art. Photography joins these two apparent opposites. It bridges the gap between them by taking principles of light and film interaction and applying them with an appreciation of the way light brings a vital emotional element to images.

In photography, light is measured and controlled with the use of a light-reading instrument known as a light meter. In every modern SLR, the light meter is built into the camera. It reads the amount of light and, in concert with the camera's exposure system, makes settings that coordinate the action of that light upon film.

The meter translates the light energy of a scene into values expressed as *f*-numbers and **shutter speeds.** Aiding in this process are the implements of light control—the aperture and the shutter—and the means by which light is focused and transmitted—the lens. Film holds light's energy as an image. Film as a recording material has a built-in sensitivity to light and a range or scale in which the scene can be recorded.

Even with the most advanced automatic metering systems and films, the delicate balance between light control and light interpretation remains in the hand and eye of the photographer. Human vision is a miraculous thing. Sight is how we understand much of what this world has to teach. It is the sense through which photographers express their feelings and opinions about themselves and the world. Making the transition from seeing something in the world to creating an expressive vision in a photograph is part of the excitement and challenge of photography.

For a photographer, light carries a message. As photographers, we develop a love affair with light. Our study allows us to contemplate its value and virtues, and that process is one of the photography's true joys.

Photography is an appreciation of how the angle of light may hide or enhance a subject's texture, or how the atmosphere through which light travels may change the entire character of a scene. As you gain experience and study other photographers' work, you will gain an emerging understanding of how making a photographic record differs from sharing an interpretation. The goal of understanding exposure is to appreciate the quality of light and to be able to apply that appreciation to making a photograph.

Light informs every photograph we make and is the carrier of our visual message. The way we translate and often enhance light in photographs is through exposure techniques. Using the camera's meter and our intuition and experience we can use the light in each and every scene to our best advantage. Knowledge of exposure technique is essential to creative photography. This rainbow appeared right after a lifting storm. This image was made using automatic exposure with a -1 stop exposure compensation override.
Photo: Grace Schaub).

The light streaming through these trees (upper left) creates a mood and setting unique to the moment and exemplary of the locale. By pointing the camera, thus the meter, up and then recomposing for this framing, the diffuse effect of the light is retained on film. This photo (upper right) of a figure bursting through the water's surface with each droplet of water caught on film, could only be done by using a high shutter speed. This portrait (left) relies both on the way light falls on the subject and the way the light was read by the photographer. Here, the camera, thus the built-in meter, takes the reading from the area on the face where the sun strikes directly. If the shadow area of the subject's hair and face were included in the reading, the golden effect and quality of light might have been lost.

Metering Light Levels

Familiarizing yourself with your camera's exposure system and how it works will give you more creative control over your photography. Before we discuss photographic exposure and coordinating aperture and shutter speed with scene brightness and film speed, let's see how metering systems work.

The basic purpose of a metering system is to translate a scene's brightness values (or its range of light, from bright areas to shadows) into aperture and shutter-speed values. These two values are then converted into actions that determine the size of the lens aperture and the speed with which the shutter travels and allows light to strike the film—the shutter speed. Aperture and shutter speed work together. They are inseparable elements that always accompany exposure.

The metering system responds to light and translates light's value to aperture and shutter speed in the context of the film's sensitivity to light, or its ISO. Either you or the camera can set the ISO when the film is loaded. This calibrates the light meter to the film's light sensitivity. If the ISO were to change, so would the readings indicated by the meter, even though the brightness of the scene you wanted to photograph might remain the same.

When you load a faster film (an ISO 400, for instance, rather than an ISO 100), you are able to work with faster shutter speeds, or narrower apertures. This can be helpful when you wish to achieve certain image effects.

The camera's exposure system has a certain way of reading light, called the metering pattern, and it indicates the area in the viewfinder from which the meter

When a camera's built-in meter "considers" a scene, it does not see subjects or objects, just levels of reflected light that have a certain brightness value. The meter takes in those values and calculates a certain exposure to correctly place the brightness values in the scene as tonal values on the scale of the film's recording range. To get a sense of how this works look at the values ascribed to certain parts of this scene. If you were to point your meter at select portions of this scene (just as if you were using a spot meter) you might well get the readings shown. In this example, we are keeping the shutter speed at 1/125 of a second throughout and using aperture values to describe the light levels. Note how they range from describing the darker (f/4) to the brighter (f/16) parts of the scene. In an averaging metering system the exposure calculations would take in all the values and create an exposure that averages the range. In this scene where we have a range of f/4 to f/16 the reading might be f/8. The progression of f/4, f/5.6, f/8, f/11 and f/16 puts f/8 right in the middle. When f/8 is the exposure the darker areas of the scene, those shown here as f/4, will record as darker values on the film and those at f/16, the brighter areas in the scene, will record as brighter areas on the film. That's a simplified version of how exposure works.

obtains information. This is an important matter and will often determine whether you get good exposures with your camera. In fact, knowing how the metering pattern reads light can give you more control over exposure than you might have imagined possible.

Think of a cub news reporter doing his or her first TV interview. When the reporter asks a question, he/she puts the microphone in front of the subject's face. When the subject responds, the reporter puts the microphone in front of his own face. The sound quality, as you might imagine, isn't too good.

The same goes for making light readings. If you point the camera toward the right place, you'll go a long way toward getting good exposures. If you don't, the camera will not get the right information and your exposure will be thrown off.

Let's say you're taking a picture of a friend standing with her back to a bright sky, and your friend's face is in shadow. If you step back and take a picture of the whole scene, the bright light from the background can throw off the light meter. The result is that on film, your friend's face will be obscured in dark shadow. If, however, you take a meter reading from your friend's face and then make the picture using that setting, you'll get the correct exposure on her face. In many cases, pointing the camera or metering device at the principal subject will go a long way toward getting the right exposure.

Metering patterns help you decide how to best achieve the correct exposure. Metering patterns indicate where the light information in the viewfinder will be read. Most cameras have a center-weighted averaging metering pattern as their sole pattern. This means that the preponderance of information used to calculate the light reading is made from the center of the viewfinder frame (in many cameras the proportion is about 70–30 between the center and edges of the frame). Note the word "averaging." This means that the meter takes in all the light it can from the area where it reads and averages those values to make a reading.

Thus, if it reads some values that are very bright and some that are very dark, the meter will average the two and get a reading. If it reads some light that is bright and some that is slightly less bright, it will do the same. (The average is calibrated to place the reading at the midpoint of the scale between light and dark.)

Just what do we mean by recording range and scale? When we make photographs, we are translating the brightness values in a scene to tonal values on film. Those tonal values represent the brightness values we saw, the range of darks and lights that define our visual picture of things. Think of a musical instrument or a singer's voice. Each has a low and a high note that represents the limits of that instrument's range of expression. We describe photography's limits of expression in

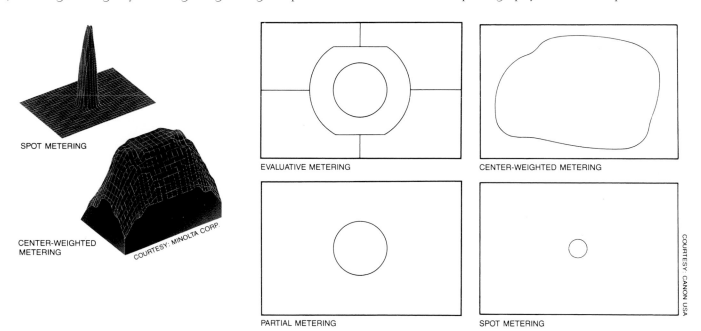

SPOT METERING

CENTER-WEIGHTED METERING

COURTESY: MINOLTA CORP.

EVALUATIVE METERING

CENTER-WEIGHTED METERING

PARTIAL METERING

SPOT METERING

COURTESY: CANON USA

35mm SLR cameras may offer a number of metering patterns, each of which reads light from a certain area of the scene you frame in the viewfinder. Note the areas of coverage in the center-weighted, partial, and spot patterns. Evaluative metering reads from all areas broken down into zones, and then calculates exposure based on complex formulas.

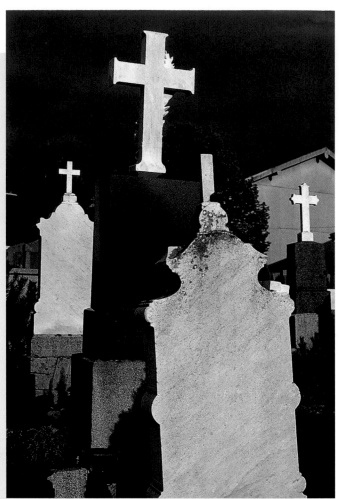

A spot-metering pattern comes in handy when you want to select a portion of the frame on which to base your exposure. Keep in mind that whatever area you read with the spot will be placed at the middle value of the film's recording range. The photo to the right was the result of a spot meter reading on the headstone in the foreground using a telephoto lens. As you gain experience, you can use spot readings to place brightness values at specific areas on the film's recording range. Black-and-white photographers often do this when they work with an exposure technique known as the Zone System. In the photo of the tree (lower right), the shadow areas in the scene are "placed" at Zone 3. This affects all the other tonal values in the scene. You might consider studying the Zone System when you gain more experience in photography. The photo below shows a spot reading made on one of the backlit leaves. This creates a strong contrast because the leaves are the brightest part of the scene, and placing a bright value at the middle of the range makes every other recorded tone darker than that bright value.

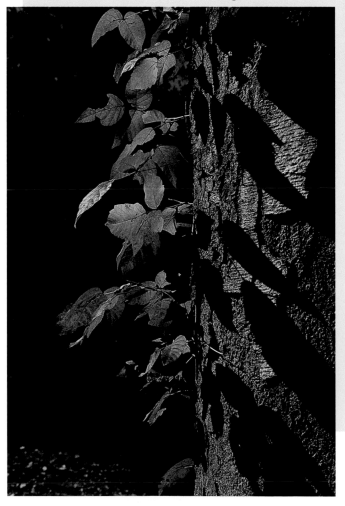

terms of tones rather than octaves. Those tones range from bright white to deep black and all the shades of gray in between. The range of tonal values works with grays instead of color to simplify matters. Think of the grays as reflected light values (bright or dark) rather than actual colors or even objects.

Now think of the range of light that a film can record, from deep shadows to bright light. If you break that up into a number of steps, say ten or eleven, with the first step representing deep black and the last representing bright white, then their average would be a middle gray value, halfway between deep black and bright white. That's what the camera's metering system averages to, a value that sits halfway between bright white and pitch black.

We'll look at instances a little later when you may have to help the camera get the right exposure. In most cases, if you point the camera at the correct part of the scene, the camera's meter will give you a good reading. Now let's discuss some other metering patterns.

Some cameras offer spot metering. This means that light information is read from a very small portion of the frame. The spot indicator may be right in the center of the viewfinder or it may be tied into one of the auto-focus detector sites, or both. In some instances, you can select a spot meter and then tie it to one of those auto-focus sites.

A spot meter comes in handy when you want to read just a portion of the scene and don't want the metering system to average a number of light values. You might want to read certain areas and average them yourself, or you might just be interested in getting that middle gray value on one select subject or area in the frame, such as that friend's portrait against the bright background we discussed earlier.

Another pattern is tied directly into the microprocessor in modern cameras. It may be called evaluative, Matrix, or intelligent metering, depending on the camera brand. This pattern breaks the viewfinder out into zones numbering from five to as many as fifteen. Light is considered from each of these zones, and then the information is fed to a microprocessor. The placement of values is compared with a large number of stored image readings, and the processor comes up with a proper exposure. This amazing piece of technology works most of the time, even in tricky lighting situations.

Why shoot with anything but the computerized exposure control? If you find that this always works for

you and that it expresses just the exposure you desire every time, by all means use it. I can assure you that it will not work exactly as you might like 100 percent or even 80 percent of the time. You may also want the feeling of taking more individual control over your exposures, and that's when center-weighted averaging or spot metering comes into play.

SETTING READINGS

Before we go further, let's make sure we all know how to find out what exposure reading the camera recommends, and how to set it if we are working with a manual-exposure camera. When the camera meter reads light it translates that energy to aperture and shutter speed settings. If you are working with an automatic-exposure camera, the camera will make the settings for you. Once you get the light value (or, as it is sometimes called, the **exposure value, or EV**) you can make the picture at that exposure or change it for other image effects. If you are working with what's called a manual-exposure camera, however, you have to make the settings yourself.

A manual-exposure camera may have a number of ways of indicating what it considers the correct exposure. In the viewfinder you may have a circle on a stick with a floating needle, plus and minus and a zero sign in the middle, or a number that lights up in red or with a bright LED next to it.

Once the camera makes a reading it is up to you to either match the needle with the circle, light up the zero indicator, or line up something that moves with a number or value that has lit up in the finder. You do this by turning either the aperture or shutter-speed dial. This moves the needle or the lights in one direction or another. If you are working in manual exposure mode with an automatic camera, you need to do the same thing. The main task is to match the aperture setting and shutter speed with what the meter reads.

That's all there is to the mechanics of metering. Yet behind the simple mechanics is a whole field of light to consider and how that lights affects your photographic expressions. Photography is a translation of light's amazing energy to film. During the translation we can manipulate light and make it work to serve every image. But before we start making interpretive exposures we should know the basics of what goes into making correct exposures. From there we can play with light as much as we like.

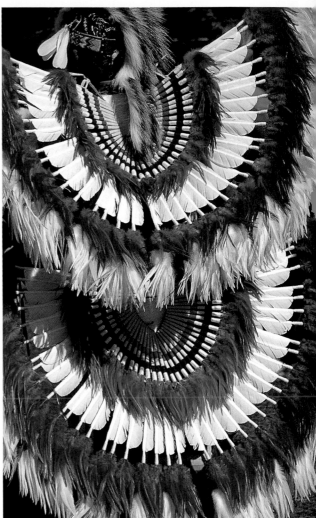

Sometimes making the right exposure reading is as simple as pointing the camera directly at the subject. Other times you might have to point the camera (thus the meter) at the subject, lock the exposure and recompose. The photos directly above and to the right are perfect examples of when you will not have to do anything to get the right exposure with a properly functioning meter and camera. Just point the camera at your subject and let autoexposure do its thing, or set the camera-recommended exposure and release the shutter button. This sunflower (top) is somewhat off center. If you were working with a center-weighted averaging metering system, you would place the flower at the center of the frame, make and lock a reading, and then recompose as desired.

Brightness Value

When you make an exposure, the brightness of light is harnessed to create a visual impression within the recording range of the film. Light can be dim, bright, or diffuse. It makes no difference to the camera's eye or to the film. This does not mean that the mood created by that light, its context and emotional value, has no influence on the recorded image. Quite the opposite. It often has everything to do with the creation of an effective photograph.

To the camera and, to an extent, to the clinical eye of the photographer, the crucial matter is how the light records. And when we talk about scene brightness we are not just talking about an average between light and dark, although that's what the metering system often calculates. One of the most important aspects of exposure is the scene contrast, or the difference between the brightest and darkest areas in the scene. That contrast, and the way in which it is handled, often determines how the scene will be rendered on film.

The relationship between the lighter and darker parts of the scene can be measured through the use of a light meter. Used properly, the meter will read the differences and allow the photographer to make informed decisions about light and subject rendition.

Therein lies a major difference between the human and photographic eye. The photographic eye makes judgments about brightness values in the context of creating a film record. The human eye considers light and instinctively reacts to changes in brightness values as it scans the scene. When we work with a camera, we tend to analyze light for its qualities and use a light-metering instrument to achieve proper exposure. When we look with our eye we blend the changes in light into a continuum of motion and energy. Our aim is the ability to analyze light so we can make the most of it in our photographs without losing our sense of wonder about it.

AUTOMATION AND EXPOSURE

Automatic exposure control allows us to bridge that gap. Sophisticated metering systems handle the many tasks of setting aperture and shutter speed so that the photographer is free to deal with image content and meaning. This may, however, lead to the belief that a camera's exposure system will handle every lighting situation and can deliver just what we desire in every

Exposure is often defined as correct or incorrect, according to how well it reproduces the brightness values in the scene on film. If a scene is overexposed, the shadow areas will be visible, but the highlights (brighter areas) will lose texture and detail (left). If a scene is underexposed, the brighter areas will have detail, but we lose detail in the darker areas of the scene (center). A correct exposure is one where tonal values reproduce the scene's detail and brightness values as accurately as possible (right). Of course, the "correct" exposure is not always the best exposure for your creative or expressive needs.

exposure. This is simply not true. There are times when you will need to override the readings recommended by the camera and meter. Failure to do so will result in poor exposures. There are other times when the photographer's creative eye requires that the meter reading be used as only a foundation for other modifications. As we'll see, an appreciation and understanding of the exposure process is key to making expressive photographs.

There are three levels to mastering exposure and metering. The first is knowing how to make a correct exposure to yield images that record as much information in the scene as possible. The next level is knowing when and how to modify the recommended exposure so that you are able to manipulate light for your creative purposes. The third is the ability to predict or previsualize results. **Previsualization** means that you know with a fair degree of accuracy what the image will look like on film and in print when you snap the shutter. It also involves an understanding of what modifications you can make in the printing stage to get the image just the way you want it.

These three steps can change a strict documentation of a scene into something uniquely creative and can lead you into the world of interpretive imaging.

The Stop, or Exposure Value (EV)

The photographic exposure system is based upon a coordinated and elegant system. The basis of this system is what is known as an **exposure value (EV)** or a stop. EV represents a level of light value that halves and doubles with each subsequent and respective step. A stop of light is a measure that is used in defining the difference in ISO numbers, aperture settings, and shut-ter-speed settings. To get a better handle on this, we'll explore each aspect of exposure and see how the coordination takes place.

ISO or Film Speed

We have already discussed film speeds and how ISO numbers work. Keep in mind that the film you load in the camera represents an important facet of exposure control and settings. It is a foundation on which exposure is built. Change film speed and you change the entire exposure equation for any scene.

Remember that each doubling of the ISO number indicates that the film designated by that number is twice as sensitive to light as the previous number in the sequence. An ISO 100 film is twice as fast or light sensitive, than an ISO 50 film and half as light sensitive, or slower than an ISO 200 film.

Shutter Speed and Aperture Values

Shutter speeds indicate the length of time the film is exposed to light and are designated in increments such as 1/60, 1/125, 1/250, and 1/500 of a second. As the numbers in the progression indicate, the amount of time during which light strikes the film is halved with each change. A slower shutter speed, such as 1/60 of a second, allows in twice as much light as the next faster shutter speed, or 1/125 of a second. As the length of time increases, the progression in light amounts remains the same. For example, going from 8 seconds to 16 seconds represents one additional stop of light, just like going from 1/30 of a second to 1/15 of a second.

Aperture values indicate the relative size of the opening of the lens iris when the exposure is made. They are expressed as *f*-numbers or f-stops, arrived at by

ISO SPEEDS

Every film is rated according to its sensitivity to light. As ratings double, the new value indicates twice the sensitivity to light. Halving the rate indicates half the sensitivity to light. ISO ratings can also refer to increases or decreases in stop increments of one-third. The following progression is from slower, or less light-sensitive, films to faster or more light-sensitive film.

Lower Sensitivity ("Slower")					Higher Sensitivity ("Faster")		
25	50	100	200	400	800	1600	3200

A 1/3-stop increment would be, for example,

50	64	80	100

The naked eye would not see these scenes as they have been rendered on film, although the photographic eye did. In each case, the light has been manipulated through exposure to create a mood. This desert landscape (below) was considerably brighter in real life. The exposure was read from the bright sand. This turned the mountains almost black and deepened the sky. (Photo by Grace Schaub) This photo (left) is about painting, not the particular painter. The light was read with a spot meter right off the canvas. This placed the bright reflective surface at the middle of the recording range and caused all the other values to go darker than seen by the eye.

dividing the focal length of the lens (in millimeters) by the diameter of the opening (in millimeters). For example, a lens with a focal length of 110mm with an opening of 10mm is set at *f*/11. An opening diameter of 20mm on the same lens would mean the setting is *f*/5.6. The lower the *f*-number, the wider the opening of the lens and the more light that is let through when an exposure is made. Aperture values are constant for every focal length. In other words, the same amount of light strikes the film with a setting of *f*/8 on a 24mm lens and a 210mm lens.

Apertures follow a typical progression of *f*/2.8, *f*/4, *f*/5.6, *f*/8, etc., with each change in the progression indicating a smaller opening and a halving, or stop, of light. Thus, an aperture setting of *f*/4 represents an exposure that lets in half as much light as *f*/2.8. To find the next aperture in a series, multiply the preceding, or larger, aperture by a factor of 1.4. Aperture values can become confusing because the higher numbers represent a value that allows in less light. In photography, sometimes thinking backwards gets you the right answer. (The reason it works this way is that the numbers are actually fractions or ratios, so a value of 1/4 is greater than a value of 1/16.)

EXPOSURE VALUE

The final link in the chain is the **exposure value (EV)**. The EV is a combination of f-stop and shutter speed that will properly expose a certain speed film. The level of scene brightness measured by the exposure meter dictates this value. Different combinations of f-stop and shutter speed will produce an equivalent EV.

Equivalent exposure means that you can use different combinations of aperture and shutter speed to attain different effects and still get the correct exposure for the scene. These photographs were made from behind a backstop at a baseball game. The exposure as read was *f*/11 at 1/125 of a second. In the top photo, exposure was made at *f*/16 at 1/60 of a second. Note the sharpness from the batter to the outfield and the fence that obstructs the view in the foreground. The exposure was then shifted to *f*/4 at 1/1000 of a second (below). Note the ball frozen right before contact with the bat and the shallow depth of field that makes even the pitcher slightly out of focus. Also note the "fading" of the fence obstruction caused by a very unsharp foreground. Both settings yield the same amount of light but completely change the image effects.

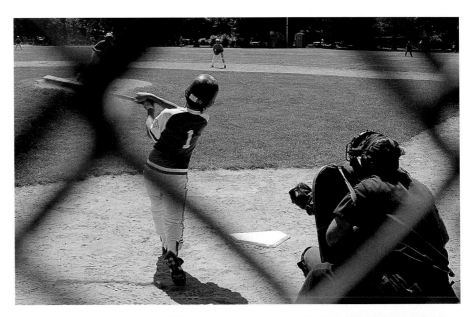

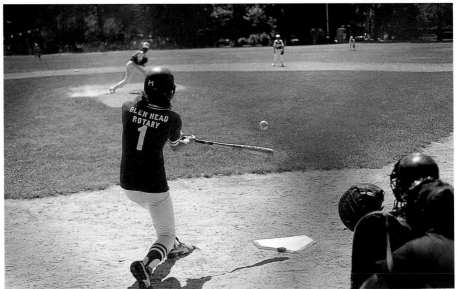

EQUIVALENT EXPOSURE

EV can be explained as a combination of aperture and shutter speed used for a certain speed film. EV is not fixed as one aperture and shutter-speed combination, but is representative of a certain amount of light. This brings us to the concept of equivalent exposures.

Equivalent exposures allow us to arrive at the same exposure (to allow in the same amount of light) while using various combinations of aperture and shutter speed. We juggle these two factors in order to get different image effects. We may want to use very fast shutter speeds for freezing action or very slow ones for creating blur. Through the use of different aperture settings, we can control depth of field, the effect of subject sharpness and unsharpness from the actual point of focus within the frame.

You don't need to memorize or even know the various EV ratings, but understanding that you can get the same exposure or amount of light with various combinations of aperture and shutter speed is important.

EV 16 with ISO 100 film, for example, represents a fairly bright scene and may be expressed as *f*/16 at 1/1000 of a second, *f*/11 at 1/2000 of a second, *f*/8 at 1/4000 of a second, and so forth. EV 5 with the same film represents dimmer light and may show settings of *f*/2.8 at 1/4 second or *f*/4 at 1/2 of a second. In each pair, the amount of exposure is the same.

Again, knowing what a particular EV value is will not mean much, but knowing that you can get the same exposure by simultaneously using a wider aperture and increasing shutter or narrowing aperture and decreasing shutter speed is the key to image creativity and control.

EQUIVALENT EXPOSURES

Equivalent exposures represent the same exposure value (EV), or light striking the film, and allow for the juggling of aperture and shutter speed to attain different image effects. The following chart represents a series of equivalent exposures that might occur in two types of lighting conditions, dim and bright light, with ISO 100 film. As we explore the effects of changing aperture and shutter speed, you'll begin to appreciate the importance of being able to get the same exposure using different settings.

DIM LIGHT
In low levels of brightness we might be forced to deal with relatively long shutter speeds. This scale represents an exposure value (EV) of 10:

Aperture	Shutter Speed
f/2.8	1/125
f/4	1/60
f/5.6	1/30
f/8	1/15
f/11	1/8
f/16	1/4
f/22	1/2

At *f*/2.8 we would attain a shallow depth of field and at 1/125 of a second we have a handholdable shutter speed. At *f*/22 we would have greater depth of field, but at 1/2 of a second we would have to steady the camera to ensure a shake-free image.

BRIGHT LIGHT
In bright light we attain faster shutter speeds as we open up the aperture. This chart represents EV 16 with ISO 100 film.

Aperture	Shutter Speed
f/22	1/125
f/16	1/250
f/11	1/500
f/8	1/1000
f/5.6	1/2000
f/4	1/4000
f/2.8	1/8000

At *f*/22 and 1/125 of a second, we would have a deep depth of field and a handholdable shutter speed. At f/2.8 and 1/8000 of a second, we would have shallow depth of field and action-stopping shutter speed.

Equivalent Exposure Applied

Let's explore two examples of when you might choose an equivalent exposure to handle a particular type of image. Suppose we are photographing sports and want to freeze the movement of the athlete. This requires a fast shutter speed, one that captures a thin slice of time.

The automatic exposure system in the camera cannot know what we want to do with the light. It just reads out suggested exposure values to properly record the light in the scene. The reading the camera yields when you activate the meter is *f*/16 at 1/250 of a second. We know that we want a faster shutter speed to freeze the action, about 1/2000 of a second. By setting the aperture at *f*/5.6 (a change of three stops), the same light level now reads *f*/5.6 at 1/2000 of a second, fast enough to freeze the motion of a speedy runner.

Conversely, we may be photographing in a dimly lit forest and want to render a flowing stream as a continuous sheet rather than splashing drops. We activate the meter and the camera yields *f*/2.8 at 1/125 of a second.

To get the smooth flow, we want to shoot at 1/8 of a second. Here we'd stop down (or close the aperture) to *f*/11, and the equivalent exposure yields our desired 1/8 of a second reading. In both exposure options, the amount of light striking the film is the same. What we have done is juggle the two light-controlling variables, aperture and shutter speed, to get just the result we want. There are times when we want to control focusing effects as well, and this is when the change in aperture values comes into play.

Thus, exposure is a sort of balancing act. The brightness values in the scene are read by a meter that translates the light into lens-opening and shutter-speed values. This exposure delivers the right amount of light to render the scene properly on a recording material with a certain sensitivity to light. It is up to us to determine how we want to juggle those two values to get just the rendition of the scene we desire. We can also alter those values to affect the color and intensity of light we record. This system is at the heart of photography and opens the doors to creative picture control.

In program mode, the camera will select the appropriate aperture and shutter speed for a correct exposure. This mode is fine for snapshot photography, but it does not allow you to make creative decisions. In the photo on the left, the camera is set at program mode, and although the exposure is correct, the juggling pins are blurred. With program shift mode you can shift the program mode's equivalent exposure to favor a fast shutter speed, such as 1/500 of a second, which freezes the pins in mid air. Or, you can switch to shutter-priority exposure mode and set the shutter speed at 1/500 of a second, and the exposure system will find the aperture for correct exposure. You can define how every scene should look using equivalent exposures and your creative input.

Contrast

Contrast is the difference between the lightest and darkest parts of a scene. In a portrait, it is the difference between the light and dark side of a face. In a landscape, it is the difference between the bright white clouds and the dark forest. When you think about contrast, always relate it to the entire range of brightness levels in the frame. It may be bright outside, but if your subject sits in the shadows of a building, then relate to the contrast in the framed scene and not what might surround it.

THE IMPORTANCE OF SEEING CONTRAST VALUES

Contrast affects how we are able to record a scene. Appreciating contrast allows us to make the most out of every lighting condition we might encounter. In some cases, we might want to render the contrast in a scene on film just as we saw it. But we can also enhance contrast for a more graphic rendition. If we are photographing desert formations in bright light, for example, we can use exposure techniques to enhance contrast, which will make the darker areas of the scene darker still.

There are numerous exposure and lab techniques that enhance or mute scene contrast and that allow us to manipulate light to our best advantage. Even with all these techniques at our disposal, the first step in managing, manipulating, and in some cases enhancing contrast in our photographs is seeing contrast as a certain range of brightness values. As you photograph, you'll begin to see that dealing with contrast is one of the most important aspects of making effective images.

For example, let's say we're out in the desert and have very deep shadows and bright light overhead. Experience will show you that to try to hold onto detail in both those deep shadows and bright highlights is difficult, if not impossible, on film. In essence, the film's recording range cannot handle it. You might get details in the shadows, but the brighter parts of the scene might become overexposed. You might also get rich highlight detail, but the shadows will become very dark and lose detail.

In high-contrast lighting conditions, we have a number of choices. We can choose not to take the picture. That's not a good solution, so we can also turn a tough situation to our advantage and meter right off the brighter areas of the scene. This places the brighter areas and puts them at the middle range of the film. If we make something bright appear darker on film, those areas in the scene that are dark will go darker still. That means we'll have a well-exposed bright area and a very deep shadow, a graphic approach to the situation.

Another option is to use fill flash, a topic we cover in our flash section. Fill flash supplies more light to the shadow area and lowers the contrast of the scene. This assumes that our subject is close enough to be covered by the flash. Another approach is open to photographers who develop their own black-and-white film and work with a custom photo lab. When working with negative film in high-contrast scenes, you can average exposure between the highlight and shadow, or read the shadow area and subtract two stops of light and then reduce the film developing time by 20 percent. This ensures that the shadow area will be recorded on film while taming the highlights. This is an advanced technique that you might not use until later in your photo explorations. I mention it here so you can sense how much control you can have over light in photography.

Contrast consciousness applies to every type of subject and scene. Let's say we have a bright light on one side of a subject's face while the other side is in shadow. If we take a reading from the shadow side, we bring that darker area to middle range and make the bright areas very bright on film. Remember that all these tonal values work in lock step. If we overexpose the brighter side too much, we will lose detail in that area. But what happens if we make an exposure reading from the brighter part of the face? The bright area goes to middle range on film and the dark area loses detail. This is when making decisions about exposure and working with contrast link up. Such situations also bring to the fore the way these exposure decisions affect how you render subjects and scenes. Exposure is both clinical and aesthetic. It all works together.

The decision is yours. Those choices influence what you record on film. Again, how you work determines what you get. Experiment with light and exposure and judge for yourself what works best in different lighting conditions with different types of subjects.

The way you handle contrast can make a big difference in the success of your photographs. In most scenes contrast is not excessive, so you can rely on your camera's exposure system to give you a good reading (below). But when contrast is high, your attention to how the light falls and how you will read it is important. In this portrait (right) a sliver of light falls on the side of the subject's face. An exposure reading was made only from the where the light fell. If a reading had been made of the entire scene, the whole mood would have been lost. Contrast and color are what make this autumn scene (lower right) work. By exposing for the brighter parts of the scene and allowing the darker parts to stay in deeper shadow, the contrast is enhanced along with the color and design.

Exposure Modes

Your camera offers a number of ways for you to work with automatic exposure control. These are called autoexposure modes. Each allows you to choose how you want to make the camera react to a scene or situation. In a sense, by setting a certain autoexposure mode, you are making the camera analyze a scene much as you might if you were working manually.

One mode almost every camera has, and the one that is probably best to avoid when learning about photography, is program mode (P). When you set P for program, you are giving up virtually all decision-making power over aperture and shutter-speed settings. True, the camera will choose what it considers to be a correct exposure for the scene, but it does so without regard to how you want to affect depth of field or depict motion. Program mode is fine for making snapshots at a party or other event where you are using the SLR like a point-and-shoot camera. It is not recommended for anyone who wants to exercise their photographic knowledge, and it is certainly not good for learning the craft. Think of P mode as a functional mode for snapshot pictures.

There are variations on P that do allow you more control over what you might like to do with a scene and subject. These modes are called pictograph, or picture modes. These modes are often indicated on your control dial as icons such as a cameo of a face, a flower, a mountain, or even the international Olympic symbol for a runner. Each indicates a picture scenario: the runner is for capturing fast action, the mountain is for landscapes, and the face is for portraits. When you select one of these picture modes, the exposure system reads the light as usual, but prioritizes aperture or shutter speed to help you attain the image effect you select.

For example, let's select the runner. The exposure system reads the light and uses equivalent exposures to come up with an exposure that favors a fast shutter speed over a narrow aperture. Say the exposure value is such that the metering system can send a signal for either 1/60 of a second at *f*/8 or 1/250 of a second at *f*/4. When the runner or action exposure mode is selected, the system will select the latter.

Let's say you are taking a landscape photograph and you select the mountain symbol, or landscape mode. The system will then prioritize a narrow aperture to get you a deep depth of field. So if the EV can be 1/30 of a second at *f*/11 or 1/250 at *f*/4, it will choose the former.

Some picture mode solutions are not so obvious. For example, in portrait mode, the program will choose a wide aperture and a faster shutter speed. The same goes for macro mode (usually indicated by a flower). Night sync mode is used in conjunction with flash. Here, the exposure system selects a slow shutter speed with flash to add more ambient light to the flash scene. We cover this in more detail in the section on flashes.

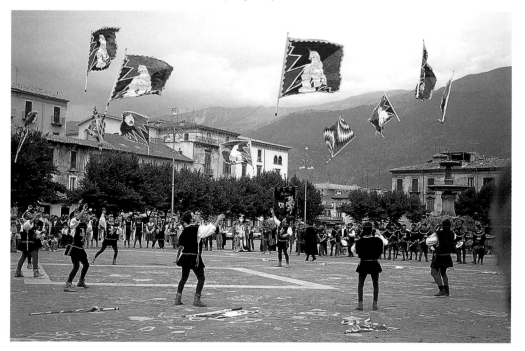

Choose an exposure mode to match the desired image effect. These flags are caught in midair because the exposure mode was set to shutter priority and the shutter speed to 1/500 of a second. This insured an action-stopping shutter speed. The exposure system automatically chose the aperture for correct exposure.

Setting the camera at aperture priority exposure mode and the aperture at *f/22* ensured that this landscape would be sharp from foreground to infinity. In general, use TV for action photos and AV for landscape work.

There are three modes that work best for those who want more control over their photography or who simply want to avoid using the picture modes: aperture-priority mode, shutter-priority mode, and manual-exposure mode. In actuality, all you need is one mode, as all the others follow along.

When you are working in aperture-priority exposure mode, you select the aperture you want to work with and the camera selects the shutter speed for you. Conversely, when you work in shutter-priority exposure mode, you select the shutter speed and the camera automatically selects the aperture. In both cases you have control over the image effect that is most important to you—the depth of field or the recording of motion—and the camera selects the other exposure factor to solve the exposure equation.

For example, say you are at a sports event and want to freeze the action. You want a fast shutter speed. Set the camera to TV, or time value (shutter priority) exposure mode, set the shutter speed to 1/1000 of a second or faster and shoot away. In some cases, when the light is low, you may set the shutter speed to 1/1000 of a second and the camera will indicate a "LOW" or "ERROR" signal or may not allow you to take the picture. What the system is telling you is that even though you'd like to work at 1/1000 of a second, you don't have enough light to do so. The system has tried to get light from the aperture, but even with the lens wide open, there's still not enough for a good exposure.

In that case, you have to do one of two things. One is to back off from the fast shutter speed and drop it back to 1/500 or 1/250 of a second or less to get rid of the error message. Or, you can raise the sensitivity of the film by changing from the film you have loaded in your camera to a faster one. This may get you the extra stops of light you need.

The same may occur in aperture priority. Say you want to make a picture in low light with an aperture of f/16 to get a deep zone of sharpness. When you make the reading, the camera gives you a low-light warning signal, or shows you that the shutter speed will drop to 1/4 of a second. In that case, you can choose to work with a faster film, back off a bit and open the lens wider, or mount the camera on a tripod or other steadying device and photograph at the slow shutter speed. Keep in mind that you can photograph at very slow speeds, but that to get shake-free pictures you need to keep the camera very steady when working at or below 1/30 of a second.

Choose manual exposure mode when you want to make the exposure settings yourself. You still rely on the camera exposure meter to provide you with recommended readings, but you turn the aperture and shutter input dials or rings and dials yourself. This may seem like a strange thing to do, given the fact that exposure automation is available. There may be times, however, when you want to change the exposure slightly or when you want to consider the effect of aperture change as you turn the aperture ring and activate the depth-of-field preview button.

Working manually also eliminates the need for use of the **autoexposure lock (AEL)** function because whatever you set manually will stay set, regardless of how you change the camera's point of view or how the light changes. Professional photographers switch back and forth between manual and autoexposure modes all the time. They use manual when they want to tweak exposures as they work and auto when they need to work fast.

AUTOEXPOSURE LOCK

We have discussed backlit exposures, and how to take a light reading off the main subject and back off for the picture. When working in autoexposure mode, the easiest way to hold an exposure reading and change composition is with the AEL button. This handy button is usually close to the exposure controls. Some AEL buttons require you to keep pressure on them to keep the reading while other, more practical designs allow you to depress it once to set it until you expose the frame.

When working in an automatic exposure mode, the AEL, or auto-exposure lock, comes in handy. It allows you to lock exposure on an area and then recompose. The exposure reading of this jug was made with a center-weighted metering pattern. The reading was made by moving to the side and placing the brighter area right in the middle of the finder. The reading was then locked using the AEL function. The picture was then recomposed and the shutter released.
Photo by Grace Schaub.

You can use an exposure lock button if you are photographing a sunset and want to enhance the rich colors in the sky without regard for the detail on the horizon. If you average the two values—the sunset being much brighter than the ground—the colors may not be as rich. If you point the camera at the sky, however, you are placing that bright value at middle range and enriching the colors, albeit at the expense of detail on the ground. You want to retain the horizon and ground for orientation and scale in the image though, so your final composition is different than your "reading" view. This is when you lock exposure. You point the camera toward the sky, lock exposure, then recompose. To see the difference between the two readings, try it yourself. Read the sky, then read the sky and ground.

There are times when you might want to lock in

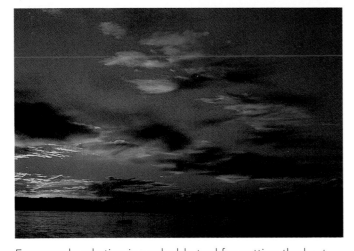

Exposure bracketing is a valuable tool for getting the best exposure in tricky lighting situations. These two slides of a sunset were made about 10 seconds apart. The difference is two stops of bracketing. The top photo was exposed at f/11 at 1/60 of a second and the one below it at f/11 at 1/250 of a second. Bracketing also helps reveal the exposure latitude and behavior of films. Use it to test how films will react to under- or overexposure.

shadow-area exposures as well, such as a scene in which your subject is strongly backlit. You can also lock in exposure to saturate colors, deepen shadows, or eliminate a bright, overcast sky. When you work with exposure lock, always remember the metering pattern you have set on your camera. That way you'll know the source of your light information and how to keep it as the foundation for your exposure.

EXPOSURE LATITUDE

One of the major factors in your ability to record scene detail is the film's exposure latitude. Exposure latitude defines the amount of over- or underexposure that a film can tolerate and still deliver a printable image or usable slide. Of course, correct exposure is always best, and an image that is extremely under- or overexposed will never yield a good picture. Exposure latitude, however, is a forgiveness factor that makes photography easier.

Latitude is indicated by the number of f-stops above or below ("plus" or "minus") the correct exposure that will still deliver a usable image. Generally, with negative film, there's more leeway on the overexposed (plus) than the underexposed (minus) side. Slide films offer a narrow exposure latitude of plus or minus one stop beyond the correct exposure. Some modern color-negative films have a five-stop latitude at +3/-2 stops; black-and-white negative film offers about the same range

If you exceed the latitude limits of your film, your pictures will lose detail and color fidelity. An underexposed image will not show much detail in the darker areas of the scene, will have poor or muddy color, and will appear grainy when a print is made or the slide is examined. Overexposure causes a loss of highlight detail, poor color, and a generally burnt-up looking image. Both over- and underexposed images will be difficult to print.

Film Tests

A simple test helps you verify a particular film's exposure latitude and gives you a good indication of how that film will behave under certain lighting conditions. Work outdoors on a sunny day, and compose a scene with a variety of bright and dark values. Choose a typical scene, but don't photograph an extremely high-contrast situation. Make a careful exposure reading of the scene, then manually add and subtract exposure by one-stop steps. When you get the film back, look at your prints or slides and see the exposure deviation at which the brighter areas in the scene overexpose, or burn up, and at what exposure deviation shadow-detail disappears. In negative film, shadow-area detail is gone

when the film is clear; clear film on a slide indicates unacceptable overexposure. Extremely dense areas in a negative film indicate overexposure. Although detail may be present, these very dense areas will be difficult to print. Extreme density on a slide indicates unacceptable underexposure.

The deviation on the plus and minus sides indicates the material's true exposure latitude. As you'll see, exposure miscues on negative film can be corrected when not extreme. The latitude should be judged as the point at which practical procedures verge into impractical manipulation and when any attempt to fix the image becomes an arduous task. If you work in a darkroom or with film scanned for use in the digital desktop darkroom, or if you work with a professional photo lab, you can save many poorly exposed images, but that should be a last resort.

EXPOSURE BRACKETING

Careful exposure will normally yield very satisfactory results. There are times, however, when the light is tricky and even the most experienced photographer may be unsure of the best exposure. This may occur in night photography, when there is a subtle differentiation of tone (such as white on white), or when there's only one chance to capture the fleeting glory of a scene, such as a fast-disappearing rainbow. That's when a technique known as bracketing comes into play.

You can try bracketing with virtually any scene. Sunsets are a very good subject because they clearly show the effects of more or less exposure in the sequence. You might also try bracketing on scenes with high contrast, bright colors, and with portraits. As you work, you'll see how different exposures can render entirely different interpretations of a subject or scene.

Bracketing means making a series of exposures to let in more light (plus bracket) and less light (minus exposure) than the recommended reading when photographing the same scene. A typical bracketing sequence of three shots might be normal (the meter-recommended reading), plus one stop and minus one stop. To translate this to aperture settings (with the shutter set at one speed), the readings might be f/8, f/5.6, and f/11. Bracketing can be done using the aperture ring on the lens, the command dial that handles the aperture changes, or, if working with shutter-speed brackets, the shutter speed dial or command ring that handles shutter-speed changes.

Some cameras have an automatic exposure bracketing (AEB) mode. This sets up a bracketing sequence that is executed by maintaining pressure on the shutter-release button throughout the plus and minus set. If you want to bracket with apertures, set the camera to shutter-priority exposure mode. If you want to bracket with shutter speed, bracket with the camera set to aperture-priority mode.

Slide films are normally bracketed in partial stops, while negative films (color and black and white) may require a full stop of bracketing to show any real change in the image recording. Often, the subtle changes sought with bracketing can be accomplished in the printing stage of negative films; slide films are subject to bracketing techniques more often than negative films.

Bracketing is a time-honored practice among photographers who know that it can often save the day. Professionals often use the technique to ensure that they get just the right effect in their work. The extra film expense is offset by the confidence that bracketing in tough lighting conditions affords.

EXPOSURE COMPENSATION

Because the light meter averages values to the middle of the film's recording range, certain subjects and lighting conditions require intervention to obtain their correct rendition on film. For example, if reading a snow-covered field on a bright sunny day, the metering system will place those bright white values at the middle of the recording range of the film and the resulting image will be a poor rendition of the dazzling scene. That's when **exposure compensation** comes into play.

There are four lighting situations when exposure compensation is helpful, if not necessary. All of these conditions assume that the subject and light sit within your composed frame. Compensation should be applied when a bright or a dark field dominates, when a dark subject stands before a bright background, and when a bright subject stands in front of a dark background. In the last two instances, compensation is not required when the reading is made selectively from the foreground subject.

Exposure compensation is also a quick way to change the overall feeling of light or color in a scene. When you want to saturate an already rich color, use autoexposure, compensate "minus," and take away anywhere from 1/3 to a full EV of light. (Set the exposure compensation at -0.3 or -1EV). If you have a scene with light tones and want to make it a high-key rendition, use exposure compensation to add light to the scene (+2/3 or +1/5 EV).

Exposure compensation is both a corrective and creative tool that helps make the most out of a camera's autoexposure modes. Use it to help the camera meter in situations where it fails situations and as a way to add an extra personal exposure touch to any scene.

EXPOSURE COMPENSATION

For general guidelines, note the lighting conditions and the compensation required for them in the accompanying table. This gives a starting point for exposure compensations; experience will fine tune these modifications.

Lighting condition	Compensation
Bright field (bright snow, reflective sand)	+1 to +1.5 stops
Dark field (deep woods, black wall)	-1 to -1.5 stops
•Backlight (Subject in shadow, bright background)	+1 to +1.5 stops
•Dark surround (Bright subject, dark background)	-1 to -1.5 stops
Reading directly off the main subject eliminates the need for compensation	

Exposure can be used to document as much of the detail in a scene as the film can record, to enhance color and form, and even to show only selected portions of a scene. In this photograph, exposure plays a vital part in communicating the mood of the moment. Exposure always plays a supporting role in photography, but without study and attention to its nuances, we will not be able to get the most out of our photographic endeavors. Here, the scene was intentionally underexposed for dramatic effect.

The in-camera meter places the averaged or read value at middle gray. In most cases, this helps us get good exposures. Understanding how the meter behaves allows us to previsualize results in all cases. We should also understand that there are times when the meter will fail and will render subjects and scenes poorly. One such instance is with "bright dominance" scenes, such as a bright sun shining on snow. An unaltered meter reading (left) gives us gray snow and makes everything else quite dark. Compensating by +1.5 EV (right) records the snow as bright and opens up the darker areas.

CREATIVE POSSIBILITIES

Once you've begun to work on the basic and some of the advanced techniques with your SLR, it's time to stretch out and begin to experiment and explore. Your camera may have custom functions that allow you to set up the operation of the camera and its functions to your liking. You can also begin to think about new lenses you'd like to try or ways of making pictures that you never thought you could accomplish before. The best thing you can do is to start making pictures, to choose themes and ideas that will spark your imagination and get you into action. That's the best way to learn about photography. Get yourself some film, load up your camera, and start making pictures.

As you do, keep in mind that you can take 36 exposures on every roll and that each frame represents an opportunity to learn. Use different exposure modes and bracketing techniques, and make your pictures from various points of view. Don't feel that every frame has to be a keeper. As you try out different techniques, you'll find some work better than others, and that some are truer expressions of the way you see than others. It's a good idea to emulate other photographers when you start out. That way you learn about the craft. But as you gain experience, you'll find yourself making your own choices about subject matter and applied technique.

Your camera may become a steady companion as you travel near and far in this world. Take the time to understand how it works and how to apply technique, and your photographic experience will be that much more rewarding. Always keep in mind that photography is a blend of art and science, but don't let the technique overcome the art.

Photography can become a way for you to express yourself artistically, to create a legacy for your family, and even a way to earn income. However you approach or use it, remember that in a photograph you are "writing with light." Always keep that small miracle in mind as you work and play.

MOTION AND TIME

Shutter speed is one of the mediators of exposure. The speed at which an exposure is made can be thought of as a slice of time, with faster speeds taking thinner slices. While life consists of motion and energy, the camera makes it all into a still life. Even the motion and blur of slower shutter speeds freeze time, albeit in a more abstract form. Very slow shutter speeds create continuums, visual Doppler effects, lines out of points, and often cause a distortion of time and space that may in some way cut closer to the heart of existence than

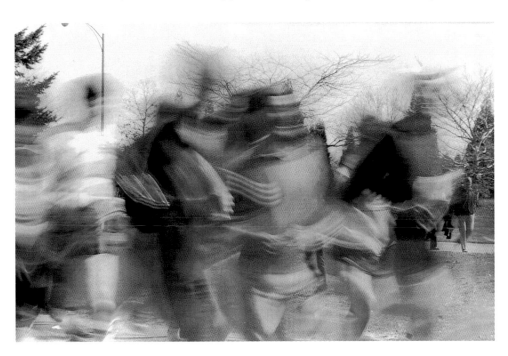

Playing with slow shutter speeds can yield some very interesting effects and unpredictable forms. This photograph was made at the starting line of a marathon race at 1/2 of a second. The camera was mounted on a tripod, as you can tell from the steady and focused trees in the background. The human forms change and elongate through the long exposure time.

those moments frozen at 1/1000 of a second. Very fast speeds capture the impending or completed gesture. We are never sure which; in every picture ever taken, some action we cannot see followed that which was captured on film. A diver caught in midair always splashes into the water, the runner whose foot never seems to fall cannot forever defy gravity.

When to choose a fast or slow shutter speed depends upon subject matter and point of view. For example, if you were taking pictures of a marathon, fast shutter speeds would show the individual runners as they go by. A slow shutter speed, such as 1/8 of a second, would show the blur of motion and form created by the racers. Pictures of flowing water are greatly affected by shutter speed. At 1/1000 of a second, individual droplets show (with the quick burst of light from a flash, the effect would be even more startling). At 1/4 of a second, the water might look more like a silken sheet.

When working with slow shutter speeds, a tripod or some other steadying device precludes camera shake. A pan-head on that tripod allows for another slow shutter-speed technique called panning along, or following with, the subject as it moves through space. This effect yields a "frozen" subject against a moving background. The shutter speed you use depends on how long the subject needs to be followed and what effect you are after. Any speed faster than 1/2 of a second may make the technique moot. Speeds slower than three seconds (a long time in photography), may cause exposure difficulties without the use of very slow-speed film.

When panning, the mirror in the camera blocks the viewfinder, meaning the subject needs be viewed over the top of the camera. Panning with a hand-held camera will cause the subject to become distorted along with the background blur. This approach can be just as much fun as working with a tripod.

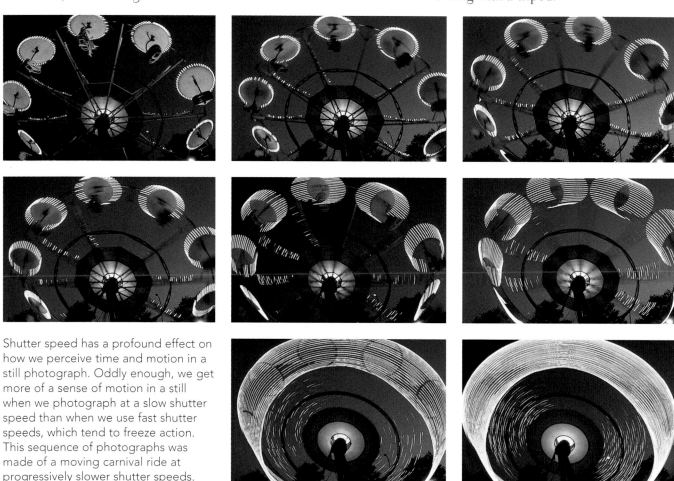

Shutter speed has a profound effect on how we perceive time and motion in a still photograph. Oddly enough, we get more of a sense of motion in a still when we photograph at a slow shutter speed than when we use fast shutter speeds, which tend to freeze action. This sequence of photographs was made of a moving carnival ride at progressively slower shutter speeds. The camera was mounted on a tripod to ensure a steady photograph. The exposure mode was automatic-shutter priority. The progression is from 1/30 of a second to 4 seconds. Note how points of light become lines and how form shifts as the exposure time increases.

FOREGROUND AND BACKGROUND

The eye is naturally attracted to the main subject in a scene, almost to the exclusion of everything else. This visual instinct allows us to focus upon prey, danger, or whatever our object of desire might be at the moment. The camera, however, sees more than the main subject. It captures the periphery, the surroundings, and makes it all part of its visual frame.

The increased automation of today's cameras may actually compound the eye's natural lack of attention to what surrounds the subject; autoexposure, autofocus, and zoom lens framing all make for very spontaneous work. While spontaneity has its rewards, some consideration should be given to what effect the *background* has upon the subject. Backgrounds can add contrast, color, sharpness/unsharpness, and can reinforce shadows.

One of the main techniques for play between foreground and background is creative use of depth of field. As we've discussed, depth of field is influenced by the distance from the camera to the subject, the aperture in use, and the focal length of the lens on the camera.

Subject placement is a major element in all this. Consider a portrait subject in front of a busy background. Your first thought might be to get closer to crop out the background, but further consideration may reveal that having the subject sharp and the background soft is more effective. When you are framing shots and thinking about depth of field for such compositions, consider the scene through the viewfinder at the lens's maximum aperture and its taking aperture. You might want to try a shallow depth of field obtained by working with a wider aperture or by incorporating the background into the context of the portrait through sharpness.

Shadows, color contrast, and line play are also important matters to consider in scene backgrounds. Subjects can be blended or offset through your consideration of the exposure and placement of background elements. Shadows help define form and inform us about the character and direction of the ambient light. Colors can blend or clash, and the harmony or dissonance of the colors in the foreground and background can be a very effective visual tool. Lines and patterns are also key background elements because they can reinforce the subject or make it stand out.

The relationship of colors within a scene can create different visual stimuli that relies on harmonies, dissonance, and other subtle effects. The colorful background of these posters in the late-day sun made a great setting; these strollers gave even more color to the scene.

The separation between the foreground and background in this essentially monochrome study is made by hints of shadow and edge, as well as by the slight touch of color. Without those elements, what might have been a flat and featureless picture has subtle shape and form.

Depth-of-field techniques are an excellent way to separate and/or blend foreground and background. This magnolia blossom was photographed at sunset using a 210mm lens set at f/5.6 and 1/125 of a second. The very shallow depth of field created a painterly background and made a color "blob" out of the sun.

The relationship of foreground to background color here creates a certain harmony that brings this scene together. Photo by Grace Schaub

This monochrome scheme also creates a certain blending of this desert scene. The darker background edge creates the border for the foreground plant.

EXPOSURE CHOICES

There is a "correct" exposure that is usually defined as that which makes the photograph resemble the original scene. In most cases, this is the exposure we strive for. But we can also choose to make a visual interpretation of a scene by consciously eliminating some of its potential tonal information for a more graphic or emotional effect. Certainly, many photographs go through an interpretive phase in the darkroom or when converted to a binary image and worked in the digital darkroom, but you can also do this right in the camera.

One such creative choice is in making silhouettes. For example, in a sunset scene, the quality of light in the sky is generally the reason we want to take the picture and is usually more important than the figures or subjects in the foreground. A "correct," full-scale exposure would attempt to get detail in all parts of the scene, the sunset sky and the foreground subject. If that's what we want or have to do, we can do so using a fill-flash technique. But we can also use that foreground element as a symbol or a form to break up the continuous expanse of the sky. It can also provide a sense of scale and place in the scene.

A silhouette is a creative use of backlighting that is, in essence, the underexposure of a foreground object that creates a graphic frame or pattern in order to add visual interest to a scene. Silhouettes can be used as "drapery," a way to break up a blank sky or edge the main subject, or they can be used as graphic reinforcement of the scene context, such as a bent tree on the edge of a canyon. Often, the silhouette is used as a graphic element to break up a flat field. It provides scale and perspective that would otherwise be lacking in the scene. Use depth-of-field techniques to keep the silhouette sharp,; unsharpness may be distracting and can detract from the visual cohesion of foreground and background.

The easiest way to expose for a silhouette effect is to make a background and foreground reading. If the difference is greater than three stops, then scene contrast is high enough to cause the foreground to lose detail. Exposure should then be made solely for the background, ignoring the foreground reading in exposure calculations. Because the silhouetted object will be dark throughout a range of exposures, manipulation of the background reading for different effects can be done with ease.

The way you position the silhouetted object yields different visual effects. Place it to the side and it gives scale and a graphic reinforcement of the scene. Center it, and it will dominate the field of view, with the background providing a context for its form. Place the silhouette on the edge, and it can serve as "marginalia" for the frame, a decorative approach that can both reinforce the main subject and enhance what might otherwise be weak or unattractive edges.

There are two stages to image creation. One is exposure, and the other is printing. The way we expose and print, or have prints made, has a profound effect on the way the image is perceived. The way the photo on the left was exposed and printed is effective visually, but it becomes more expressive when printed darker, as in the print on the right.

Some scenes does not exist in nature. Exposure and camera placement—the photographer's point of view—can change the feeling of the time of day, the intensity of color and light, and can even exchange a real subject for an abstract form. Making these decisions is part of what makes photography so exciting. Understanding how and when they work best is gained through experience and developing a photographic eye.

These two photographs were made in the same location, a slot canyon in California. On one side of the canyon wall, the subjects sat in shade; on the other, the sun filled the rock with light. Each side had different lighting and presented different exposure possibilities. The photo on the left (above) was made in the shade. We see all the details in the tree and canyon wall. In the photo on the right (above), the tree has become a silhouette and lends us its form rather than its detail. On the left, exposure was read from the canyon wall; in the other photo, a reading was made of the entire scene.

Silhouettes are easy to create. Identify a lighting condition where the foreground is at least three stops darker than the background, base your reading solely on the background light, and compose the foreground as you would a sculpture defining a space.

Shadows help define space and form and give us a way to add dimensionality to a scene. When working with shadows, you may have to choose between showing detail in the shadow or using it as a graphic exclamation point in the scene. When you see a deep shadow, compose with it in mind. This photograph exploits a deep shadow rendition in its composition. Exposure was read from the brighter parts of the scene, ignoring the shadow. This ensured that the shadow area recorded very dark.

MOOD LIGHTING

Like music, photography has its moods and modalities. Because we can manipulate light, and because we have an infinite range of subject matter and lighting conditions available to us, our ability to enhance content through interpretative techniques seems limitless. One way to play with the mood of light is to work with something referred to as mixed light. This means that you include light sources with different color temperatures in the same scene or, more simply, daylight and artificial light. Because film "sees" correct color in daylight, not using filters or not using tungsten-balanced specialty films means that the light will record in a fashion other than you might have seen with your eyes. Experience will guide you in how successfully this will actually work out, but experimentation is also fun.

Another way you can approach light is to seek images that offer **high-key** and **low-key** moods. High key emphasizes the brighter moods of light, the light grays and whites, and the lighter shades of color. Low key is more somber and works in the shadows and dark areas of the spectrum and tones. When matched with the appropriate subject matter, the moods can make a profound difference on the effect of the image.

While the actual character of light and the subject in the scene itself will determine which way to go, exposure manipulation is critical to making the most out of the key effects. For high-key renditions, slight overexposure (+1/2 stop on slide film, +1 stop on negative film) will usually do the trick. Excessive overexposure will result in harsh images and will raise contrast to undesirable levels.

For low-key images, slight underexposure on slide film (-1/2 to -1 stop, depending on the scene) is best. When going for low-key effects using negative film, normal exposure is best, with low-key effects applied in the printing stage.

These visual moods have more to do with the overall effect than with contrast. A high-contrast scene is one in which there is a big difference between the dark and light tonal values, while a high-key photograph may, in fact, be quite flat, having low contrast overall.

Working with mixed light exploits the way different light sources record on film. This marina is illuminated by neon, streetlights, incandescent bulbs, fluorescent lights, and even a touch of light from an on-camera flash.

High key is a general description of images that work with lighter tones. Often, adding exposure to the camera's recommended reading enhances the effect. In this scene, an additional stop of exposure was added.

Low-key images communicate mood through a more somber or deep tonal scale. Taking away some exposure from the camera's recommended reading often enhances this effect. This photograph received a -1 EV exposure compensation. Learn to recognize potential opportunities for creating high- and low-key renditions and bracket exposures to get a sense of how much compensation you will need in different lighting conditions.

THE SKY AND NATURAL LIGHT

The sky is filled with infinite and glorious displays, with every color, shade, and mood imaginable. While our interests are generally more earthbound, most photographers cannot avoid pointing the camera skyward when a particularly spectacular event occurs. Too often, however, the resulting images can be disappointing and don't come close to capturing the energy and power seen through the viewfinder.

How you handle sky pictures depends upon the medium on which you record the scene. With slide film, the initial exposure is paramount, as any loss of tone or color intensity in exposure cannot be recaptured later. In general, slight underexposure will yield the best results. If the subject is a sunset or a rainbow, you should bracket exposures downward from the meter reading, starting at -1/2 or 1/3 stop to a full stop compensation. If the sky is dark and overcast, going down as much as -1.5 stops in the bracket works best.

Using negative film to photograph sky presents a different situation. Here, the problem is more with the printing of the image than with the exposure. Aim the meter or camera at the sky and expose at the recommended reading. Make your prints darker than normal. This technique assures that subtle details will be recorded and that mood or intensity is added in the final stage of the image's realization. When you bring your film to the photo lab, mention that you would like all the sky photographs to be printed darker. A second trip to the counter may then be unnecessary.

The best time for photographing sunsets is right after the sun dips below the horizon. Pointing the camera at the sun before it has set results in substantial underexposure of all the different tonal effects visible in the sky and may also injure your eyes. Direct rays from the sun will also cause flare, which is a ghost image caused by the light reflecting off the sides of the lens and the glass.

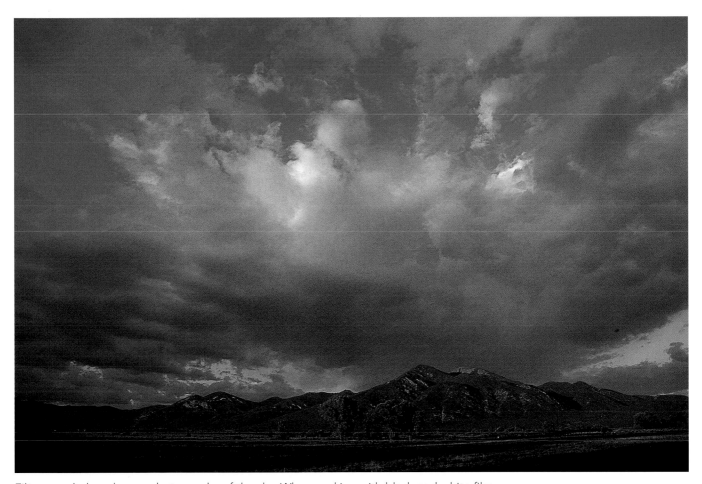

Filters can help enhance photographs of the sky. When working with black-and-white film, use a yellow, orange, or red filter to deepen the blue and the drama. Polarizing filters are also great sky enhancers. When making photographs in which the sky is the subject, make your reading from the sky itself. Lock the exposure, and then recompose to include some of the horizon. When you expose for the sky, make some insurance images by bracketing.

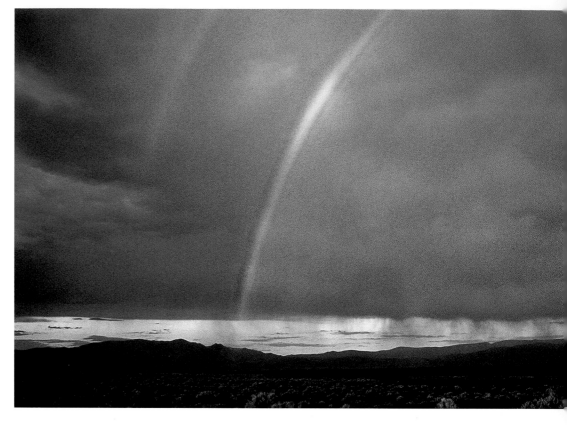

Capturing rainbows on film is a matter of luck and timing. They generally form against a darker sky when light steaks across the horizon. It is a good idea to subtract a stop using exposure compensation or manual overrides because the meter has a tendency to lighten the scene when pointed at such a dark field. Compensating by -1 EV gets you just the right exposure.
Photo by Grace Schaub

NIGHT AND LOW-LIGHT PHOTOGRAPHY

Photography does not stop when the lights are low or when the sun goes down. Even without flash or fast films, slow shutter speeds and the use of a tripod allow for a wide range of picture-taking opportunities in even the dimmest light. The key to low-light shooting is knowing when to shoot and how to read the light to capture the most detail in a scene.

Your first instinct might be to work with the fastest film available in any low-light situation. That is wise for hand-held shooting, when shutter speed is limited by the danger of camera-shake. When using a tripod or some other steadying technique, however, you can use the slowest shutter speed your camera offers.

The sensitivity of some films does change at very slow shutter speeds. Known as reciprocity law failure, these films may require more exposure time than usual for proper exposure. For example, say a film behaves correctly when exposed in a range of 1/10,000 of a second to one second. If exposure time is two seconds or more, an exposure factor might have to be applied. In some cases, a correct exposure for a reading of two seconds might actually be four seconds or more. If you pursue night and low-light photography, it is important to know about the reciprocity factor and the required compensation. This information is available from the film manufac-

turer or searchable on the Internet under "film: technical specifications."

If you are photographing a street scene with street lamps included in the frame, your meter could be thrown off by the brighter lights, causing the rest of the scene to be underexposed. The best course is to read from the principal subject, not from the light source. While any open bulbs will "burn up"—become grossly overexposed—as a result, the main subject of the scene will record properly. The one exception to this rule is when photographing the lights themselves, such as bright displays of neon. In that case, just aim the camera at the lights, make the reading and release the shutter. The artificial lights will record with full color intensity. Because of the big difference in brightness, most other subjects will record with no detail.

In some cases, the best night photography is done right after the sun sets or just before dawn, when just a hint of light begins to fill the sky. This works best with photographs of architecture and skylines, when the city lights are still lit or are just coming on and there is still a bit of trace light filling the sky.

Although weather is uncontrollable, some of the best nighttime street scenes are made after a rain. The street—a sponge for lights—becomes a reflective surface and seems to dance with color. If the pho-

tographs are of neon-lit areas, such as New York's Times Square or the Las Vegas Strip, the play is even greater. Moviemakers often use this trick.

The main challenge of low-light photography is maintaining the mood without losing image information. The techniques you can use to accomplish this depend upon the medium on which the photograph is made. When you shoot with slide film, the best approach is to make a general reading of the scene, then underexpose by a stop. This compensates for the meter's tendency to average to the middle range. For negative film, allow the meter to read the average, then either go with the reading or, with very low light, add an additional stop of exposure. Mood can be altered effectively when the print is made.

Photographing fireworks is a popular form of night photography involving very bright light against a dark background, as well as the study of time and motion. As the rockets and shells burst, they send out streams of color and light. The most effective shots are those that show the dazzling flow of light, rather than only a few puffs of colored smoke in the night sky. Though made at night, fireworks photographs do not necessarily require the use of fast film. Because exposures are quite long, any color film will do. There's no practical way to make exposure readings, as brightness varies with each fusillade, and the duration of each shot will vary according to the length of the fiery trail.

The easiest way to capture the excitement is to mount a camera on a tripod, thus eliminating camera shake, and to set the camera at B, for bulb setting. This setting keeps the shutter open for as long as the shutter release is depressed. Use a cable release to reduce the possibility of camera shake caused by finger pressure or motion during exposure. Set the aperture in accordance with the film you use. For faster films, such as ISO 400 speeds, set it at $f/11$; for slower films, such as ISO 100 or 50, set the aperture at $f/5.6$ or $f/4$, respectively.

Put the camera on manual-exposure mode and set the shutter speed to B. Don't use an automatic exposure mode, as it poses a danger of overexposure. The metering system might read the night sky and stay open longer than required. To ensure a proper exposure, try various aperture settings throughout the event.

Aim the camera at an area of the sky where the most action is occurring, and release the shutter at the moment when the fireworks first light up the sky. Keep the shutter open until the trail has played itself out or whenever the sequence of bursts diminishes. If you want to record multiple bursts, cover the lens with a dark cloth until the next burst sequence begins, then remove it.

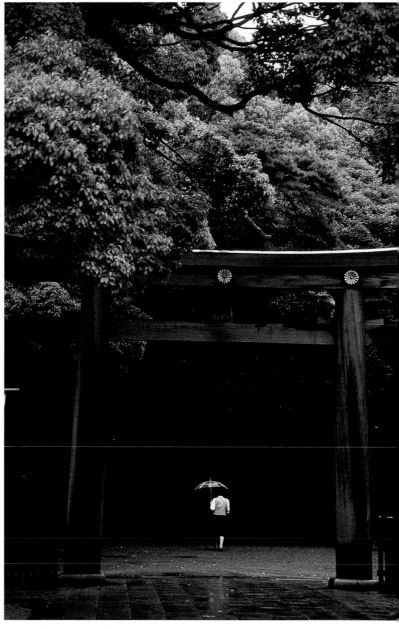

This photograph required timing and special metering techniques. The idea was to make the photograph as the person was right at the edge of light and dark. The first step was making an exposure reading. Pointing the camera straight ahead would have resulted in opening up the shadow area but losing the whole sense of light. I made the reading off the trees at the top of the frame and locked it. I then recomposed the frame and set focus. The shutter was snapped just as the figure was entering the darkness. I could see into the dark area quite well, but didn't want to show any detail there on film. Manipulating the light through tonal placement and exposure reading was the key to this photograph's success.

FLASH PHOTOGRAPHY

Electronic flash works with the same basic exposure principles as natural light. There are many reasons you might use flash. It allows you to shoot in low light, it often gives more control over contrast, and it can be used for many image effects and photographs that would be impossible without it.

Modern flash systems coordinate directly with the camera exposure system and make what was previously a complex process a simple matter. Even without total automation, working with flash is as easy as plugging a few numbers into a basic exposure formula.

Flash can be used indoors and outdoors. Indoors, it brings richer color to interior photographs. Outdoors, it can eliminate backlighting problems and bring color and contrast to dull days. Although flash exposure has been made easier, creating a pleasing light with flash can be more challenging, as the direct, sometimes harsh light of flash is not a very complimentary light source.

Flash is an instantaneous burst of light that ranges in duration from about 1/400 to as fast as 1/1000 of a second. Because of this, shutter speed has no influence on flash exposure. What does control flash exposure is the aperture. The wider the aperture, the more the light from the flash is used in exposure. That's why you should use wider apertures when you want to maximize the distance a flash can cover.

A more powerful flash allows for greater distance coverage and for the use of smaller apertures at greater distances. Say you're photographing a large group of people standing on tiers, and the distance from the front row to the back row is 10 feet. To keep the entire group sharp, a fairly small aperture is required. Thus, a flash with enough power to shoot at *f*/11 is necessary to cover the distance from the camera and flash to the subjects and the required depth of field. As you gain experience, you should consider purchasing an auxiliary flash unit. If you have a built-in flash, you have a good start, as long as you understand that unless you work with very fast film, your flash generally cannot provide coverage for subjects more than 10 feet away.

FLASH MODES

Like exposure modes, flash modes can be used to match subject and lighting conditions. Automatic, or A-TTL flash, is for when you want the exposure system to fully control flash exposure. It works very well in most situations. Slow sync flash mode, used for flash at night and special effects, allows you to set any shutter speed slower than sync speed (or, if automatic, chooses a programmed slow shutter speed). Slow sync is for when you want to record the background light while you add flash exposure to the foreground subject. This is an important technique that we'll explore more fully.

If you can work with the flash off camera using a radio remote, light trigger, or corded flash, you can achieve many different effects with one light. These two photos were made with the flash positioned off-camera and pointed at the subject from different directions.

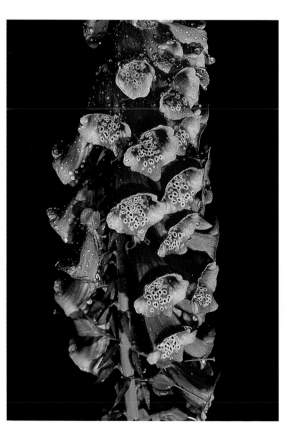

Red-eye reduction mode reduces the flash's harsh glare in subjects' eyes caused by the flash being mounted too close to the axis of the lens (see also diffused flash). This is more of a bother with a flash built into the camera body, but it can occur with shoe-mount flashes under certain conditions. Strobe mode emits a burst of short flashes that create a stroboscopic effect on a subject but is only effective at relatively short distances.

FLASH OUTPUT COMPENSATION

Some automatic flash units feature push-button flash exposure compensation. Like camera exposrue, compensation is a way to modify light. Here, the compensation is applied to the flash output. Sometimes, the full power of the flash can give a harsh, unnatural look to the subject. In other cases, you may want more light from the flash. Compensation can subtract or add exposure to the subject being lit by the flash. With automatic flash units, the range is generally +/- 3 stops in 1/3 EV (stop) steps. Manual flash units have power-ratio controls that allow you to compensate the output by 1/2, 1/4, 1/8 and so forth power. Power-ratio controls are useful when you want to subtract light to avoid overpowering the subject or scene with the flash.

BOUNCE AND DIFFUSED FLASH

Flash is a wonderful ally in low-light situations. That being said, there is nothing less complimentary or more harsh than the direct burst of light emitted by flash. It emits light on a straight line and, in portraits, emphasizes every line and wrinkle on a subject's face.

In large rooms, direct flash tends to isolate the foreground subject against a dark background (though slow sync flash, the next topic, can help solve this problem). In cluttered environments, flash tends to overexpose subjects close to the camera and underexpose those farther away. In some instances, it can cause an effect known as red-eye. The only way to compensate for all of the flash's harsh effects is to diffuse it, either by adding a **diffusion** device over the flash tube or by bouncing the light so that it travels on an indirect rather than a straight path to the subject.

Bounce flash is available in most flash units that mount directly on the camera. You can rotate the head of the flash up to 180 degrees (straight up), rather than be limited by the direct angle from which a standard flash is usually aimed at the subject. When it is angled, the light can bounce off a ceiling or be directed into a bounce card mounted on the flash unit itself. A bounce card is a piece of white cardboard or vinyl that catches the light and redirects it, with greater spread, onto the subject. You can easily buy or make one yourself.

Because the light is being bounced off of another surface, that surface (especially if it is a ceiling) will absorb some of the light's brightness, so you will have to make some compensation in exposure. In some camera systems with TTL flash exposure capability, the metering system may handle the exposure adjustment automatically.

Even with the TTL feature, loss of light means less flash coverage. For example, say the exposure for a subject ten feet away is $f/8$. When the light is bounced off

When you work with flash, you can alter the character and often the sense of the direction of light in a scene. This photograph (left) was made under artificial light in a studio. Note the yellow cast due to working with daylight-balanced film. When flash is used the colors are more natural and details on the feathers are enhanced.

a ceiling, the distance the flash may have to travel may increase to 15 feet or more. At 15 feet, the aperture for correct exposure would be *f*/5.6. Unless the ceiling is glossy, bright white, an extra stop more compensation may be necessary.

If the flash cannot be bounced, apply some diffusion to help soften the light. You can do this with diffusion setups (available commerically) or with a simple translucent cloth tied over the flash head. Lens cleaning paper or facial tissue will do the job also.

SLOW SYNCHRO

Flash sync speed defines the speed at which the flash and shutter act in concert. The speed generally ranges from 1/90 to 1/250 of a second, depending on the camera. Shooting at faster speeds will cause a loss of illumination in part of the frame—the faster the shutter speed, the greater the loss. This does not mean, however, that you cannot use slower speeds; in fact, using slow shutter speeds can be very useful, especially when there is a risk that a full, direct flash will cause a subject to be isolated against a dark background.

Keep in mind that when you are using flash, aperture setting determines flash coverage, while shutter speed controls ambient light exposure. If there is some **ambient light** in a scene, (meaning any light coming from a source other than a flash), using a slow shutter speed will increase the likelihood of that light appearing on film.

For example, let's say your subject is in a street market at night, with colorful stalls and roaming crowds in the background. If you want the exposure just for the foreground, set your shutter speed to sync speed, and set the aperture based on the distance from the flash to the subject. At that aperture, correct exposure for the background scene without flash is 1/4 of a second. To get the best exposure for both, keep the aperture set for foreground flash exposure, but set the shutter speed to 1/4 of a second to bring in the background.

When the shutter speed is that slow, without tripod support your pictures may exhibit the results of camera shake. That shake can be a creative element, or it can be troublesome. Just keep in mind that sync speeds can be as slow as required, and can record even dimly lit backgrounds.

Some 35mm SLR cameras add spice to your lighting possibilities with a feature known as second-curtain sync. In general, a flash fires as soon as the shutter curtain opens, which means that, in slow sync, whatever is occurring at the front end of the exposure will record on film. There may be times, such as with very slow

shutter speeds and slow-motion studies, when it would be better if the flash-burst occurred right before the shutter closed. Second-curtain sync would illuminate a moving subject like a comet, for instance, by activating the flash at the end of the comet's travel in the frame, creating a more logical implied sequence of events, putting the tail at the end of the comet, so to speak.

DAYLIGHT FILL

Using flash outdoors may seem unnecessary, but there are many instances when it serves to resolve contrast problems that would otherwise be difficult or just about impossible to overcome. The human eye has the ability to resolve high-contrast lighting conditions. It constantly scans a scene and, by constricting and dilating the iris, adjusts itself to various levels of brightness. Film cannot adjust itself and has only one exposure setting for a scene. As a scene's light contrast increases, the film's ability to record both the shadows and the bright areas decreases.

This is a classic backlight situation that you see people miss every day, especially if you live in an area populated by tourists. Strong backlight is resolved by adding a burst of light to illuminate the foreground subject. Daylight fill is great for candid photography as well.

Taken at the Easter Parade, this photograph benefits greatly from the use of fill flash. Note how the light from the sun throws shadows toward the camera. That's always a good cue to work with fill flash. Photo by Grace Schaub

Daylight **fill-flash** is the term used to describe the use of a flash outdoors. The technique allows us to add illumination to foreground subjects, thus decreasing the contrast between them and the background and increasing our chances of properly recording both areas on film.

Use daylight fill-flash when a subject wears a broad hat that shadows his or her face; when a subject stands with his or her back to the sun; when a subject stands against a very bright, reflective wall; or a when your subject is in shade with a bright background. Fill flash can be used effectively in landscapes, portraits, still life work, and reportage. Experience will teach you when to use daylight fill.

Most modern SLRs have an automatic fill-flash exposure mode. Many activate this function when you turn on the flash when shooting outdoors. Others require that a fill-flash mode be activated before shooting. This automation is wonderful, but testing is important. You might find, for example, that the amount of fill is too

This beach scene can be rendered using only natural light or by adding a small fill flash "kicker."

much and that it is too obvious that the flash has been used. This can create a false look. Try various flash compensation settings at different camera-to-subject distances.

Even without such automation, it's fairly easy to calculate fill-flash exposure. First, make a reading for the background exposure, setting the shutter speed at the camera's normal flash synchronization speed. You can do this in manual or shutter-priority mode. Note the aperture setting the camera recommends.

Next, find the flash Guide Number, found in its instruction manual, making sure to use the Guide Number specified for the film speed in your camera. Then, use the following formula to determine the flash exposure: GN ÷ distance = f-formula (guide number divided by the distance from the camera to the subject equals aperture setting for correct exposure).

For example, say the reading for the background exposure is f/11 at 1/125 of a second. The guide number of the flash is 88. Divide the guide number (88) by

the aperture (11); this gives you 8 feet, the distance from the camera to the subject at which the flash will give a fill-flash exposure.

Manual flashes usually have a chart on their backs to aid in this calculation. You can calculate the aperture setting for fill flash with any camera-to-subject distance. Keep in mind, however, that that distance is limited by the output of the flash. If flash power is small (a low GN), you will only be able to use daylight fill at narrow apertures at close distances.

Using the GN formula is a good starting point, but using full flash power for daylight fill can sometimes yield an artificial effect. For better results, cut down the flash power by 1/4 or 1/2, or dampen the flash output by placing a diffuser over the flash tube. You can also effectively cut down on the flash output with units that offer a power ratio control or that have flash exposure compensation settings. In general, when working outdoors, take away 1 EV or more, or use 1/2, 1/4 or even 1/16 power on the power ratio control.

BLACK-AND-WHITE PHOTOGRAPHY

Although the vast majority of film used in the world today is color, a dedicated group of photographers still work in black and white. For many of them, photography without black-and-white film and prints would be a much less attractive medium. Black and white is both very familiar and quite abstract. We see black-and-white photographs in the newspapers every day, and many of us have grown up with family albums mainly photographed and printed in black and white. The abstraction of a world without color allows us to see form, texture, and pattern in new ways. And even though it lacks full color, many see black and white as a more gritty, realistic form of expression.

One problem with black and white for many people is getting decent film processing. Most labs concentrate on color and do black and white as an afterthought. That's why many photographers who are dedicated to black and white process their own film. Others only send it to specialized professional labs that are more attentive to black-and-white work.

If you'd like to try black and white, one good alternative is chromogenic film. This film is now readily available from most camera stores and can be processed in color chemistry, in same way as the color film you bring into the corner lab. Although it is processed in color chemistry, it has no color-recording layer, so you can only get monochrome prints from the lab. These prints can be made in any monochrome tint, from sepia to blue, or can be printed in a more neutral grayscale tone.

As you become more involved with photography, try using black-and-white film. It offers many pleasures and visual possibilities. Putting in a roll of black-and-white film may just change the way you see in as dramatic a way as putting a new lens on your camera.

Many photographers have rediscovered the wonderful world of black and white. Black-and-white photography offers an exciting way to look at the world. It deals in texture, tone, and content without the distraction of color. Black and white is a wonderful medium for candids and street photography. It's also a great medium for creating mood through light.

THE DIGITAL DARKROOM

Making prints is part of photography that many people have not been able to enjoy. Color film-developing and printing is a complex task that involves expensive equipment and a good deal of training. Making prints also requires a darkroom space in your home, studio or office, as well as plumbing, special enlargers and a good many accessories to get it right. The **digital** imaging revolution has changed much of that. Now, in the space of a desktop, the whole field of printing your own images is accesible to you. Affordable digital printers produce beautiful photo-quality prints. Getting your images from film to digital form has also never been easier.

The point of digital imaging is not just to produce wacky and wild images, although that's always an option. Digital gives you something that many who have pursued the art and craft of photography have come to understand is very important to their development as photographers: the ability to complete the circle of creating an image by making a print. Unfortunately, because of issues such as budgeting, time, or space, many people have had to surrender this aspect of their work to labs and big industrial complexes, which are often just photo "mills" that churn out indifferent results, at best.

Now, more photographers can begin to become deeply involved in the completion of their vision. And they can do so using papers and inks, and even graphic techniques, that have been lost to traditional photographic processes. The access to such processes that digital imaging has provided is one of the most exciting developments in photography in years.

True, it requires a good investment in time and money to get involved in digital imaging. But many of us already have the equipment, although perhaps without the software. We also now have access to the world through the Internet, which allows us to get information about photography and possibly share our work.

The new possibilities the digital darkroom affords are exciting for both older hands, like myself, and for those new to photography's wonders. Whenever digital imaging is mentioned someone inevitably asks: Is film dead? That question misses the point of digital photography. Photography is not about a particular piece of film or type of camera. It is about the visual instincts of the photographer and how he or she uses tools to create a unique vision of the world. Film, digital, virtual, or real image—the distinctions are of little importance. Photography allows us to explore the world and ourselves and that is something that will always be vital and important.

This faded and yellowed slide was rescued by digitally scanning it and adding blue to it using an image manipulation software program.

The digital darkroom can be used to correct exposure problems, rescue old photographic images from extinction and create new and exciting renditions of your negatives and slides. You can create digital files from your photographs by scanning them yourself or by bringing them into a photo or digital lab to do the work for you. Color was added to this black-and-white image of a cactus right in the computer.

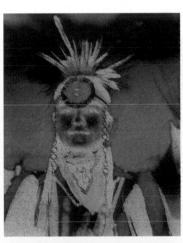

It's easy and fun to create graphic images from your prints and slides. These variations on an image were created by scanning a print into the computer and using image-editing software to make the changes.
Photo by Grace Schaub

GLOSSARY

AMBIENT LIGHT: The light in the scene, as opposed to the light provided by the photographer with flash, photofloods, etc.

ANGLE OF VIEW: The maximum angle a lens covers in the field. Measured in degrees, and qualified by terms such as wide-angle, normal, and telephoto. A wide-angle lens has a wider angle of view than a telephoto lens. A 135mm lens on a 35mm SLR covers an 18-degree angle of view; a 28mm lens covers a 75-degree angle of view.

APERTURE: The opening of a lens, the size of which is controlled by a diaphragm. The term is commonly used to designate f-stops, such as f/4, f/5.6 etc., which are actually arrived at by dividing the focal length of the lens by the diameter of the aperture. Thus, f/11 on a 110mm focal-length lens means the opening is 10mm. The wider the opening, the lower the f-number, and the more light is let through the lens. Each step in aperture represents a halving or doubling of light. Thus, f/8 allows in half as much light as f/5.6, and twice as much light as f/11.

APERTURE PRIORITY MODE: An autoexposure mode in which the aperture is selected and the exposure system selects the appropriate shutter speed for a correct exposure. Sometimes referred to as AV or simply A on exposure mode controls.

ARCHIVAL: Long-lasting. In processing, those procedures that help ensure stability of the image. Also, storage materials that will not damage photographic film and paper.

ARTIFICIAL LIGHT: Any light not directly produced by the sun. Can be tungsten, flash, household bulbs, sodium-vapor street lamps, etc. In many cases, the color produced by artificial light is deficient in the blue end of the spectrum, thus daylight-balanced color films will record the light as being warm/red/amber. Tungsten-balanced slide films or color-balancing filters over the lens will generally correct this problem. In some cases, color print film can be rebalanced when prints are made.

ASPECT RATIO: The relationship of height to width. A 24 x 36mm frame of film has a 2:3 aspect ratio.

AUTOEXPOSURE: A method of exposure where aperture and shutter-speed settings are first read, then set, by the camera's exposure system. Various autoexposure modes allow for customization or biasing the readings.

AUTOEXPOSURE LOCK: A push-button, switch, or lever that locks in exposure after the initial reading has been made, regardless of a change in camera position or light conditions after the lock is activated. Release of the lock button returns the exposure system to normal. Useful for making highlight or shadow readings of select portions of the frame, and an essential feature for critical exposure control with automatic exposure cameras.

AUTOFOCUS: A method of focusing where focusing distances are set automatically. In 35mm SLRs, a passive phase-detection system that compares contrast and edge of subjects within the confines of the autofocus brackets or sites in the viewfinder and automatically sets focusing distance on the lens. Autofocusing motors may be in the camera body or the lens itself. Active IR (infrared) autofocusing systems may also be in 35mm SLRs in the form of beams in dedicated autofocus flash units, or, in a few models, built into the camera itself. These beams are emitted from the camera or flash, bounce off the subject, then return and set focusing range.

AUXILIARY LENS: An add-on optical device that alters the focal length of the prime lens for close-up, telephoto, or other special effects photography. The close-up devices, for example, usually comes in +1, +2, and +3 powers; the higher the number the greater the magnification.

AUXILIARY LIGHT: A flash, strobe, or tungsten lamp or bulbs used to change the character of light in a scene. Any light under the control of the photographer.

AVAILABLE LIGHT: The light that's normal in a scene, although the term is generally used when the light level is low. Available light shooting usually involves fast film, low shutter speeds and apertures, and/or the use of a tripod.

AVERAGING: In light metering, where the light is read from most of the viewfinder frame then averaged to yield an overall, standard exposure for the scene. This setup works fine in normal lighting conditions but may need some additional input when light is flat or contrasty.

B or BULB: A shutter setting that indicates that the shutter will remain open for as long as the shutter release is pressed. The term originated with the rubber bulbs used to operate pneumatic shutters in the old days. B settings are generally used in nighttime and time/motion study photography.

BACKGROUND: The portion of a scene that sits behind the main, foreground subject. The background can be made sharp or unsharp through the use of selective focusing techniques and depth of field manipulation.

BACKLIGHTING: From camera position, light that comes from behind the subject. Usually, a backlit main subject will be underexposed unless the metering system is set to read selectively off the subject, or exposure on a center-weighted meter is compensated accordingly. See also Fill-In Flash. Extreme backlighting can be exploited to create silhouettes.

BATTERY: The power supply of the camera and flash. In many of today's cameras (and certainly in flashes), no power means no pictures.

BLACK-AND-WHITE: A photographic film or paper used to create monochrome images. Though we think of black and white mainly in terms of a grayscale, prints can have a wide variety of subtle tones, from blue- to brown-black and brilliant to creamy white. Though the overwhelming majority of photography today is shot and printed in color, black-and-white has attracted a fiercely loyal and dedicated group of photographers.

BLUR: Unsharpness because of the movement of the camera or subject during exposure. Blur can be used for many creative effects.

BOUNCE LIGHT: In flash photography, directing the burst of light from the flash so it literally bounces off a ceiling, wall, or other surface before it illuminates the subject. This method of flash is often preferred because it softens the overall light and eliminates the harsh, frontal effect of an on-camera, straightforward flash.

BRACKET: Making exposures above and below the "normal" exposure, or overriding the exposure suggested by the camera's autoexposure system. Useful as a fail-safe method for getting "correct" exposure in difficult light-

ing conditions. Bracketing can also be used to make subtle changes in the nuance of tone and light in any scene. With slide film, bracketing will show an effect in 1/3 stop increments; with negative film a full stop of bracketing is advised.

BRIGHTNESS: The luminance of objects. The brightness of any area of the subject is dependent on how much light falls on it and how reflective it is. Brightness range is the relationship we perceive between the light and dark subjects in a scene. Brightness contrast is a judgment of the relative measure of that range, such as high, low, or normal. Brightness values are sometimes referred to as EV (exposure values), a combination of aperture and shutter speed. Brightness values in the scene are translated to tonal values on film.

BURNT-OUT: Term that refers to loss of details in the highlight portion of a scene due to overexposure. With slide film, it might mean that no image detail has been recorded on the film, or that highlights show no texture or tonal information. A highly burnt-out, or burnt-up slide may show clear film base in overexposed areas.

C-41: The current process for all standard color negative films.

CABLE RELEASE: A flexible encased wire attached to a threaded metal coupler that screws into the shutter release button on the camera. When one end of the wire is depressed with a plunger the other end activates the shutter. Electronic cable releases for all-electronic cameras work with electrical impulses rather than mechanical plungers. The two types are incompatible. Useful for long exposures to avoid camera shake and for remote release of the shutter.

CAMERA: A light-tight box containing light sensitive film that is used to make images. Today's cameras incorporate microprocessors and sophisticated exposure systems; in a sense, the instrument itself mirrors the age, just as the pictures it makes reflect the world in which we live.

CENTER-WEIGHTED: In a metering scheme, an exposure system that takes most of its information from the center portion of the frame. Most center-weighted systems also take additional readings from the surround, but weight the reading towards the center.

CHIP: Common name for any computerized part of a camera. Actually a silicon wafer with circuit paths etched or printed in layers.

CHROMA: The color information. Hue, saturation.

CLOSE DOWN: Term that refers to making a photograph with less exposure than previously used. With apertures, using a narrower apertures; with shutter speed, using a faster shutter speed. For example, going from f/8 to f/11 means closing down the lens by one stop.

CLOSE-UP: Any photograph made from a distance that is generally closer than our normal viewing distance. Close-up pictures are often startling in the detail they reveal.

COLD TONE: A print or slide in which the overall color is biased towards blue, although the colors in the image itself don't necessarily have to contain blue. "Cool" or "blue-biased" is also used to describe this cast, or tendency.

COLOR BALANCE: The color balance of a film refers to the kind of light under which it will faithfully render color without the need for filters. Most films are daylight-balanced, which means that in daylight, or with a daylight balanced flash, colors will be true. A tungsten-balanced film can be used under certain types of artificial light to give true colors without filters or special printing techniques.

COLOR COUPLER: A colorless substance contained in color film emulsions. When film is developed the couplers form the color dyes in layers that combine to create a color image.

COLOR NEGATIVE FILM: A film that forms a photographic image in which light tones are rendered dark (and vice versa) and colors are reproduced as their complements (such as blue being recorded as yellow). These negative tones and colors are then reversed in printing to form a positive record. Color negative film has an orange mask (an aid to printing), so may be difficult to "read." Color negative film comes in a range of speeds (ISO), or sensitivities to light. Each speed of film has its uses and characteristics that can be matched to particular shooting needs.

COLOR TEMPERATURE: The Kelvin scale, rated in degrees. It is used as a standard for balancing daylight films (approximately 5500 degrees K) and tungsten-balanced film (approximately 3200 degrees K.) Color conditions that vary from the standards will create a color cast in photographs made with these films, e.g., a daylight film used with artificial light will record with an amber cast; a tungsten film used outdoors will record with a blue cast.

COMPOSITION: The arrangement of subject matter, graphic elements, tones, and light in a scene. Can be harmonious or discordant, depending on the photographer, his or her mood, the subject at hand and the expressive requirements of the scene. There are no set rules of composition, just suggestions. Successful compositions are those that visually express particular feelings about a subject or scene.

CONTACT PRINT: A print made the same size as the negative.

CONTINUOUS: In motorized-advance cameras, the mode which allows for continuous firing without lifting the finder from the release button. In autofocusing SLRs, the mode in which the camera focuses continually as the subject is tracked. In continuous mode, the camera will fire regardless of whether the subject is or is not in focus. In tonality, a smooth range of tones from black to white.

CONTRAST: The relationship between the lightest and darkest areas in a scene and/or photograph. A small difference means low contrast; a great difference high contrast. High contrast scenes usually cause the most exposure problems; however, their difficulty often holds greater potential for expression. Although contrast is often linked with scene brightness, there can be low contrast in a bright scene and high contrast in dim light. Contrast can also describe attributes of color, composition, and inherent qualities of film.

CONTRAST GRADE: In black-and-white printing, an indication of the contrast rendition the paper will yield. #0 and #1 are low contrast; #4 and #5 are high contrast. The "normal" contrast grade is #2.

CONVERSION FILTER: A filter that allows daylight film to record color faithfully in artificial light or, conversely, for tungsten-balanced film in daylight. For example, orange conversion filters are used when exposing tungsten-balanced films in daylight, bluish filters for daylight-balanced films in tungsten light. Most useful with slide films, as color negative imbalances can usually be corrected when prints are made.

CORRECT EXPOSURE: The combination of aperture and shutter speed that best emulates the light values in scene as tonal values on film. The constants in any given exposure calculation are the speed of the film and the brightness of the scene; the variables are the aperture and shutter speed.

CROP: To select a portion of the full-frame image as the final picture. Cropping is done in the darkroom or computer environment by the photographer, or in a commercial photo lab.

DAYLIGHT-BALANCED: A film that will reproduce colors faithfully when exposed in daylight.

DEDICATED FLASH: A flash that coordinates with the camera's exposure, and sometimes focusing systems. Dedicated flashes may, among other things, read the loaded film's ISO, set the camera shutter speed to X-sync, and "tell" the camera when it's ready to fire. Flashes dedicated to autofocusing cameras may also vary their angle of flash throw according to the lens in use (even with zoom lenses), and contain autofocus beams that aid focusing in very dim light or even total darkness. For outdoor work, dedicated flashes may provide totally automatic daylight fill-flash exposure.

DENSITY: In general terms, the measure of the light-gathering power of silver or dye deposits in film. Also, the build-up of silver that creates the image in film and paper. A "dense" negative or slide is more opaque than a "thin" one. There is an ideal density for film, one that yields good prints or slides. Too little density usually means that a negative film was underexposed (or underdeveloped), too much means its been overexposed (or overdeveloped).

DEPTH OF FIELD: The zone, or range of distances within a scene that will record on film as sharp. Depth of field is influenced by the focal length of the lens in use, the f-number setting on the lens, and the distance from the camera to the subject. It can be shallow or deep, and can be totally controlled by the photographer. It is one of the most creative effects available to photographers.

DEPTH-OF-FIELD PREVIEW BUTTON: A switch, button, or electronic push-button that allows for preview of the depth of field of the set aperture in the viewfinder. During composition the lens is wide open, thus the depth of field in the viewfinder is always that of the maximum aperture of the lens. DOF preview is very useful for critical selective focus shots. Although some rightfully consider it no more than an approximation, others feel that an SLR lacking a depth-of-field preview function is greatly diminished as a creative tool.

DEVELOPING: A series of chemical and physical actions that converts light-struck film to an image that can be viewed directly or printed; making prints from negatives.

DIAPHRAGM: A set of blades or plates in the lens. By varying the diameter of the opening more or less light is let through. Also referred to as an iris diaphragm.

DIFFUSION: The spreading of light in various directions as it passes through a translucent material or is reflected from a surface. Diffusion filters can be added to a lens. The light coming through the trees in the early morning fog.

DIGITAL: Information used by the computer, represented by numbers. The buzzword for any capture device that converts photons to electrons. The use of that information to store, manipulate, transmit or output images in a computer environment. As opposed to analog.

DISTORTION: Any changing of line, form, or even light by photographic materials, such as lenses, films, or filters. Although most manufacturers do all they can to eliminate distortion from lenses, most photographers take the "if you can't beat 'em, join 'em" approach and exploit it wherever they find it. Distortion can be bothersome or used as part of visual expression.

DODGING: In conventional or digital printing and image manipulation, the select reduction of density in certain areas of the scene.

DX-CODING: A system of film cassette coding and in-camera pins that informs the camera's exposure system that a specific speed and exposure length film is loaded. Most modern 35mm cameras and films have this feature.

DYNAMIC RANGE: The ability of a film to record a range of light. Negative films have a wider dynamic range than slide films.

E-6 PROCESSING: The current developing process for the majority of today's color slide films. The term also refers to films developed by this process, such as E-6 type films.

18% GRAY CARD: A neutral-color cardboard used as the standard for medium tones when making reflected (in-camera) light readings. This card reflects about 18-percent of the light striking it, which is about the same as that of the "normal" photographic scene with a distribution of light and dark tones and colors. Most exposure meters are calibrated using this card.

ELECTRONIC FLASH: Known as a flash gun, strobe, or speedlight, it consists of a gas-filled tube that is fired by an electrical charge. It can be mounted directly on the camera hot shoe (which links the shutter firing to the flash firing), or on a bracket or stand and be connected to the camera via a sync cord or radio remote.

EMULSION: Used alternately with film. It refers to the sensitized coating on the acetate film base. Emulsions consist of light-sensitive silver salts, color couplers, filters, and other layers that work together to both protect and form the actual photographic image on film.

ENLARGEMENT: Making a print from a negative or slide; generally, making a print larger than standard size, such as an 8 x 10-inch or bigger "blow-up" from 35mm film.

EQUIVALENT EXPOSURE: Recording the same amount of light, even though aperture and shutter speeds have shifted. For example, an exposure of f/11 at 1/125 of a second is equivalent to an exposure of f/8 at 1/250 of a second.

EXPOSURE: The amount of light that enters the lens and strikes the film. Exposures are broken down into aperture, which is the diameter of the opening of the lens, and shutter speed, which is the amount of time the light strikes the film. Thus, exposure is a combination of the intensity and duration of light. Often referred to as an EV or exposure value.

EXPOSURE COMPENSATION: A camera function that allows for overriding the automatic exposure reading. The bias, or shift can be in full or partial stops. This is used in difficult lighting conditions, when the reflective meter might fail (dark or bright dominance), or for deliberate under- or overexposure of a scene. Can also be used for bracketing exposures.

EXPOSURE LATITUDE: The range of under- and overexposure in which a satisfactory image will be produced on a particular type of film.

EXPOSURE METERS: Light reading instruments that yield signals that are translated to f-stops and shutter speeds. Reflected-light meters read light reflected off the subject; incident meters reads light falling upon the subject. All in-camera meters are of the reflected-light type.

EV NUMBERS: A way of expressing light intensity, or value, that can be used to describe average scene brightness, a specific light value within that scene or a combination of apertures and shutter speeds that will correctly expose a certain scene with a certain speed film. For example, EV 15 with ISO 100 film might mean 1/1000 of a second at f/5.6, or 1/500 second at f/8, and so forth. EV numbers are also used to express a meter's or autofocusing mechanism's range of sensitivity to light.

F-NUMBERS: A series of numbers designating the apertures, or openings at which a lens is set. The higher the number, the narrower the aperture. For example, f/16 is narrower (by one stop) than f/11—it lets in half as much light. An f-number range might be f/2.8, f/4, f/5.6, f/8, f/11...To find the next aperture in a narrowing series, multiply by 1.4. F-numbers are arrived at by dividing the diameter of the

opening into the focal length of the lens, thus a 10mm diameter opening on a 110mm lens is *f*/11. Alternately used with f-stops.

FAST: A term used to describe a film with a relatively high light sensitivity, a lens with a relatively wide maximum aperture, or a shutter speed, such as 1/1000 of a second, that will freeze quick action.

FILL-IN FLASH: Flash used outdoors, generally to balance the contrast on a subject that is backlit. Can also be used to add light to shadows, or brighten colors on an overcast day.

FILTERS: Any transparent accessory added to the light path that alters the character of the passing light. With film, filters can alter contrast, color rendition, or the character of the light itself (diffusion, diffraction, etc.)

FILM: A compilation of light sensitive silver salts, color couplers (in color film), and other materials suspended in an emulsion and coated on an acetate base. The storehouse of our visions, dreams and legacy.

FINE GRAIN: Usually found in slow speed films, a fine-grained image is one where the medium of light capture and storage, the silver halide grain, is virtually invisible in the print or slide. With high, or coarse grain films (usually very high speed films) the texture of the grain becomes part of the physical reality, or weave of the image.

FIXER: The third step in black-and-white print and film processing; the bath removes unexposed silver halides. The discovery of a fixer led to the invention of photography. Previous to its discovery and use silver-halide images would turn black on exposure to light.

FLARE: In lenses, internal reflections and/or stray light that can cause fogging or light streak marks on film. In general, zoom lenses have more potential for flare than fixed-focal-length lenses. A lens hood helps reduce the problem.

FLASH: The common term used to describe light produced by passing electrical current through gas in a glass tube.

FLAT: Low in contrast, usually caused by underexposure or underdevelopment of film. Flat light shows no change in brightness value throughout the entire scene.

FOCAL LENGTH: The distance from the lens to the film plane that focuses light at infinity. The length, expressed in millimeters, is more useful as an indication of the angle of view of a particular lens. A shorter focal length lens, such as a 28mm, offers a wider angle of view than a longer one, such as 100mm.

FOCUS: Causing light to form a point, or sharp image.

FOCUS LOCK: In autofocus camera systems, a button, lever, or push-button control that locks focus at a particular distance setting, often used when the main subject is off to the side of the frame or not covered by the autofocus brackets in the viewfinder.

FORMAT: The size of the film, thus the camera that uses such film.

FRAME: The outer borders of a picture, or its ratio of the height to width. The individual image on a roll of film. Also, to compose a picture.

FRAMING RATE: The speed at which the shutter is fired. Expressed as frames-per-second (fps). The number of frames that can be exposed in one second.

GRAIN: The appearance or echoes of the silver crystals in film in the final negative or positive image. The larger the area of the grain in the film emulsion, the more sensitive the film is to light; the more sensitive it is to light the "faster" it is. Larger grains are manifest in the image as mottled or salt-and-pepper clumps of light and dark tones, usually apparent in very fast films on visual inspection, in slow films upon extreme magnification. Grain is most easily seen as non-uniform density in areas sharing the same tone (such as a gray sky.)

GRAYSCALE: The range and separation of tones, from pure white to pitch black that can be reproduced in a film and print.

GROUND GLASS: A specially prepared glass used as the focusing screen in cameras.

GUIDE NUMBER: A number that helps define the output of electronic flash when used with a particular speed film. The higher the guide number, the more the light output. Guide numbers, or GN, serve as a way to calculate aperture when shooting flash in manual exposure mode. Dividing distance into guide number gives the aperture. For example, a flash with a guide number of 56 (with ISO 100 film) would give a correct exposure at 10 feet with an aperture of *f*/5.6. With advances in today's automatic exposure systems and flash technology, guide numbers are more useful for comparing the relative power of one flash to another.

HIGH CONTRAST: A scene where the range between the brightest and darkest areas is extreme, or is such that it may cause exposure problems. A film that renders scenes in high-contrast fashion. The absence of middle grays.

HIGH KEY: An image that relies on the lighter shades of gray or pale colors for its effect, or one that is deliberately overexposed to yield an ethereal look. Often used in fashion, glamour, nature and portrait photography.

HIGHLIGHTS: The brightest parts of a scene that yield texture or image information. With slide film, it's best to bias expose for the highlights, as overexposure of bright areas will yield a burnt-out look. A spectral highlight is pure light and will print as "paper" white.

HOT: Very intense colors. High color saturation. Also, highly reflective surfaces that can cause exposure problems on film; any overexposed highlights.

HOT SHOE: The mount on the camera body in which electronic flashes are secured. Hot shoes usually contain electrical contact points that signal the flash to discharge when the shutter is fired.

HYPERFOCAL DISTANCE: The nearest point in the scene which is in focus when the lens is focused at infinity. This distance changes according to the focal length of the lens and the aperture at which it is set. Setting a lens at its hyperfocal distance allows for maximum depth of field when photographing near-to-far scenes.

IMAGE: A fancy word for picture.

INFINITY: On a camera-lens distance scale, the distance greater than the last finite number, and beyond.

INFRARED FILM: Film which is highly sensitive to red/near infrared radiation. A red filter should be used to get the best effect with this film.

ISO NUMBER: A prefix on film speed ratings that stands for International Standards Organization, the group that standardizes, among other things, the figures that define the relative speed of films.

LATENT IMAGE: The invisible image that is formed when the silver halide compounds in film are struck by light. Upon development, this image is made visible.

LENS: A combination of shaped glasses and air spaces set in a specific arrangement within a barrel. Within the lens is a diaphragm that can be opened and closed to allow in specific amounts of light. This is controlled manually by a ring on the outside of the lens barrel, or electronically via pins in the coupling ring that mounts the lens to the camera. Lenses have two primary functions: one is to focus light with as little distortion or aberration as possible

on to film. Focusing is accomplished by changing the relationship of the elements in the lens to the film plane. The other function is to control the amount of light hitting the film by use of the lens aperture. Autofocusing lenses may contain small motors for racking the lens back and forth in response to changes dictated by the camera's autofocusing system.

LENS COATING: A thin layer of transparent material applied to glass surfaces in a lens to control light reflections, reduce flare, and increase image contrast.

LOW KEY: A scene with no bright tones or highlights. Usually imparts a somber, moody feeling.

LUMINANCE: The brightness of a scene.

MACRO: Another word for close-up photography, but specifically referring to taking pictures at or near life-size. Can be defined as a ratio; for example, a 1:2 ratio means that the image on film is half-life-size of the object in nature.

MANUAL EXPOSURE MODE: An exposure "mode" where the exposure system recommends a setting that is then made by the photographer by selecting aperture and shutter speeds manually. The booklet one doesn't read before shooting three or four rolls of film with a new camera.

MAXIMUM APERTURE: The widest opening or f-stop a lens affords. An $f/1.4$ lens is referred to as fast because it has a relatively wide maximum aperture; an $f/4.5$ lens is slow because of its relatively narrow maximum aperture. Fast lenses come in handy for hand held low-light photography.

MENU: The available tools, functions and commands in a camera's program.

MINIMUM APERTURE: The smallest opening a lens affords. Generally, wide-angle lenses have a minimum aperture of $f/22$; normal lenses of $f/16$; and telephoto lenses of $f/32$.

MIRROR LENS: A lens where the light path is bent and reflected internally to increase the focal length of the lens; a simplified system that is usually less expensive than conventional super-telephoto (300mm and up) lenses and generally of considerably lower optical quality.

MODE: A way of doing things. Exposure modes are preprogrammed, user-selectable ways of controlling the readings to meet certain subject or picture conditions. These include aperture-priority mode, shutter-priority mode, program-action mode, etc. Autofocusing modes allow a choice of how the camera/lens will go about autofocusing.

MOUNT: In lenses, a specific set of pins and cams that couple a particular lens to a particular camera body.

NEGATIVE: An image where the tones (recorded brightness values) and, with color film, the colors are reverse of those in the scene. When printed, the negative becomes "positive."

OVEREXPOSURE: When too much light strikes the film for a proper rendition of the scene. Minor overexposure may cause a loss of details or texture in the scene highlights; severe overexposure will cause a serious deterioration of picture quality in color and black-and-white print film, and a complete loss of picture information with slide films.

OVERRIDES: Making adjustments or intervening to change the camera's autoexposure system reading. Some overrides include exposure compensation and changing ISO ratings.

PANNING: A shooting technique where the subject is followed during exposure; generally done with a slow shutter speed.

PERSPECTIVE: The relationship of objects near and far, or impression of depth when a three-dimensional scene is rendered on a 2-dimensional plane.

PHOTOFINISHING: Generally, mass-production that involves processing and printing film, although custom labs and mini-labs are also in the photofinishing business.

PHOTOGRAPHY: Writing with light.

POLARIZING FILTER: A filter that transmits light waves vibrating in one direction, used to deepen blue sky with color film, tame contrast in very bright scenes, and to "see" through reflective surfaces, such as water and glass.

POSITIVE: Another word for slide, as is "transparency." Also, a print from a negative.

PREVISUALIZATION: A thought process that helps a photographer "see" what the photograph will look like on film, and/or a print, before exposure and while the picture is being composed.

PROGRAM EXPOSURE MODE: A preset arrangement of aperture and shutter speed that is programmed into the exposure system of a camera to respond to a certain level of brightness when the camera is loaded with a certain speed of film. Custom program modes include landscape mode (sometimes referred to as program depth) which chooses a higher aperture at the expense of shutter speed in the exposure equation. Program tele (or action) chooses a higher shutter speed at the expense of aperture. Program normal, or simply program, makes all the decisions about aperture and shutter speed settings.

REFLECTED LIGHT METER: A meter that reads light reflected from the subject. All in-camera meters are of this type.

REFLEX VIEWING SYSTEM: A system of mirrors in an SLR that makes the scene right-reading in the camera's eye-level viewfinder.

SATURATION: In color, a vividness, or intensity. Some films have more inherent color saturation than others. Saturation can be slightly increased by moderate underexposure of certain slide films. Saturation can be increased in color negative film by moderate overexposure.

SELECTIVE FOCUS: The creative use of focus. Focus can be set so that one plane or subject in a crowded scene emerges, or for sharpness near to far in a scene that covers miles. Selective focus is achieved through the use of various focal length lenses, by altering camera to subject distance, and by changing f-stop settings.

SHARPNESS: The perception that a picture, or parts of a picture are in focus. Also, the rendition of edges or tonal borders.

SHUTTER: A set of curtains that travel past the film gate and allows light to strike the film within a set period of time.

SHUTTER RELEASE BUTTON: The button that releases the shutter and "fires" the camera. Many shutter release buttons have two stages: slight pressure actuates the meter or autofocus system (or both), further pressure fires the shutter.

SHUTTER PRIORITY MODE: An autoexposure mode where the shutter speed is user-selected and the exposure system chooses an appropriate aperture for correct exposure.

SHUTTER SPEED: An element of exposure; the duration of time in which light is allowed to strike the film.

SILVER HALIDE: Silver salts. The light-sensitive element in film.

SINGLE: In autofocus SLRs, the mode in which the camera will not allow the shutter to be released until the detector has locked focus on a subject. In motorized-advance cameras, the mode in which the shutter is released when the shutter button is pressed, but in which sequential shooting requires repeated pressure on the shutter release button.

SINGLE LENS REFLEX: Or SLR. A type of camera that has a movable mirror behind the lens and a ground glass for viewing the image. Film sits behind the mirror assembly, which swings out of the way when an exposure is made. "Single-lens" distinguishes it from TLR, or twin-lens-reflex cameras, where separate lenses are for viewing and taking.

SLIDE: A positive image on a transparent film base, used for projection viewing, printing, or photomechanical reproduction.

SLOW: A term used to describe a film with a relatively low sensitivity to light, a lens with a fairly narrow maximum aperture, or a shutter speed at or below 1/30 of a second.

SOFT FOCUS: A picture, or an area in a picture that is left slightly out-of-focus for effect, or a lens or filter that diffuses light and "softens" the overall scene.

SPECIAL EFFECTS: Any technique, lens, filter, accessory, computer effect, use of film, etc. that converts or distorts the "reality" of nature in a picture. Special effects can be sublime or ridiculous, depending on the subtlety with which they're used.

SPEED: With a shutter, the duration of time in which light strikes the film. With film, the sensitivity to light. With a lens, the maximum aperture. All can be described as either fast, medium, or slow speed.

SPOT METERING: Taking an exposure reading from a very select portion of the frame. Cameras with built-in spot metering indicate this portion with a circular ring in the viewfinder screen. Cameras with multiple AF sites may have spot metering for each site.

STOP: A relative measure of light that can be used to describe an aperture or shutter speed, although it is more commonly used with aperture settings. A difference of one stop indicates half or double the amount of light. To stop down means to narrow the aperture; to open up means to expand it.

SYNCHRONIZATION, or SYNC: The timing of the firing of the flash to coincide with the opening of the shutter so that the maximum light from that flash records on the film.

TELEPHOTO: A generic name for a lens with a focal length of higher than 50mm and an angle of view less than 45 degrees (with 35mm format.) A moderate telephoto might be in the 80mm class; a medium telephoto in the 135mm grouping; while a long-range, or extreme telephoto might have a 300mm or higher focal length.

TEXTURE: The appearance of surface detail, or the recording of tones below clear white. With slide films, texture in the highlights usually signals a correct exposure; lack of texture may mean a burnt up, or overexposed slide. In print films, texture in the highlights should be, at the minimum, darker than the paper backing of the print.

TIME EXPOSURE: A long exposure, usually not handheld, for recording scenes at night or in very dim rooms.

TONE: When used to refer to the grayscale, a step in the scale of continuous movement from black to white. The quality of light in a picture. Tones are the range of dark to light that make up the recorded image, and may or may not match the original brightness values in the scene. Tones can be altered through exposure or later when prints are made. Tone can also describe a certain overall cast, or hue. Like many terms in photography, "tone" comes from music, and can be described as high or low, resonant or discordant.

TRIPOD: A three-legged device with a platform and/or head used to steady the camera during exposure. It's most useful for exposures longer than 1/30 of a second, when using long telephoto lenses or when a constant framing must be maintained throughout a series of shots.

TTL: Through-the-lens metering. A flash autoexposure mode that measures light as it reflects off the film plane is referred to as OTF-TTL (off-the-film plane TTL.)

TUNGSTEN-BALANCED: Film that it balanced to reproduce colors faithfully when exposed under artificial tungsten light sources. Also, the lamps that emit that light.

UNDEREXPOSURE: Failure to expose correctly caused by too little light striking the film. Underexposed pictures are dark; the more the underexposure the darker they become. Color also suffers when film is underexposed, although a slight amount of underexposure can be used to increase color saturation in certain color slide films.

UV FILTER: A clear, colorless filter that stops most ultraviolet rays from recording on film. Handy for shooting distant landscape shots, as it eliminates the bluish haze that might otherwise veil the picture.

VIEWFINDER: The viewing screen in an SLR on which composition takes place; viewfinders may also contain various guides to exposure, focus, and flash-readiness. In all senses, the control panel where work can be done without removing the eye from following the scene.

WASHED OUT: Seriously overexposed slides, or overexposed highlight areas within slides and prints. It's as if the colors have been diluted to the extent that all pigments have been "washed out."

WARM TONE: The look or mood of a print or slide that tends toward the amber, or yellow/red. In black and white, a brown or sepia-toned print, or a brown-black printing paper.

WIDE-ANGLE LENS: A lens that offers a wide angle of view, usually in the 35 to 24mm focal length range. Ultra wide-angle lenses range from 20mm to 8mm. Wide-angle lenses also allow use of very deep zones of focus.

ZONE FOCUSING: A way to focus that utilizes the depth of field scale rather than the actual distance from camera to subject. Zone focusing is most useful for candid, street photography.

ZONE SYSTEM: An exposure calculating system based upon previsualizing the scene as a set of tonal variations, and exposing and developing to maximize the selected tonal set.

ZOOM LENS: A lens that allows for variation in focal length settings, as opposed to a fixed focal length lens. Zooms come in various focal length ranges, such as 35 to 105mm; all focal lengths within the zoom's range can be

Index

Accessories, 86–101
AF. *See* Autofocus
Angle of view, 56, 57
Aperture, maximum, 42
Aperture controls, 46–47
Aperture-priority mode, 24
Aperture-setting effects, 24, 48–49, 111
Aperture values, 122, 124
Autoexposure lock, 28–29, 131–132
Autofocusing, 34
Autofocusing modes, 27, 32, 33, 107–110
Automation, and exposure, 121–126

Background, foreground and, 137–138
Black-and-white film, 79, 80, 81
and creativity, 151
filters with, 91–93
Bounce flash, 147–148
Bracketing, exposure, 133
Brightness value of film, 121–126

Camera (s), 12
components of, 16–23
history of, 13
single-lens-reflex, 8, 11, 12, 36–37
Camera back, 18–20
Camera controls, 24–37
Carrying cases, 101
Color balance, 72, 73, 74
Color bias, 76–77
Color conversion, 89
Color correction, 89
Color-negative films, 78
Color sensitivity, 75
Color-slide film, 78, 79
Compensation
exposure, 35, 133–134
flash output, 147
Continuous (C) autofocusing mode, 27, 32, 33, 107
Contrast, 85, 127–128
Conversion, color, 89
Correction, color, 89
Cool colors, 76

Darkroom, digital, 152–153
Daylight-balanced films, 72, 73
Daylight fill flash,148–150
Dedicated flash, 99
Depth of field, 40, 55, 57, 59, 110–113
Developing, film, 84
Digital darkroom, 152–153
Distance, focusing, 54, 111, 112
Distortion, 59–60
DX-coding, 18

Exposure, 114–134
automation and, 131–136
creative, 139–140
equivalent, 124, 125–126
manual, 24, 35
Exposure compensation, 35, 133–134
Exposure controls, 28–29
Exposure latitude, 85, 132–133
Exposure-metering modes, 34
Exposure modes, 34–35, 129–134
Exposure value (EV), 122, 124

Film (s), 64–85
black-and-white, 79, 80, 81, 151
color-negative, 78
color-slide, 78–79
grain of, 69–71
loading and rewinding of, 22–23
negative and positive, 14, 65, 67, 78
professional and amateur,84–85
stability of, 82, 83, 84
types of, 78–85
Film speed, 67–69, 122
Filters, 88–95
Flare, 87
Flash, 96–99
bounce and diffused, 147–148
and creativity, 146–150
Flash modes, 146–147
Focal length, 40, 42, 43, 44–45, 56, 57, 111
Focusing, 102–113

close, 63
Focusing modes, 32–33. *See also* Autofocusing modes
Framing rates, 19, 35

Grain of film, 69–71
Guide number (GN), 97, 99, 150

History of photography, 13
Horizontal angle of view, 57
Hot shoe, 99
Hyperfocal distance settings, 112

Image formation, 14, 65–66, 79
Infrared films, 75
ISO number, 64, 122

LCD panels, 20, 21
Lens (es), 38–63
autofocus, 41
mounting of, 38–39
short-range telephoto, 45
specialty, 50–53
super wide-angle, 44, 59–60
telephoto, 45, 61
wide-angle, 44, 59–60
zoom, 52–53
Lens mount, 17–18
Light,
low, 144–145
natural, sky and, 143–144
Lighting
and compensation, 134
mood, 141–145
Light sensitivity, 67–69
Loading film, 22–23

Macro lens, 62–63
Metering, 34, 88, 116–120

Negatives, 14, 65, 67, 78
Nighttime photography, 144–145

Orthochromatic films, 75,

Panchromatic films, 75
Perspective, 40, 56, 58–59
Photographic terms, 34–35
Picture modes, 35

Portrait photography, 86
Program shift mode, 24

Rewinding film, 22–23

Selective focus, 102
Shutter, 19
Shutter-priority mode, 24
Shutter release, 19, 20
Shutter speed, 114, 122, 124
Single (S) autofocusing mode, 27, 32, 33, 107
SLR (single-lens-reflex) camera, 8, 11, 12
35mm, features checklist for, 36–37
Speed
of film, 67–69
of shutter, 114, 122, 124
Sports photography, 86
Stacking, 61
Syncro, slow, 148

Telephoto lens, 45, 61
short-range, 45
super, 45
Temperature scale, Kelvin, 72, 73
Travel photography, 86
Tripods, 100–101
Tripod socket, 31
TTL (through the lens) metering, 88
Tungsten-balanced film, 72–73

User input, 35

Value (s),
aperture, 122, 124
brightness, 120–126
contrast, 127
exposure (EV), 122, 124
View, angle of, 56
Viewfinders, 18, 104–106

Warm colors, 76, 77
Watt/second rating, 97
Wide-angle lens, 44
super, 44, 59–60

Zoom lens, 52–53